The Real World™ X
BACK TO NEW YORK
24/7

The Real World™ X
BACK TO NEW YORK
24/7

by ALISON POLLET

MUSIC TELEVISION®

POCKET
BOOKS

New York • London • Toronto • Sydney • Singapore

An *Original* Publication of MTV Books/Pocket Books

POCKET
BOOKS MUSIC TELEVISION®

POCKET BOOKS, a division of Simon & Schuster, Inc.
1230 Avenue of the Americas, New York, NY 10020

ISBN: 0-7434-2837-4

First MTV Books/Pocket Books trade paperback printing November 2001

10 9 8 7 6 5 4 3 2 1

POCKET and colophon are registered trademarks of Simon & Schuster, Inc.

Cover and interior design by Nicholas Caruso/Red Herring Design

Printed in the U.S.A.

For information regarding special discounts for bulk purchases, please contact Simon & Schuster Special Sales at 1-800-456-6798 or business@simonandschuster.com.

SPECIAL THANKS TO

Scott Freeman, Vice President, Creative Affairs for Bunim/Murray Productions

Tracy Chaplin, Coordinating Producer

The CAST of THE REAL WORLD X: Coral, Kevin, Lori, Malik, Mike, Nicole and Rachel

The CAST of THE REAL WORLD IX: Danny, David, Jamie, Julie, Kelley, Matt and Melissa

Christine Alloro, Brett Alphin, Bobby, Brian Blatz, Liz Brooks, Mary-Ellis Bunim, Tricia Connolly, Joyce Corrington, Michelle Dorn, Ken Freda, Michelle Gurney, Russell Heldt, Greer Kessel Hendricks, Jacob Hoye, Jisela, Jonathan Jones, Andrea LaBate Glanz, Preston Kevin Lewis, Lionel Milton, Jon Murray, Donna O'Neill, Erin Paullus, Jeff Pederson, Lisa Silfen, Robin Silverman, Donald Silvey, Liate Stehlik, Van Toffler, Kara Welsh, Maggie Zeltner

PHOTO CREDITS

Front Cover Photography courtesy of Mando Gonzales

Back Cover Photography courtesy of Mando Gonzales, Tracy Chaplin, and the cast of *The Real World Back to New York*

The Real World cartoon characters courtesy of Lionel Milton, ElleOne

TRACY CHAPLIN: 8, 12, 16, 20, 32, 40, 43, 46, 48, 49, 50, 51, 53, 54, 55, 56, 60, 61, 62, 63, 64, 66, 67, 70, 72, 76, 80, 82, 87, 88, 91, 93, 99, 102, 103, 107, 110, 111, 112, 114, 115, 116, 118, 120

MANDO GONZALES: 10, 14-15, 24, 28, 44-45, 48, 96, 100, 104, 122, 123

JOEY CASTILLO: 38, 39, 40, 43, 65, 81, 91, 106, 108

ANDREW BROWN: 39

JIMMY MALECKI: 130, 134, 142, 146, 150, 152

Candids very kindly provided by the cast of *The Real World Back to New York, The Real World New Orleans,* and the staff of Bunim/Murray Productions.

table of contents

I hope people see a lot of the fun that we had. Like previous casts we did fight, but I hope that's not all that gets shown. I hope it also shows that we're funny and how much we really do care about one another.

—Rachel

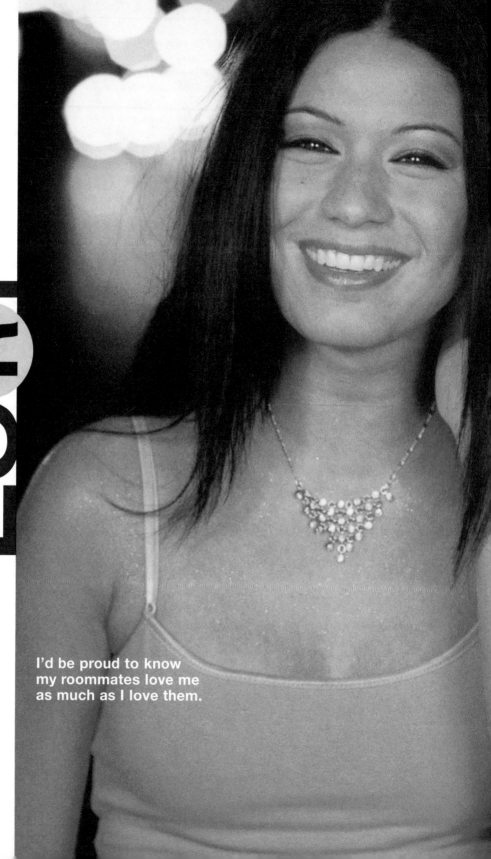

Lori

I'd be proud to know
my roommates love me
as much as I love them.

I'm done with the cameras, but I'm not really done with my roommates. We molded together, and now we're being torn apart. It's hard to stomach; the whole thing is making me feel totally chaotic and directionless.

I was obsessed with the Seattle season. Actually, a scene from the Seattle season inspired me to try out for the show. Rebecca said she was glad she'd never gotten her heart broken, because it meant she wasn't bitter. None of her roommates responded to her. But there I was in my apartment jumping up and down. I was yelling, "No, no, no! Heartbreak is good!" That moment motivated me. I wanted to get on the show and voice my opinion. I'm all into psychology and I'm a ten-year journal keeper. I'm obsessed with learning as much as I can about myself.

Once I got on the show, a lot of things surprised me. In the beginning I thought less about my appearance than at the end. In the beginning, all I'd do was sit around in my pajamas doing nothing. We'd get dressed only to go out. For some reason, I thought no one was going to see me. In a way, I think I was less cognizant of the cameras in the beginning than in the end.

I really don't think people changed the way they behaved for the cameras. Sure, we curbed certain aspects of our behavior. I'd go on camera and say I was quitting smoking and then stop smoking only during the day. I don't think that makes me a hypocrite. I was just living my life. I always say I'm going to quit smoking.

I go to Boston College, which is a party school, but I'm barely a partier there. In New York, it was different. I got on the show and immediately suggested, "Come on, let's go get beer." I thought it'd be fun. I don't want to come off as an alcoholic, and I don't think I will, but I definitely got drunk a lot. Mostly it was off-camera. I'd fall on my a**. My best friend visited and got me obliterated. I threw up like crazy. They didn't get any of it on camera, thank God.

I had a lot of breaks from the camera, a lot more than I thought I'd have. Not that I didn't love the crew. In fact, I made an a** of myself with a crew member. I went to a party, and was looking for guys. There was one good-looking guy, so I went up to him. I was shocked to realize he had a light in his hand. It turned out he was a crew member! Geez.

I couldn't help making jokes with him and about him. I teased him all the time. As a result, his wall was up higher than anyone else's. It made me feel heartbroken. If I have one regret, it's letting him know I liked him. Actually, I have another regret: I wish I'd done more confessionals and gotten my thoughts out more—that's why I came to New York, after all. I'm scared that people are going to think I don't have any thoughts in my head. Also, I cried too much. I'm not a crybaby at all, but I was homesick a lot in the beginning.

I feel that my roommates love me, but aside from Coral, I'm not sure if they are passionate about me. I hope so. I'm most proud of the friendships I made here—as cheesy as that sounds. I'd be proud to know my roommates love me as much as I love them.

In my regular life I'm more like Coral. I'm more caustic, opinionated. In the house I felt sort of indefinable. I'm not a pushover; I do react to things, but something in the house made me feel stymied. When you're around really vibrant colors, you wonder if you're bland in comparison. One time we were imitating one another. All of my roommates had quirks that you could easily copy. I said, "Imitate me!" and no one could. It made me feel like a ghost.

the v.i.p. room

malik

Lori's so smart and neat and funny. I know she worries about how she's going to be portrayed, but I don't think she's going to have a problem. Our friendship is about sharing little stuff. We sing notes together. We both like our music loud. We wound up doing a lot of late-night kicking it. And she's funny. She'd have me burst-into-tears laughing.

kevin

Lori's a sweet girl. Despite the initial tension—on her part, not mine—we've been good. We get along really well. Lori says a lot of random stuff, and I'd be the only person who was right with her, following her train of thought. Even when we had tension, we were still fine. Actually, I think we'll be friends forever.

rachel

Lori is my favorite person in the house and I know I'm going to miss her. I hope that Lori and I are still very good friends. In the house, she's the one I felt closest to. It bothered her that I wasn't around a lot. We've talked about it and I've let her know I really do care.

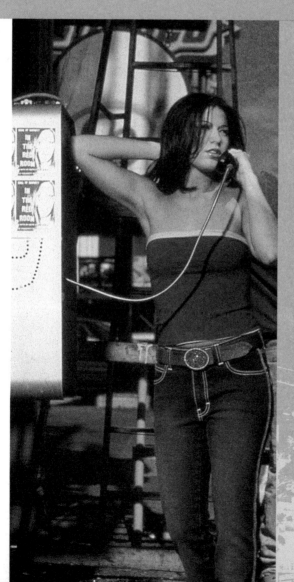

Here's another big thing that happened during the last four months. My hair started thinning. I don't know if it was a reaction to stress, or what. I already have really thin hair and my scalp just shines through it. It was a big joke in the house. It's the only thing I'm paranoid about physically. I'm scared people are going to make fun of how I'm balding. People were joking about me getting Rogaine.

mike

Lori has a great voice. It's so beautiful. Musically, she's learned what she needs to be, a singer. I think she's grown a lot. I think she has the talent, the look, the dance. She kind of lacks confidence. What I see is not what she sees.

coral

Lori's the person I became closest to in the house. If you're upset, you're just glad she's your friend. She's a great listener. She's very talented. She's smart and she's not arrogant, she's ready to learn. I think she's funny. I like her. We have a lot to talk about—from ex-boyfriends to parents to whatever.

nicole

I really didn't know Lori that well, but I was fine with her. She's probably the person I'll always want to get to know better. When Lori and I are alone, we're really cool. I think she's so bright and witty. I wouldn't mind keeping in touch with her at all. I think she's excellent.

russell heldt, producer

Lori's casting tape mesmerized the staff. Whenever I would watch her tape, it would stop traffic in the office. The men walking by my office would hit the brakes, eyes popping out of their heads, and they'd say, "Wow! Who's that girl?" Yet Lori is one of the most insecure beautiful women I've ever met. I think she realizes she's beautiful and talented. But she makes it so easy for people to get under her skin. She worries about what people say about her. Lori is completely honest about her insecurities. She would bravely—and somewhat recklessly—expose her emotions. Lori has definitely grown. I saw her push herself and realize that if she wants something, she has to do something about it. During her time in New York, she confronted some of her limits, and pushed past them. It was nice to see.

jon murray, co-creator

MTVi asked us to put five of our semifinalists up on the Internet site and let MTV's viewers choose one to go to finals. When we included Lori, we thought she'd be a popular choice, but we never guessed viewers would overwhelmingly choose her to go to finals. I guess they saw the same great things in her that we saw.

mary-ellis bunim, co-creator

Lori has a genius sense of humor. She's so quick, smart, and talented. Guess everyone will have to go out and buy the *Real World You Never Saw–New York* video to see the Lori you didn't see!

hope fear advice

Wanna be seen as...
Smart, perceptive, and empathetic. My friends and Coral think I'm funny, but I know I'm not going to be portrayed as funny. That's just a shame: to have a good sense of humor and no one's going to know. That sucks!

Scared I'm gonna be seen as...
The typical aspiring musician who's just using *The Real World* for exposure. Also, I think I'll seem stupid and boy-crazy, but I just like having crushes on people.

To all the little Loris out there...
Empathy is the most important quality. Know where other people are coming from. Let go of your own opinions. Walk in someone else's shoes. Stay who you are fundamentally, but open yourself up to change.

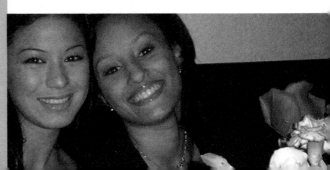

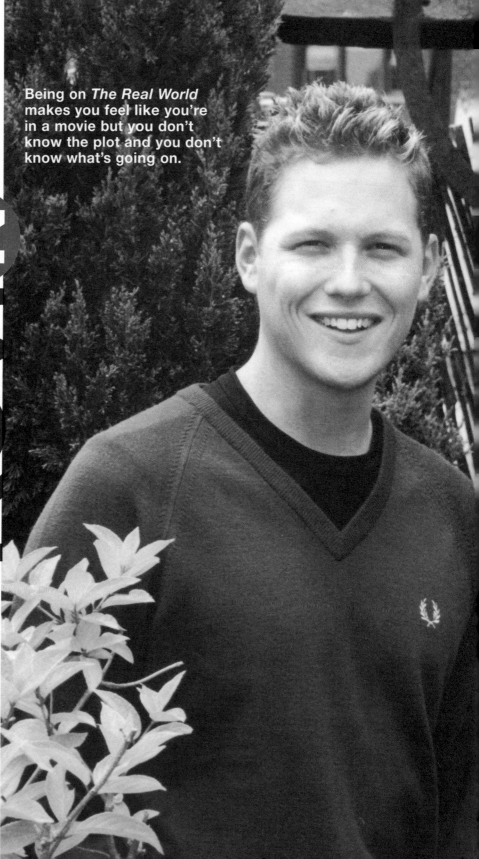

Being on *The Real World* makes you feel like you're in a movie but you don't know the plot and you don't know what's going on.

Kevin

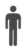

If you're not growing, you're decaying. Someone once told me that. I'm really into philosophy. There's always some philosophical passage, some advice that can make you feel better. If I had a life philosophy, it'd be that life is short. If you are absolutely blessed by the grace of God, you live 80 years. So have fun and remain even-keeled.

There was a lot of bitching in our house. Come on! You've got to remember there's always someone out there who has it worse. It's a cliché, but look at the glass as if it's half full.

Right now, I'm extremely happy, yet sad. Happy because I don't have cameras in my face anymore and I can be independent. Sad because this was a once-in-a-lifetime experience I'll never get to relive. But I have to say it's a real relief to have the mikes off. All that remiking and demiking, it ruins your shirts!

There's something viewers won't know about me: I'm religious. I went to church only six or seven times in New York, but I prayed every night before I went to bed. I'm Catholic. I believe that if you're good-hearted, you're going to go to heaven.

Religion is a big part of my life, but it's a quiet part. I think Malik knew I was praying each night, but it's not something I talk about. I don't think it will make the show. You can film me lying in the dark having a private conversation with God, but that's probably not good TV. God didn't sign a consent form, so that's OK.

I don't like to talk about myself. I just take things in. I don't really speak. I watch what happens, form my opinion, and if it's necessary I'll speak. This show forces you to talk. And even though I had some problems with the cameras, there were times when I really wished they were around. There were some talks I had with Mike and Malik that were so great but no one will see. It's frustrating. But of course every hug I exchanged with Lori is on film!

Being on *The Real World* makes you feel like you're in a movie but you don't know the plot and you don't know what's going on.

My friends at home are more like me. We all have the same sense of humor. I think they'll take the show for what it is: a TV show, a story. I don't really think I'm going to come off bad. Life's too short to worry about how I'm portrayed, and I hope people just feel entertained.

I'm looking forward to going home and getting back into my life. Do I have a girl waiting for me? No, but there are a couple of girls I like. I think I'm in a place where I could really commit. I've dated girls, but I want someone I can really depend on. I was such an independent person before I got to New York. Through the friends I've made, I've become a little bit more dependent. I like it. It reminds me of what it's like to trust someone.

Will the next person I go out with have trouble with my impending fame? I've thought about that a lot. It's going to be difficult. And will I trust that the girl wants me just for me? Of anyone, I think Malik will have a real difficult time with that. He's too warm-hearted. He trusts everyone.

On *The Real World,* I learned to be vulnerable, to talk about the difficult parts of my life. I talked about my disease, my lack of patience, and learning to love people. If you let the show do its thing, give in to the process and let it work for you, and embrace change, everything will be good.

the v.i.p. room

nicole

I think Kevin's witty, smart, and really charismatic. When we first moved to the house, I thought we'd be so cool and tight and then the whole Malik situation happened. Kevin took Malik's side and wouldn't stay in the middle. I was hurt by that. I think Kevin's sort of fake. We're definitely not friends. He adapts well to situations and you don't know if he's agreeing with you or just being cordial. He's a yes man. It's a surface thing with me and him. I don't want to get close to him.

malik

Kevin's an incredible person. He's my boy. From the beginning, we knew we'd be straight, that we'd get along. We challenge each other. I definitely think that even though Kevin is a Republican, he's very liberal in his thinking.

lori

Kevin can be quick to judge. Also, he'll just insult you out of nowhere and then claim he was just "being honest." He'll say, "You were so annoying last night." He thinks somehow that because he's "being honest," that's OK. Because of my feelings for him, the beginning of our relationship was rocky. Now that I don't want him anymore, it's a lot easier for us to be friends.

I bet no one knows I have a photographic memory for sports. I do. I can remember games play-by-play dating back to 1983. Malik watched a sports classics channel with me once. I freaked him out completely. I knew moves the mascot would make.

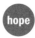
hope fear advice

Wanna be seen as...
Open-minded, caring, funny, and individual.

Scared I'm gonna be seen as...
Arrogant, when I'm really just extremely confident. I think they could view me as detached or apathetic.

To all the little Kevins out there...
Everyone's coming from different places. Things that are normal to you are weird to other people. Be happy with who you are, don't be petty, and try to understand where people are coming from.

CAST

rachel

I'm going to miss Kevin a lot. I'm going to miss his honesty and his sarcasm and the things about him that are so Kevin. I'm especially going to miss joking around that we're going to get married. But for the record, let me say that I was never really attracted to Kevin. I was once asked to whom among the male roommates I was most attracted. That would be Kevin, but only because I had a limited selection.

coral

Kevin is a cool dude. He's a gentleman. He's very articulate and intelligent and refined. He doesn't argue, and that can be annoying. He's had a life with a lot of negativity, and he's at a point where he doesn't want to deal with it anymore. At first I mistook his not dealing with stuff for arrogance, but I was patient and finally understood what he was about.

mike

Kevin was always there—even when everyone hated me in the house. He's the type of person who can fit in with any group. He'll give you what you want to hear. That's a good thing, since what he wants to be is a businessman. We never get in arguments. We get into brotherly fights. I love ragging on him. We love each other to death.

russell heldt

During the season, Kevin exhibited a sense of humor and knack for interpreting things. I don't think he took as many emotional risks as possible. He had too much self-restraint to really let his guard down. But, he had an explanation for it: Because he had cancer, he's just happy to be alive. Why get upset if someone is rubbing him the wrong way? It's just not that big a deal. He doesn't feel an incredible need to confront people. He wants things to roll right off him. Ultimately, this attitude will save Kevin a lot of heartache. You see, Kevin is a Texas Longhorn, and I'm a Nebraska Cornhusker. Kevin will have to get used to the Huskers beating his team over and over again. This is where letting things roll off his back will pay off for him!

jon murray

Part of what makes Kevin so appealing as a cast member is that he holds back and stays a little mysterious. And as we all know, girls love guys who hold back and stay a little mysterious. Just ask Lori!

mary-ellis bunim

Kevin surely was mysterious. Personally, I wish Kevin had opened up more and expressed the incredible range we saw during the casting process. What you see in the series is only a hint of who he is. Kevin will make an awesome politician—maybe even President!

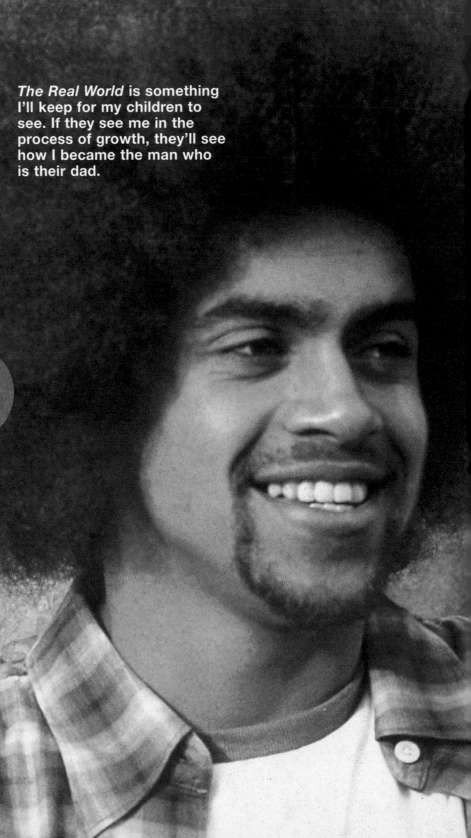

The Real World is something I'll keep for my children to see. If they see me in the process of growth, they'll see how I became the man who is their dad.

Malik

This experience has made me feel the world is big and small. Big in the sense that being in New York expanded my horizons and made me want bigger and better things. Small in the sense that all the people I meet remind me of people at home, and it makes me want to go there.

I wish I'd had more time in New York. I visited every borough. I went to all kinds of parties and clubs. I took dance lessons. I worked out. But I wanted to take break-dancing lessons. I wanted to see some famous street basketball I'd heard about. I wanted to meet the magician David Blaine. I'm leaving too soon!

What made me want to do the show in the first place? My friend Mei made me go to the casting call. I was in line with all these people and some of those girls were so gorgeous. I was thinking: Damn, if I could live with y'all, that would be phat. All the kids who hang out on the street were talking crap about the people in line. I really wasn't taking the whole thing seriously until I found out the show was going to be in New York. If I could go to New York, I could meet my dad's side of the family. That inspired me.

And, in fact, meeting my family was really incredible. If it seems like I was even-keeled about it, it's not that I was emotionless. I was just mentally prepared. I think I was ready to meet them. Since I don't talk to my dad, it was weird to meet his side of the family without him. I did call him, but he didn't want to talk to me on a tapped phone. Meeting my sister, my dad's daughter, was cool because we really identified. I told her I was psyched because my sister at home was about to have a kid and I would be an uncle. She was like, "You're already an uncle because I have a kid." That was amazing to me.

I want to make a big family and adopt a lot of kids. When I was young, all I wanted was to have eight kids of my own and adopt four other kids. I wanted a baby from every part of the world. It still is kind of my goal. I want to have one wife and a lot of kids with her, but I definitely want to adopt babies from different countries.

I'm glad to be part of the most racially mixed cast of *The Real World*. It feels good to me. It makes you realize that people of all different racial backgrounds can get along. I know we talked a lot about race, and we have lots of different perspectives, so that's good.

When you live with strangers, you have to compensate. You can't think your opinions are more valid than others. People are different. Differences in opinion should help you to reassess your views or confirm them. Where I'm from, I don't have enemies and my views aren't challenged, they're considered the norm. It was good for me to be in a different element, to confirm my ways of thinking. People can change each other. You change so much between 18 and 25. I changed here. I've become so confident. I used to be so shy—especially around girls. Now I'm up-front about actions and views. I was the oldest one in the house. When I look at Rachel and at Mike, I think, *My God, I can't believe how much they're going to change in the next few years.*

I will always be learning something and seeking teachers. Before I die, I want to have as many talents as possible. I want to pursue music and every element of hip-hop from deejaying to making music. I want to do martial arts. I want to write books and screenplays.

I'm excited to go home. I'm going to move into a friend's house and we're going to start a club. My sister's going to give birth to her first child. I have one more semester of college left.

I got my palm read the other day. The reader said I had a long life line and a long success line. *The Real World* is something I'll keep for my children to see. If they see me in the process of growth, they'll see how I became the man who is their dad.

nicole

I considered Malik a friend in the beginning, but after the whole situation, I don't trust him. He lies. He's a people pleaser. I have a problem with people who don't have opinions. You don't have to agree with everything I say. There's no intellectual exchange with Malik. I'm cool to have a peaceful relationship with him. He's a nice person, but I'd prefer an honest person.

lori

Malik and I have a lot of private jokes. I'd do shows for him, pretending I was on TV, because he and I both missed TV. He's one of my favorite people to laugh with because he laughs really hard.

coral

Malik and I are homies. We were just happy to be living together. Malik is a big ball of positive energy. I kind of questioned it in the beginning. He never really got mad. I've seen him hurt, but I've never seen him pissed. He's been through a lot more than he lets on.

russell heldt

This is an overstatement, but I joked in casting that Malik is Jesus Christ but didn't know it. He definitely has a heart big enough to love the world—and there's still room for a few more planets! He's all about love. He's unflappable. He'll deal with the good and bad and still remain in a harmonious state. In casting, he told a story about how his home was burglarized. He found the kid who did it, a teenager who lived in the neighborhood. Instead of railing against the kid, Malik told him to keep the money, but he wanted him to know he was hurt that the kid would rob him instead of asking him for the money. In Malik's words, much love.

jon murray

OK, I admit it; having cool hair helps your chance of getting on the show; or at least it caught our attention at an open casting call.

mary-ellis bunim

I admit to being partial to UC-Berkeley students, but that's not the only reason he was cast! Malik is peace personified. His calm and intelligent demeanor had a good effect on his roommates and his environment. I hope he writes a book on his experiences.

 hope fear advice

Wanna be seen as...
A peaceful person who's open-minded and nonjudgmental.

Scared I'm gonna be seen as...
I'm not really scared of anything. If I'm scared of anything, it's that people won't see all of me.

To all the little Maliks out there...
Keep your mind open, learn, become multi-talented. This whole world is open to you. Pursue what makes you happy.

When I was young, my mom and I used to make family out of friends we made. We just established all this kin. We have this big family of friends we know. That's how I lived my life. But it's dope to meet family you look like, whom you're connected to by blood.

the v.i.p. room

kevin

Malik is my brother from a different mother. Our friendship has gotten so close, it's telepathic. We finish each other's sentences. We're so close, I think we'd lay down in front of a train for each other. This is a lifelong friendship, without a doubt. We'll be 70 years old in Jamaica lying on the beach together listening to Bob Marley.

mike

Malik is like God. He's so positive. Not a negative bone in his body. He's so generous. He's the nicest person in the world. We're best friends. I'd do anything for him. He's the best teacher anyone could have. He's so cool and so chill.

rachel

Malik and I are just cool. I don't think I got to know him extremely well, but I still love him for the fact that he'll go out of his way to make people happy. He tries to understand both sides of every story, and I think I'm safe to have a good relationship with him because of it. I just can't be as kind to humanity as he is.

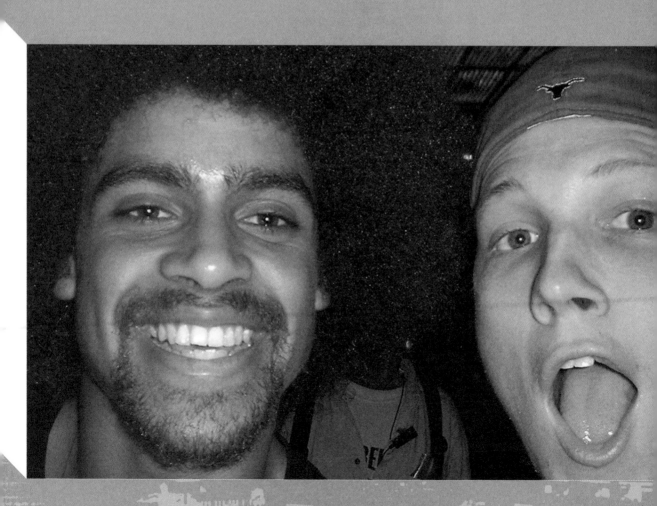

CoraL

There are two people in my life whom I trust: me, and the other one ain't you.

I feel like I've been on a really long walk and now it's over. The things I learned during my time on *The Real World,* I maybe could have learned in therapy. Maybe. This is such a bizarre experience. Usually you get to live life freely and without consequences. But on camera, you're responsible for everything you do; your actions are held against you. And that really changes you.

When you're on camera all the time, you're doing your life in a normal way, but it feels like a bigger deal. It's hard not to be conscious about the cameras. It's hard not think about what you're saying, what story lines you're creating. It's an awkward feeling to know your pain is providing other people with entertainment.

I feel like I was the same on and off camera. Everybody gets nervous, and of course it's awkward. But if I didn't act like myself, it'd be a bunch of crap. Sure, some people held back more. But there are things they don't want America to know. Everybody doesn't need to know what color panties I have on.

I'm fine with everything I said. I don't plan on answering to anybody about anything. The people who matter are not going to react at all. The people who don't matter might hate my guts. I can't worry about that stuff. I'm going to have an outgoing message on my phone that says, "If you're calling to talk about *The Real World,* shut the hell up."

I've done some of the stupidest stuff in my life. I don't want to get into it, but there are things that make me very insecure. I'm not secure about my looks. I'm scared of seeming too up-front and intimidating. I'm scared about people coming in my life and leaving. My life has always been a big crazy whirlwind, and the only thing I have is peace within myself. That's why I keep stuff in. I need to be able to walk through a hurricane. My biggest flaw is the fact that I make boundaries for myself, but it's just that I need to keep inner peace.

Don't get me wrong, I'm social, I'm a party girl, but I can't make a lot of deep friends. I'd like to be more sensitive. I'd like to trust people more. There's a battle within myself every time I make a new friend. That would explain why I've never had a slew of pals. I've always been doing for me. That's who I trust: me. There's this phrase: There are two people in my life whom I trust: me and the other one ain't you. I can feel that. But I know that's the easy way out.

How do I manage my anger? I'm vocal. I talk about stuff. The thing about voicing your anger is that you feel better after. It doesn't matter if the argument is resolved. Even if I hate the person more than I did before, that's OK. Anything that comes out of confrontation is good. Why should I stew in my anger?

Why did I do the show? Well, I was doing child care for two kids. I was working from 7:30 AM to 6:30 PM and then taking classes afterward. I was tired of doing the same thing every day. And, yes, I do think *The Real World* will change the course of my life—though I don't know how. How could it not? Everything was so crappy before. I hated school—the truth is, I'm not a school person. I was so busy and overwrought and all those bills! It was just a time in my life that I wanted to escape and I'm lucky to have gotten the chance.

I don't know what I'm going to do now. I'm going to stay in the Bay Area, but I don't have any real plans. I'm not planted. I want the kind of job everyone else wants. You know the kind...the one where you get a whole lot of money, travel, and everyone loves you. The rich and fun job, that one.

Regardless of what happens, I'm happier now. I'm on the road to self-knowledge, and that's worth a lot to me.

the v.i.p. room

nicole

When I came into the house, Coral was the person I was unsure about. I didn't think we could be friends. She proved me wrong. When I went through a difficult time in the house, we were real close. What don't I like about her? This is going to seem petty, but she tells lies—not huge ones, but lies. Someone who lies can't be trusted.

kevin

Coral's got that edginess to her. She can definitely be mean, but once you break down barriers she's a really good person to know. We got really close in the last week here.

lori

I'm closest to Coral in the house, absolutely. She can upset me the most and make me the happiest. Everything about her is extreme. She's very happy or very angry. It can cause conflict. We have different principles sometimes. If she feels anything, she'll say it to the person's face. I don't think that kind of confrontation is always necessary. I don't think honesty is always the best policy. I trusted Coral immediately because you can tell she's got this undying loyalty. I'm nervous about Coral, though. She burns bridges if she feels betrayed. There may be stuff I said that she doesn't like. I'm curious to see how it's going to go down once it airs.

The best thing about me? I don't know what that is. Maybe the fact that I'm really loyal. Once I let people in, I'm a really good friend. I'm kinda funny, too. I like having a sense of humor. But it can get me in trouble sometimes.

malik

I love Coral. Coral has never had a crew she belonged to. This is her first real group of friends. It's cool that she's part of something because she is a teacher and a good leader. She's wonderful.

rachel

My relationship with Coral was very up and down. One second I'd feel we were tight, the next I'd feel she disliked me. I know I said at one point in an interview that I didn't care if I was friends with Coral after the show stopped taping. That's not really true. Or maybe it is. I don't know. My feelings about her fluctuate.

mike

Coral is a very strong person. She's honest. She'll tell you straight up: "You look like crap today." You want Coral on your side. When she's your enemy, oh boy, all hell breaks loose. When she becomes your friend, there's a sweetness that comes out. It's nice.

russell heldt

Coral was the person I was most interested in getting cast. I thought there was a vulnerable side to the headstrong troublemaker everyone else saw. But when Coral got here, we wondered whether she'd be willing to grow. In the beginning, she held Mike accountable for his racist remarks. And then she realized it was harder to hate a person than to not hate him. Coral really taught Mike. There were times I thought I saw her open his head up and fill it with enlightenment. She came in here closed off, a tough woman—angry and uptight. Coral puts out a strong front. She makes herself feel better by giving advice to Lori, but deep down she's probably just as insecure as Lori is. I think you need an intricate map to get to Coral's soft center; if you survive the journey there, you'll find she's incredibly warmhearted.

jon murray

I've always believed that the people with the most difficult pasts make the most interesting cast members; Coral proves this fact once again. I hope her sense of humor comes out in the shows because it is very sharp and very funny.

mary-ellis bunim

Sharp-witted, bitingly intolerant of almost everyone in her path, Coral learned a lot about herself and living with people who were quite different from her. There was a huge change in Coral after Nicole called a meeting of the cast mates to discuss their conflicts. It's fun—and good—to see someone grow and change.

hope **fear** **advice**

Wanna be seen as...
Funny, honest, and a good friend. I hope viewers see me as strong, confident and a sensitive person. I hope they see the lighter side of me—not just the dark, deep part.

Scared I'm gonna be seen as...
Mean and bitchy. I am that way at times. But there's so much more to me than that.

To all the little Corals out there...
Make yourself happy. When you're happy, people around you are happy. Stand up to people, but admit your mistakes. Don't dwell on the bad stuff. No one wants to be around people who hate themselves.

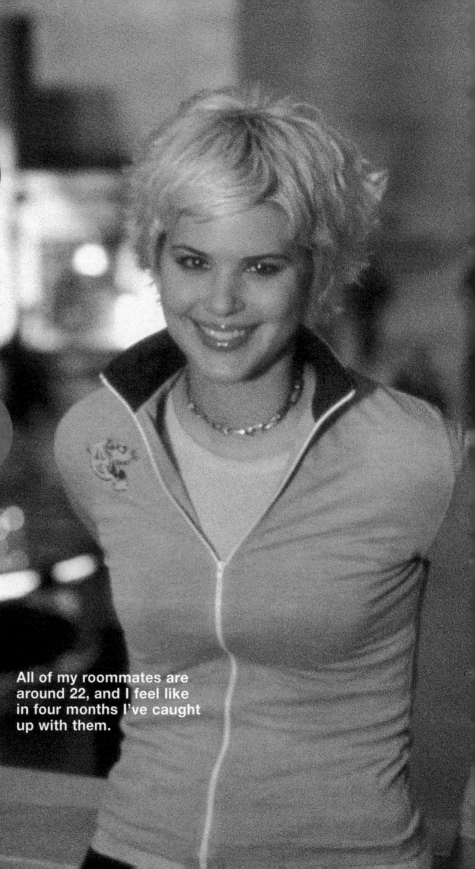

RАchel

All of my roommates are around 22, and I feel like in four months I've caught up with them.

I definitely feel I've changed in the months I've been here. I've learned I can be independent and make my own decisions. I think I've mellowed myself out.

All of my roommates are around 22, and I feel that in four months I've caught up with them. They'd all say that if *they* were 18, they wouldn't be able to deal with this situation. They gave me props for it.

I never actually thought of doing *The Real World.* One of my friends said I had to come to this open call, that I'd be perfect. And they kept calling me back. I was wondering what the casting people saw in me. I think it was the fact that I'm at a turning point in my life. I'm just figuring out how to live on my own without my mom. I need to make choices by myself and not because of her.

We didn't have cable TV growing up. All I'd seen was a few Casting Specials and several episodes of the New Orleans season. I had no preconceptions about being on the show. All I could obsess over was whether I'd be on *The Real World* or *Road Rules.*

The show has already changed my life. I changed my major from journalism to television production because of this show. I watched the crew, and sometimes I wanted to be behind the camera. You can't talk to the crew, but I fell in love with them all. All three of us—minus Nicole—love a specific crew member a little too much.

little people I've baby-sat watching me make mistakes and stay up all night. And I'm not very excited about my ex-boyfriend and his girlfriend seeing me rag on them. I called her a knit bitch on television. What's a knit bitch? Someone who at 19 sits around in grandma slippers knitting! Who does that?

The truth is, I've learned to not care what people think, and to block out a lot of things. It's a big confidence booster to be on this show. It makes you feel special. And I needed to feel special. Before I got here, I had such a gruesome breakup with my boyfriend, Justin. The one person I wanted didn't want me. Well, now I've got a whole group of friends and a whole group of guys. I don't need him.

I'm scared to see myself cry on television. I feel like a complete and total baby and idiot when I cry. Interviews make you cry. They make you think. You have to analyze every solitary thing you do. You learn more about yourself from the interviews than you can ever imagine.

I hope people see a lot of the fun that we had. Like previous casts we did fight, but I hope that's not all that gets shown. I hope it also shows that we're funny and how much we really do care about one another.

My mom came and visited. My favorite crew member is a sound guy. I love him! Anyway, he was miking me. He had to put his hand up my shirt to do so. I didn't mind, but my mom freaked. She nearly had a heart attack.

I'm scared about a lot of stuff my mom is going to see. She is going to kill me when she sees alcohol in my hands. Our parents are going to learn a lot more than they might want to know about their children, and that's a bit scary. It's going to be weird having my little cousins and the

malik

Rachel's like my young cousin. She's really messy, always getting in trouble. Watching her made me think, *I remember when I was your age….* We're friends. We didn't spend a lot of the nightlife together, 'cause she'd be at shows and I'd be at clubs. But she's a sweet girl.

mike

Rachel is 18, but she's still mommied. I've been trying to get her to detach from her mom, to grow up and be a woman. She still gets grounded. Who gets grounded at 18? I was like, "Rachel, you need to stick up for yourself." I'd rag on her, saying "Mommy, do this," and "Mommy, do that." I hope she'll have her mom stop bossing her around and live her life the way she wants. Rachel is very influenced by other people.

coral

Rachel's not as innocent as everyone thinks. Okay, she's still probably never seen a penis, but she went to a strip club and got a lapdance. We'd be having some crude conversation and she'd be cursing up a storm. Then her mom would call and she'd go into baby talk. Rachel's a little groupie. The girl gets her band thing on. I'll miss her energy but we don't really connect on a level we'd need to in order to be daily friends. We have respect for each other, but that's it. We're different.

hope fear advice

Wanna be seen as…

Someone who has learned and grown up, who is fun and really nice.

Scared I'm gonna be seen as…

The young, naive one.

To all the little Rachels out there…

You can live for yourself, but—no matter how much you are your own person—remember that your actions affect other people.

I had to find friends outside the house, because no one in the house liked doing what I liked. I don't like hanging out at clubs or bars. It's not my scene. I feel out of place. I like to go to concerts. I like to eat vegetarian food and listen to good music. And no one in the house would do that with me.

the v.i.p. room

kevin

I feel really protective of Rachel. I just want to make sure she doesn't get hurt. She hasn't had a lot of relationship experience, and I want to look out for her. She's still learning about what she wants to do.

lori

Rachel and I got really close. We are usually on the same page about how to deal with stuff, so it's relaxing to be around her. I've never had to explain stuff to her. Sadly, we've drifted apart. She found her own niche in the city. She found her own group of friends. We were really tight at one point, and I still love her.

nicole

I really want to be friends with Rachel, but she makes it difficult. I tried really hard to be nice, to be sensitive, but then she goes and says stuff or gives attitude. She acts up and I don't want to be around her. She's really self-absorbed. The thing is: I want to be her good friend. I've never said anything really negative—self-absorbed doesn't count, right?—about her. Because when we're one-on-one, we're cool.

russell heldt

I've seen Rachel grow. I think she still worries about what Mom is going to think, but I think that's a good thing. She *should* listen to her mom about some things! She tasted independence and was confronted by people's perceptions of her bad qualities—mainly her messiness and her cattiness. The roommates made her feel like a baby, and though I'd have preferred she'd spent the time with her roommates, I was impressed that Rachel went out and found her own friends and her own comfort level. In this TV world, we want everyone to have this phenomenal growth, but give her another two years and she's really going to change.

jon murray

Rachel is a wonderful blend of spunk, humor, and naivete; she is also very smart, all of which make her irresistible to the camera.

mary-ellis bunim

What a mixture of blond femme fatale and girl next door. Madonna meets Meg Ryan. Rachel was a little naughtier than anyone expected—or even gave her credit for. Will she be able to return to her former life? Will she run off with a band member? It'll be fun to check in on Rachel in five years—she'll surprise us all.

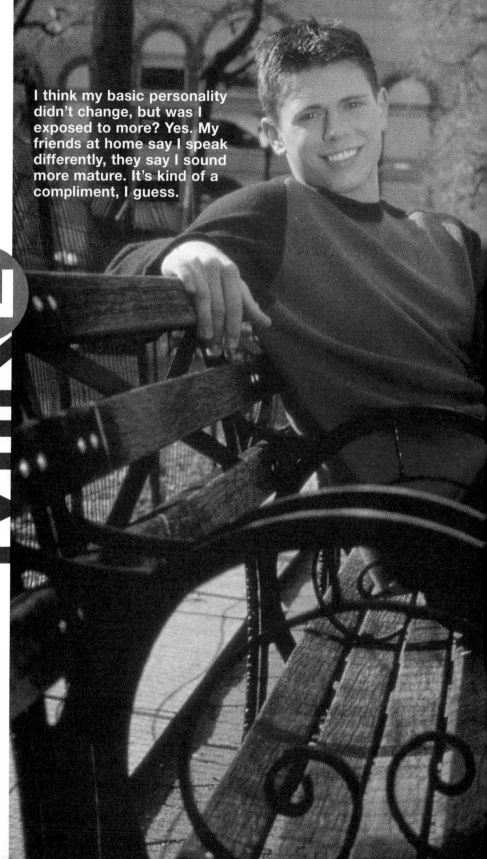

I think my basic personality didn't change, but was I exposed to more? Yes. My friends at home say I speak differently, they say I sound more mature. It's kind of a compliment, I guess.

MiKE

I came to New York not knowing anything about different cultures. Parma, Ohio, is this: long white knee socks with shorts, lawn sculptures, stereotypically white-trashy. It is also really racist. The first black people who moved into our neighborhood got a cross burned on their lawn. I was always an open-minded person, but I never knew black or gay people.

I'm going to go home and realize how dumb and ignorant my friends are. Not dumb, but culturally illiterate. My friends say the "n" word. If I ever hear one of them say it again, I'm going to kill them. I could imagine the hurt in Malik's eyes if one of my friends said that. I'm just going to go home and teach all my friends. I think they should get out of the city and explore places. Until you live it, you don't really know.

I actually looked at myself when I was in New York. In the beginning, I felt like an outcast. No one liked me. Actually, everyone hated me. I thought I was going to be the Puck of the house. I was actually scared of getting kicked out.

I think my basic personality didn't change, but was I exposed to more? Yes. My friends at home say I speak differently, they say I sound more mature. It's kind of a compliment, I guess.

I'd seen a couple of the *Real Worlds*—San Francisco and New Orleans. It's completely different from your expectations. It's a lot harder than you think. People say stuff to you all the time. They scream at you on the street. It makes you feel crappy. They ask you, "What's so special about you that you get to be on *The Real World*?"

At first I got mad at that. But once I was with Malik when it happened. Malik smiled and was like, "Hey, how you doing?" He was nice. And I decided that's what I would do too. It got kind of fun toward the end.

I've learned so much from Malik. As opposed to Coral, he sat me down and taught me something about black culture every day. He doesn't have a negative bone in his body. He'd give a bum his last dollar. He gives and he teaches. He's the kind of person people will walk up to and just touch.

People will say, "Hey, I love your hair." I don't give off that vibe. I don't think I have that charisma.

I wanted co-ed rooms at first, but it was cool sharing a room with the guys. We know everything about each other. Yeah, they saw me hook up. I had a lot of hookups. How many girls did I kiss in New York? Probably about six or seven. I only got laid in the house once. That was it. Some girls actually slept in my bed but we didn't do much.

No, I do not regret using the word *pantydroppers*. At first people couldn't stand that. They were like, "Oh, it's so degrading to women." At the end, everyone was using it. "Pantydroppers" is a funny thing to say. It's all fun with me. It's all games. That's what sucked about this whole thing. People didn't know who I was, where I was coming from. No one knew each other's comfort zones, where we could draw the line.

I'm not sure what my future holds. I don't think I want to stay in Ohio. I love my friends; they know where I'm coming from. But I want to travel and see the world. I'm just going to take it day by day.

I would love to go on the Challenge. I love competitions. I'm really looking forward to doing the speaking tours. And I'd love to go to wrestling school. I would love to become a professional wrestler. Seriously, that would be my dream occupation.

I don't want to be at a desk job. I don't want my life to just fly by. I said this on the show ninety times: I like to live my life without regrets. I just want to have fun. That's all that matters. Just do it. Just go after stuff.

the v.i.p. room

coral

I was carving Mike's headstone after the second day in the house. He was definitely on the Coral s**t list and that list is reserved for a prized few. I had a lot of issues with some of the things he said. I had to look past them and see the good. He has a childlike soul and it's refreshing. We came around and now it's great.

kevin

I've grown so close to Mike. He's just energy. He is who he is. Not everyone is going to act like you do, but you need to try to get along. He and I have gotten so close.

malik

Mike learned so much in his time here. Mike is like a sponge, willing to soak it all in. I schooled him about race, but also about people in general. We had long dinners about our families and back stories. Mike's the younger brother I never had but always wanted.

russell heldt

The perfect cast member is a cast member who can't help but be himself. That's why Mike was wonderful. When I first saw Mike, I thought he was a buckethead, a loud-mouthed, horny frat guy. But, there was something about him—he just can't help being himself. I think he went through a crisis of self-doubt in the *Real World* house. Some of his ways of behaving didn't fly. When he finally went back to being himself, he became perhaps the most liked person in the house. Initially you think that Mike's got no game, but he really does. His Miz alter ego is the perfect foil. Everyone wants to be the Miz or be attacked by the Miz. Mike's the person who tries to make everyone comfortable and if you stick around him long enough, he's a person everybody ultimately likes—just keep your sisters away from him!

jon murray

To all the *Real World* viewers out there, I say, give Mike a chance; don't judge him too early. He's going to surprise you.

mary-ellis bunim

One of the most relatable guys ever cast on *The Real World,* Mike represents the "regular Joe," the Midwest guy who says exactly what he thinks. There's no pretense—until you get to the Miz, and then Mike's split personality shines through and you have no idea what's going to happen next.

I'm like a parasite. Not a parasite, more like a thing that grows on you and grows on you. You'll hate it at first, but once you get used to it, you love it.

rachel

Even though Mike can be completely insane and the Miz can annoy the hell out of me, I've come to love him. I was a big Mike fan when we met, and then I thought he was too big to handle, but now I've come around. He has an amazing heart, but sometimes his mouth gets in the way of showing that. I was always happy to show Mike off to my friends. Even though sometimes I wanted to get away from the Miz more than anything, I will definitely miss it.

lori

I liked Mike a lot in the beginning and got annoyed with him in the middle. He's high energy all the time. I'd get really frustrated with him. But I just grew to appreciate him. He just wants to have a good time, and you might as well have a good time with him as opposed to being annoyed with him.

nicole

I've always had a special patience for Mike. You know why? Because he's always been comfortable about learning. He may say the word *ghetto,* but he's cool if you tell him not to. There have definitely been times when I didn't want to talk to Mike. Like when I heard he poked a homeless person in the street. Mike wants a reaction, whether it's good or bad.

Wanna be seen as...
A fun guy who's wanting to live life the best he can.

Scared I'm gonna be seen as...
A racist. I'm an open-minded person and I hope people will see that.

To all the little Mikes out there...
Party hard. Get laid and have some fun.

Nicole

I was living with seven different people who think that agreeing is more important than honesty. It was hard to live in a house with people you feel are not being real.

What made me want to do *The Real World*? I was getting ready to graduate college at Morris Brown. I didn't know what I wanted to do. I'd seen *The Real World* and I thought it'd be a perfect thing to do. I'd watched every season except Hawaii, and my favorite one was New York. I heard the show was going back to New York. Well, to me that seemed like a lot of fun.

But everything I thought the show was, it wasn't. We became the characters we didn't like. Or at least I did. I'd made a vow not to be the stereotypical black girl, the kind you see on *Ricki Lake* or *Jerry Springer*. I didn't want to be snapping and putting my fingers in people's face. Well, guess what? That's exactly what I ended up doing. My friends at home have never seen me argue. They've never seen me do those gesticulations. I used to go off on people when I was young, but not since high school. I never lost control in college. I thought I'd grown.

I want viewers to see a positive role of a black woman, someone who has come from little and gotten through a lot. I'm scared they're going to see an angry person with low self-esteem.

What you see on TV is not always how it is. It's not going to be the whole picture. There's a lot of pressure in the house that viewers probably can't imagine. You have emotions, you're trying to learn people, you explode. You just throw opinions at each other. And, yes, a lot of people act. I've seen five of the six roommates act. I've seen people perform. They lie about everything, from who used the toothpaste to what they said five minutes ago.

How are my roommates not real? Well, some people are easily influenced and easily persuaded and if the situation becomes confrontational, they become even faker. People act with the camera and off-camera. Malik acts. Coral lies. Rachel changes stories a lot. Lori backs off from positions. Kevin is a total yes man. The only person who doesn't act is Mike.

For me, it's harder to leave the crew. They know me in a way that the roommates don't. I was living with six different people who think that agreeing is more important than honesty. It was hard to live in a house with people you feel are not being real. I wish everyone in the house the best success with whatever they want to do.

I think I'm defensive, yeah. I was the P.C. police in the house. I don't like the use of certain words. I don't like people making fun of people. I was dirty. I was made fun of. My whole family has had weight issues. People call other people fat. I hate that! I struggle with my own weight. I didn't touch the scale in that bathroom. I'm conscious of what I eat. When Rachel would start talking about weight, I'd say, "Please don't talk about this." We, the two vegans, were the biggest people in the house, while the carnivores wore a size 4.

A lot of positives came from living in the house, and from the experience. I learned to look at my past in a good light. I am who I am because of stuff that happened in the past, because of my relationship with my mom, having witnessed her abuse, growing up poor, having people make fun of me. To this day, I don't have a mother-daughter relationship with my mom. It's more of a friends thing.

Being in New York City definitely changed me. Being around that much culture and diversity made me realize what a small world I have. My apartment is so small and my group of friends is so small. I want to expand my horizons. I need to.

I feel bad I don't feel close to anybody. Some people are leaving here with lifelong friends, and it's sad that I don't have that. I don't trust the people here. I trust them with my purse, but not with being honest or being real.

malik

All Nicole wants in life is to find the ideal husband. She has said she'd drop out of school for a husband. That's not for me. I'm more career-oriented. Nicole was responsible for a lot of bad energy in the house. But she made it better. Our friendship is cool now. Without even saying much, we were able to squash whatever bad things happened between us.

coral

Nicole was really eager to get home and that kind of put a damper on the sanctity of our friendship. I wish she had stayed the course and put more effort into it. She made me feel she didn't care about me, which is fine, but I would have thought she'd be more emotional about leaving. She had other crap on her mind, and that's how she chose to be with it. There was a rumor buzzing that she said she'd miss New York and not the roommates. Oh well. Nicole's a cool girl. I don't know whether or when we'll call each other. Life goes on.

kevin

I'm really glad that Nicole and I could get a friendship going in our last month here. I think she has a good heart. I think she's had a lot of experiences in life that have jaded her. I don't think we'll continue to be good friends, but I'll always care about her because she was a roommate. I wouldn't be surprised if she said she didn't have lasting friends in this house. She's a loner. She has problems dealing with people. I wish her the best of luck and hope she can succeed in life. She is a really hard worker.

 hope fear advice

Wanna be seen as...
Honest to other people and honest to myself. Someone who's consistent, who doesn't tailor herself depending on the situation.

Scared I'm gonna be seen as...
No fun, stubborn, coldhearted, and boring, I guess.

To all the little Nicoles out there...
If you don't stand for anything, you'll fall for anything. If you're being real to yourself, you can never be fake.

the v.i.p. room

lori

I only really got to know Nicole late in the process. She's a fun girl, but she's hard to get close to. She's high-maintenance and she knows it; that creates a lot of room for conflict. It's exhausting to see her fight with people. She doesn't let go of issues. She holds grudges. She and I have never had a bad fight. We laugh over lots of dumb stuff. Nicole and I crack up over stuff no one else thinks is funny, stupid things. I really enjoy it.

russell heldt

I think Nicole came in to the house insecure and full of self-doubt. She came here with a limited number of friends and strict moral guidelines. She doesn't cuss. She told me the last time she used a swear word was in eighth grade when a girl called her sister fat, and she called the girl a bitch. She told me she went home and cried about it, and hasn't used profane words since. She is one of the least hypocritical people I've ever met. She lives and acts out what she believes and says. Her roommates will probably say she's judgmental, but I don't fault her for her defenses. She traps herself. She has high expectations and doesn't allow for human fault and redemption. I hope she does end up having lasting friendships with people here. She could have one with me.

jon murray

Nicole is so compelling. The first thing about her that caught our attention was her makeup. Wow! But underneath the makeup is a very smart, very vulnerable, very complicated young woman. Her standards are so high, she'd be funny as the host of *The Weakest Link*.

mary-ellis bunim

Did Nicole enjoy this experience? I'm not sure. We certainly enjoyed what she added to the dynamic. She's honest, and she demanded that from everyone around her.

mike

Nicole is very opinionated. What she says goes. She's a very good leader. She doesn't talk to a lot of people. If you're at a club hanging out, she'll leave in the middle because she's not having fun. She's antisocial. On our last day at Arista, everyone talked and partied, and Nicole just sat there. I think we'll remain friends, not close friends, but we'll talk here and there.

rachel

I think my relationship with Nicole is really hard to explain. In many ways, it's been the same the whole time. It's all shopping and joking and hair. We've enjoyed each other's company doing silly stuff together. It's hard because I'll think we're cool, but then she'll jump all over me and we won't be cool. I'm scared that once she sees the show, she'll hate me. I said a lot of things about her in interviews and confessionals. Her big thing is "Tell me to my face." Well, that's not who I am. I'm not confrontational. She has to take that into consideration, too.

Yeah, I really want to be married. I don't like the whole dating thing. I'm ready to have kids, my ovaries are moving, I'm in love, and I want someone to be in love with me. I like knowing who's going to call me, having a boyfriend, all that good stuff.

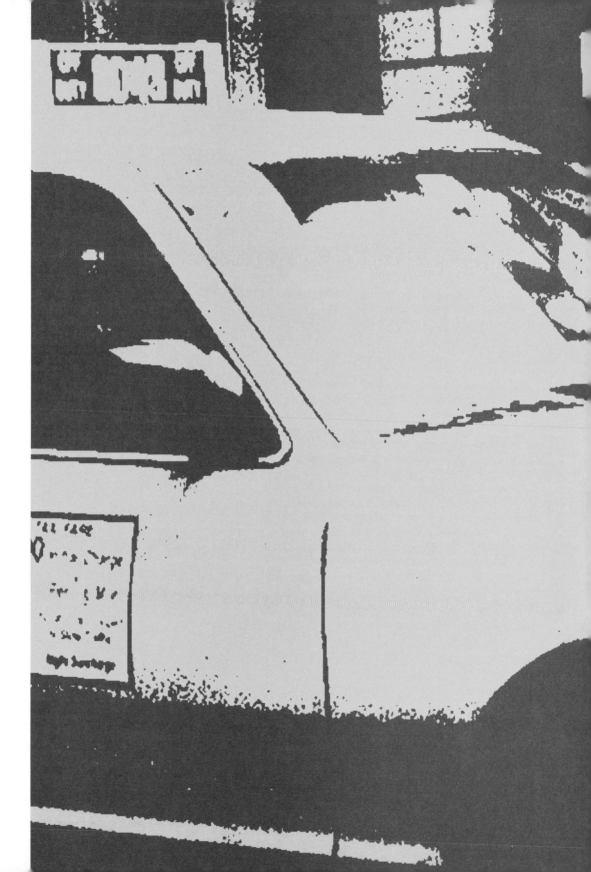

DRAMA

In public, everywhere we went, people asked us why the girls were so bitchy. They'd ask what the girls' problems were. If I had a dime for every time that was said, I'd be in Hawaii.

—Kevin

drama

24/7

first impressions

LORI'S FIRST IMPRESSIONS

CORAL
I liked her instantly, though she worried me because it seemed like she got mad easily.

KEVIN
I didn't notice him at first. Then I was like, "Oh, he's good-looking."

MALIK
I thought he was going to be harsh. I didn't realize he'd be so nice and gentle.

NICOLE'S FIRST IMPRESSIONS

LORI
I thought she was really laid-back and Catherine Zeta-Jones–ish. She didn't get into all the petty stuff, and I appreciated it.

RACHEL
I thought she seemed quirky. I was taken aback by the Midwestern accent and the whole innocent thing.

CORAL
I thought she was going to be the stereotypical *Ricki Lake* black girl. Luckily, she didn't turn out that way.

KEVIN'S FIRST IMPRESSIONS

MALIK
When I first saw him, I thought, *Wow, that's a phat 'fro. That 'fro is just off the hook.* Once I started to talk to him, I thought, *This kid and I have the exact same perspective on life and we're going to get along really well.* I was totally psyched to be on the same show as him.

NICOLE
I thought she was wearing really nice fashion and I thought: "Man, she wears a lot of makeup."

CORAL
The first time I talked to Coral, I thought she seemed edgy and uncomfortable around people.

RACHEL'S FIRST IMPRESSIONS

LORI
When I saw Lori on the Internet, I thought she looked like a stuck-up sorority girl. I thought, *What the hell is she doing listening to Christina Aguilera?* I won't like her at all. I told all my friends not to vote for her, and to vote for one of the guys, so there'd be less girl competition at finals.

CORAL
I thought Coral was really bitchy when I first met her. All she did in the casting finals was fight with Ellen and Dustin. She sounded like a mother. She was always saying things like: "When I was your age, this is how it was...."

NICOLE
At first, I was mesmerized by how much makeup Nicole wore. She was pretty negative. All she'd say was she wasn't going to make it and would have to go back to her crappy apartment.

RACHEL

She was wearing a white flowered shirt and khaki pants. I thought it was ugly, the most miserable shirt ever. She was always in a different circle from me. I didn't know what to say to her. Everyone said she was floppy and bouncy and sweet.

MIKE

I thought he was just a jerk. The very first thing he said to me was, "Do you have a boyfriend?" I told him I had a boyfriend—I did at the time—and he asked, "Then why did you come here?" I was thinking, *Frat boy, get out of my face.*

NICOLE

I thought she was fashionable and cool. I made her laugh. I guess I like when people laugh at my jokes, because that made me like her.

KEVIN

I thought he was real cool, real clean-cut and Banana Republic. I was shocked to find out he had cancer.

MIKE

All I thought was, *frat boy.*

MALIK

He was all smiley and sweaty. I thought he'd be into hip-hop more than he was. I really dug him. I joked about how we'd get married and live in Atlanta together.

LORI

I thought that she was a pretty girl who was really sarcastic and funny. She seemed to be digging me immediately.

MIKE

I thought he was just putting on a show trying to be funny. It took me a while to realize that really was him.

RACHEL

I thought she was young and a bit naive. She seemed really sweet. She looked like she had a lot to experience in life.

MIKE

I thought that Mike was the biggest perverted frat boy to ever walk the face of this earth. All he talked about was how he videotaped his frat parties. Other than that, I had a generally good impression of him.

KEVIN

I realized right away that Kevin was so brutally honest, he was painful to be around. He seemed easygoing and friendly and someone who seemed like he really enjoyed life.

MALIK

I first saw Malik through the window of the vans at finals. All I saw was this big 'fro, and I thought he was going to be this insane hip-hop kid. I thought Malik would be all "Yo, wassup!" Probably I thought that because I don't come from the most racially diverse environment.

CORAL'S FIRST IMPRESSIONS

LORI
I always knew she was cool. She seemed really cute and fun to hang out with. I wanted to live with her, but I didn't think we'd be able to get too deep.

MIKE
We had a really long conversation in casting. I was intrigued by his listening skills. He listened very well. He really didn't know a lot of stuff. I'd watched previous seasons, and I couldn't believe there were people who actually said *colored*. But here I was confronted with it. It was weird to meet someone who lived such a sheltered life.

MALIK
He was just a bright presence. He exuded this happiness, so to speak. We didn't talk a lot in finals, I had the feeling there was something about him that was deeper and more intense. I wanted to get on a show with him, because I thought he'd keep me grounded. I did notice that he needed deodorant.

MIKE'S FIRST IMPRESSIONS

KEVIN
He had his green shirt tucked in, and I thought, *OK, he's not going to make it.* Then I talked to him and heard about how he'd gone through cancer. I realized that he doesn't actually care about making it. He told me, "Mike, I have so much going on in Austin, I really don't care."

MALIK
We weren't allowed to wear white or logos, and he was wearing a white shirt with a football logo. I remember him saying "hella" every other word, which I thought was weird. But he seemed to know what he was talking about, which was cool.

RACHEL
My first impression of Rachel was that she was blah. Then I realized she was such a cutie, a fragile little porcelain doll. I wanted to pack her up and take her home. I really wanted to be on the show with her.

MALIK'S FIRST IMPRESSIONS

LORI
Casting finals, Lori and I got on really well. I was digging her mellow vibe.

RACHEL
I thought: She is really worried about her mom!

CORAL
We kicked it from the beginning, me and Coral. She's a good group-oriented person.

NICOLE

I thought she was cool. She seemed down. They asked me about her and Malik as a couple, and I said that it was all over my head. I hadn't seen anything. I didn't think Nicole was outgoing enough. She seemed crushed by her upbringing.

RACHEL

I didn't hang out with Rachel at all in casting. If I had a first impression, it was that she was a young cute girl who liked to flirt. They asked me about her and Blair, and again, I totally missed that. I feel like I'm an old soul, someone who's had a lot of life experience. She doesn't fit that.

KEVIN

Kevin was just there. When the casting person asked me my impressions of Kevin, I had to say I had none. I barely knew who he was. Most of the people I ended up living with were those I didn't really hang out with at casting.

CORAL

I met Coral in the van on the way to the hotel. She was checking her makeup and pushing her shirt down so her boobs weren't coming out. She had that high hairline, like Tyra Banks. I could sense the attitude in the van. I got into some really deep conversations with her and we really got along during casting. I thought she was intellectual.

LORI

She was the only girl I found really attractive at casting finals. Then I saw her smoking, and I was like, *You shouldn't be smoking.* I asked her if she had a boyfriend and I think I offended her. I wasn't trying to get with her, but I was just trying to make conversation with her.

NICOLE

I didn't find her attractive at first. She had a flower in her hair, and I thought, *Hm, nothing really cool.* I talked to her once or twice and that was about it.

KEVIN

We didn't know whether we'd be on *The Real World* or *Road Rules*, but we knew we'd be tight.

MIKE

I knew right away that he'd be receptive to me.

NICOLE

I thought she was hella cool. We joked around a lot at first.

LORI

The girls, we were just all over the place. It started off in pairs: Coral and I, and Nicole and Rachel. Not that Nicole and Rachel were really close, but they liked to go shopping together and make fun of each other. Rachel and I would hang out sporadically, same with Coral and Nicole. And then it became the four of us. Every night, the girls would end up on the couches in the living room. It was a little sisterhood, if you will. Truthfully, those were some of my favorite times in the house.

Then the whole picking-on-Rachel stuff started happening. We all bullied Rachel a bit in a little-sister way. And then the line we weren't supposed to cross got blurrier and blurrier. Rachel started getting hurt. I was a little sister in my family and I started to feel really protective of her. Coral and Nicole kept picking on her, and I felt the need to watch her back. The four started getting torn apart. And then it became Rachel and Lori vs. Coral and Nicole.

As Coral explains it, she and Nicole were bonded over misery. They both passionately didn't like our job and both didn't like the boys. Coral and Nicole sat around a lot and clowned a little bit about the other people. They didn't see that they were doing anything wrong, but Rachel saw it as hypocrisy. They claimed that whatever they said behind the boys' backs, they'd say to the boys. I don't know if that was true. It was a time of such negativity, it was hard to stomach.

The whole thing made me very uncomfortable and then angry and then impatient. Everybody had decided to not be friends! It was so annoying! Coral and Nicole became very intimidating to be around. That's why Rachel and I spent a lot of time together. We were on the same page. I didn't know Coral well, but I knew there was a boundary and that if I crossed it I'd be screwed. It was that way with Nicole, too.

The lines just got really divided, and then there was a huge confrontation over Outkast....

THE DEAL WITH THE OUTKAST TICKETS

LORI

So, here's the real deal with the Outkast tickets. Adam and Devin gave them to us. They gave them to everybody except Coral and Nicole, because they weren't there. Well, we thought we were being rewarded for working so hard, and the truth was, Coral and Nicole hadn't been working hard at all. We could have spoken up for them, said, "What about Coral and Nicole? Don't they get tickets?" But that's not good work etiquette. Plus, Coral and Nicole are big on speaking for themselves, I didn't know the right thing to do in that situation. I still don't.

The paging situation was this: Coral and Nicole said that they were not going to work until 3 or 4, because that's when the street team started. Well, when the street team was canceled, and I paged Coral to tell her so, I thought I was doing her a favor by informing her she didn't have to come in. She saw it differently. She thought it was deceptive of me. She thought what I was doing was keeping from her the fact that the five of us were sitting around working. She and Nicole were yelling at me and Rachel and insinuating that I wasn't a good friend. She said she was a better friend than I was. Well, if there's one thing in the world I am, it's a really good friend.

I started crying and I hate that. I was crying out of rage, not out of sadness. It may look like sadness, but I'm pissed. Rachel and I apologized to Coral and Nicole more than we thought we should have or wanted to. The whole thing was based on miscommunication and differences of opinion, and that was everyone's fault, not just ours. But it's hard to argue with Coral and Nicole. They argue very passionately. I get flustered. I lose my balance. I apologize too overzealously and act like I didn't do anything wrong.

And then, when the fight was over, Coral and Nicole just kept harping on the whole thing. Here we'd had this upsetting fight and Rachel and I just wanted to put the whole thing to rest. They kept talking about it. I asked Coral to stop and she told me I was the one who'd messed something up, and it wasn't her job to make me feel better. I was not able to respond. I should have said, "Well, it's not your job to make me feel worse either. If we're done with this argument, it's done." Instead, I lost my nerve.

At that point, I felt that Coral was really unapproachable. I had a very hard time telling her anything. I never understood when Coral was going to be mad or happy. From Outkast to Morocco, that was the bad time for us.

On the plane to Morocco was when it really went nuts. We had this huge fight. I guess it'll be on the show, because maybe there were these little digital cameras being used. Anyway, when Coral, Nicole, and I were done with our food, we took our trays and put them on Rachel's table. When Rachel came back from taking a nap, she said, "Take the trays off the table." Well, Nicole and Coral immediately made fun of her. Rachel had just woken up and she wasn't playing along. She got pissed. And Coral just got madder and madder. Finally I said, "Take your damn trays!" and I threw Coral's tray in her lap.

Now, Coral's got a different version, and it's really wrong. She remembers it as her taking the tray back and being really nice about it and that I didn't tell her to take her damn tray back. I remember stories verbatim, and I think she has a distorted memory.

Now, it was Coral and Nicole versus me and Rachel and there was no going back. The Road Rulers we hung out with, they gave us a lot of perspective. They told me and Rachel to confront Nicole and Coral. The confrontation was useless. I was so nervous, I thought I was going to die. The whole thing wasn't even

about me. I was never even bullied; I don't know why I took Rachel's cause. I served as moderator. I said, "I feel torn and uncomfortable all the time and it's not fair."

We got Nicole's respect, but Coral got defensive and hurt. In my opinion, if you realize you're hurting people, you get defensive. Anyway, it went nowhere. It wasn't until we did the Challenge against the Road Rulers that things got a bit better among the four of us. That's when we really had to support each other.

When we got home, things took a turn. One night Nicole, Coral, and I went to the Art Bar. We talked about a lot of things and told stories. Personally, I felt a lot better about everything. But things were still not good with Rachel. Rachel was getting increasingly upset. And it didn't help that Rachel refused to clean.

One night, Rachel and I had plans to go for dinner with the boys. Coral totally blew up at Rachel before dinner. Then at dinner, the boys were dogging on Coral the whole time. Coral and I had been getting closer, and I was becoming uncomfortable with it. I kept changing the subject.

Coral and I were putting more and more time in with each other. We were very conscious about hanging out with each other. And she was changing. For example, at one point during the HMV window assignment, she snapped at me. Later, when the cameras weren't around, she said, "What I said before really came out wrong and I'm sorry."

I was actually a lot more patient in this house than I am in life. I think I'm a bigger bitch in my regular life. Normally at school I'm with this singing group and there are always a lot of conflicts. And I am used to being more irritated. During the HMV thing, I came into my own; I was being nastier and more snappish and Coral noticed it. I was glad she saw a different side of me.

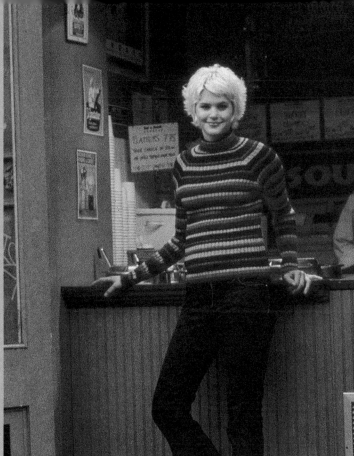

The weather got warm, and everything changed. It was the last week in April, and Nicole called a meeting. We had the meeting on the roof. It was beautiful and warm out. Nicole apologized for being closed to us. I have no idea why she did, but she did. That night, it just felt different. The next day, we're all talking and Nicole told Coral what happened the night before and Coral said, "You know I'm going to make a conscious effort to hang out with everyone." I actually think Nicole sparked the change in Coral.

And then Coral became a different person. She became patient and happier and all of a sudden there was no negativity. It was awesome. We all made up and started to enjoy each other. We went to the Bostonians show. And there were even improvements with Nicole. On the way home from Boston, Nicole called out, "Shotgun." She and I talked the whole time. We played a game asking each other what our biggest regret was. Mine was I hadn't asked enough questions about people. I really meant *her*. We talked for eight straight hours and I was really happy.

Coral and I were attached from that time on. Meanwhile, Rachel was out meeting new people. She was drifting off slowly and then all of a sudden she was gone. Coral took Rachel's place and it was me and Coral and the guys.

Coral and Nicole are still good friends but I think they're a little more aware of how they're different. They argue differently. Nicole gets upset and offended really easily. She has a lot of little demands and it's exhausting. I don't feel bad that Nicole's leaving without an ally. I wish she cared more about us, but what can you do?

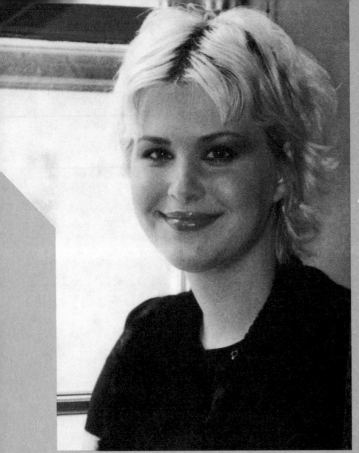

RACHEL
I got jealous of Loral—oops, I mean Lori and Coral—because they'd gotten so close.

NICOLE
For a while it was the boys versus the girls. The boys were a clique and the girls just hung out. Then Rachel started getting defensive, and then it was me and Coral and Rachel and Lori. Coral and I have a lot in common in terms of music and going to clubs, but we stopped hanging out after Morocco.

I think Coral separated from me because I was not in the spotlight anymore. When everything was cool in the house, she veered off to the mainstream. The storm was no longer around me, so she moved on. I think Coral always has to be the center of attention. When there was strife in the house—how can I explain it?—she wanted to be at the center of it. So when I was going through

strife, she hung with me, because she knew there'd be story. Wherever the story was, that's where Coral wanted to be.

She was competitive about attention. She would ask me, "How long was your interview?" And when we saw the show, she even counted her lines in the *Real World* opening. She was proud she got to say "*The Real World.*" If that's your main goal—to be the most important person on the show—well, I don't like that.

Lori and Coral got close because Lori hangs on Coral's every word. I think she looks to Coral for guidance. When Coral laughs, she laughs. I think Lori could really hold her own. My advice to her: Be a big sister, not a little sister.

I mean, Lori knows Coral can lie. She said that Coral lied during the HMV windows—about how something that was Kevin's idea was her idea. She didn't have the guts to confront Coral about it, and when she did, well, Coral denied it all. Lori just let it go.

Coral once told somebody she was a quarter Puerto Rican. I was like, *I thought your parents were Creole.* Coral reminds me of why I don't hang out with a lot of girls. Little lies lead to big lies. You have to nip that in the bud.

Eventually, Rachel ended up going off with her rock friends. Coral, Lori, and the guys became "the five musketeers" and there I was, kicking it by myself. I felt all alone in the house after Coral and I stopped talking. I felt completely out of sync. I felt like an outcast. I can see through stuff with them and I can't tolerate it, so then I'm the outcast. It's OK.

CORAL
What's my take on the girls' relationships? Lori and I started bonding in the beginning. Then she started doing things with Rachel, things I wasn't into. It

wasn't "Bye, Coral." I just didn't want to do what they wanted to do.

It was cold out. I was cold. I stayed home. Nicole and I had a lot in common. We both hung out at home a lot and then when we went out, we liked the same things. It was nothing against Rachel or Lori. As that was happening, I missed hanging out with Lori.

Nicole made her speech to the housemates. She told me it didn't apply to me, so I didn't need to go. Off-camera, she told me: "Don't trip, you don't have to come. We're 100% cool. Our friendship is separate from all this." She didn't need to apologize to me and I didn't need an apology from her.

Then, whatever happened between me and Nicole had to do with Nicole. Maybe she saw things in me she didn't like. It wasn't one thing, it wasn't one conversation, it just happened. We had little spats, but they don't even merit talking about. In fact, Lori and I had more little spats than Nicole and I did.

I think Nicole was fed up. I think she wanted to go home. She was eager to get back to school. Her relationship with Bobby was blossoming. She just had other stuff going on.

I missed being able to chill with her, but I wasn't going to chase after the girl. She has to do her own thing. She's an adult.

At that point, I was happy to be in the house and I didn't want anything to bring me down.

KEVIN

Coral and Nicole's friendship really faded. They were really a twosome, and then they started getting into fights. There were two or three really bad ones, where Nicole couldn't figure out where Coral was coming from. Coral can be really negative. And with Nicole, it's her way or the highway. Coral started to realize there were parts of Nicole she didn't identify with or realized they weren't good ways to be. Coral, in her nature, is incredibly nurturing. She's got a really motherly instinct. I think that won out in the end.

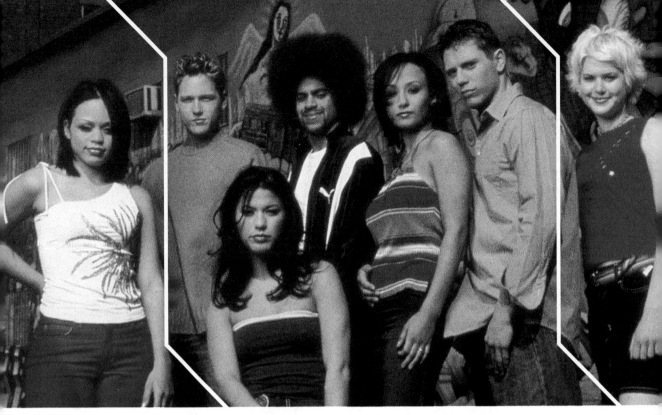

THE FIVE MUSKETEERS

NICOLE

A couple of days before the show ended, Coral, Lori, Kevin, Mike, and Malik were sitting in the living room screaming, "We're five musketeers!" Rachel and I were in our room, thinking, *Oh, I guess we're not in it.*

They're so high school. Rachel's the youngest and she doesn't even act like that. That whole thing just seemed real juvenile. Mike is still in his high school phase, and the rest of them joined him!

CORAL

Saying we're the five musketeers means we're cliquey? I'm too old to be in a clique. I wouldn't use the word "cliquey" to describe our friendships. I think that's a juvenile word. The five of us made a bond and we liked it. I don't think Nicole and Rachel cared, and if they did they certainly did a good job of hiding it. They distanced themselves from the house and we considered that a personal choice on their part.

KEVIN

It's a cliquey thing to do, calling ourselves the five musketeers. I didn't make it up. I think Coral did. That's kind of interesting. I mean, the four of us had been hanging out the whole time and not calling ourselves a name. Maybe Coral called us the five musketeers, because she really felt it strongly. She was finally fitting in and she liked it.

RACHEL

The musketeer thing kinda stung. Nicole and I kept telling each other we didn't need the group. We were trying to hide the fact that we were let down.

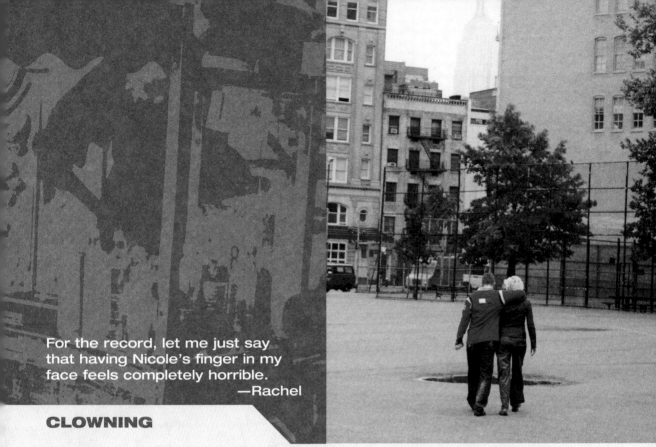

> For the record, let me just say that having Nicole's finger in my face feels completely horrible.
> —Rachel

CLOWNING

RACHEL

Obviously, no one wants to get picked on and you don't hang out with people who pick on you. A lot of people have brothers and sisters who pick on them and maybe they can deal with it. But I'm an only child. To come here and have people nag me and pick on me and be very vocal about everything I'm doing wrong—it got to me after a while.

It was probably just after we got comfortable in the house that the picking on me started. After a couple of weeks, my roommates let their guards down and started vocalizing their likes and dislikes. I still felt I didn't know my roommates well. I didn't have a history with them. I couldn't tell if it was all fun. I didn't know them well enough to judge. I still don't think I know. I still can't tell.

It's completely impossible to tell Coral and Nicole anything you think, because they'll always have a comeback. Nicole and Coral can say whatever they want, use any tone of voice, walk out on any conversation, but the rest of us can't. There's a

double standard. After a while, I gave up. It doesn't matter how "right" I knew I was. I can't deal with their confrontational styles. I ended up voicing my frustrations in interviews. Will they be shocked by stuff I said in interviews? Probably. Everything I said I felt is, I think, justified.

I just never have comebacks. All my emotions just well up. I end up crying and feel like a baby. Any time I cry, I just beat myself up ten times more because I'm so mad at myself for crying. I can't get any words out through my sobs. It's just so embarrassing.

My way of dealing with Coral and Nicole was to run away from the situation. I'd rather just not deal with it. Once, when the cameras weren't around, Nicole, Lori, and I were in a cab and we just got into it. Here's what happened: I was talking to Lori about the crew member she had a crush on. I was in midsentence and Nicole interrupted me. I said to her, "I'm talking to Lori." She freaked out on me. She was shaking her finger in my face.

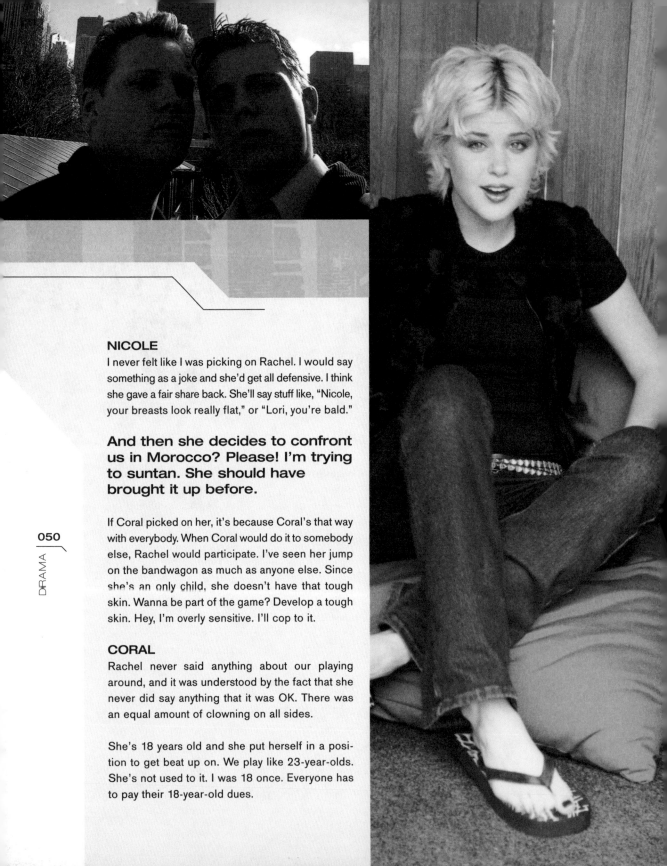

NICOLE

I never felt like I was picking on Rachel. I would say something as a joke and she'd get all defensive. I think she gave a fair share back. She'll say stuff like, "Nicole, your breasts look really flat," or "Lori, you're bald."

And then she decides to confront us in Morocco? Please! I'm trying to suntan. She should have brought it up before.

If Coral picked on her, it's because Coral's that way with everybody. When Coral would do it to somebody else, Rachel would participate. I've seen her jump on the bandwagon as much as anyone else. Since she's an only child, she doesn't have that tough skin. Wanna be part of the game? Develop a tough skin. Hey, I'm overly sensitive. I'll cop to it.

CORAL

Rachel never said anything about our playing around, and it was understood by the fact that she never did say anything that it was OK. There was an equal amount of clowning on all sides.

She's 18 years old and she put herself in a position to get beat up on. We play like 23-year-olds. She's not used to it. I was 18 once. Everyone has to pay their 18-year-old dues.

KEVIN

In many ways, the clowning was odd and hard to see. I rarely pick on people. Watching Coral and Nicole do that, I thought it was immature and revealed a lot of insecurities they had in themselves. I became someone Rachel turned to. She was very vulnerable. There were times when Rachel would come to me off-camera and want to talk about how much Nicole and Coral were pissing her off. She said she didn't respect them.

MALIK

There was a lot of picking on people's mannerisms. Some of it was undeserved. It bothered me. But some of it was deserved—especially when it had to do with Rachel's messiness. On her weeks to clean, she wouldn't clean. She'd leave filthy dishes everywhere. I could see how Coral would rag on her. And, you know, Rachel did her fair share of clowning Mike. There was one time when Rachel and I went out. We met at Chelsea's and she complained about how bad it was to be clowned by the girls. I was like, "Listen, you got to think about what you put out there. What goes around comes around."

MIKE

It sucks that Coral wants to pick on people. Coral's comedy is sort of clowning on people. She's funny like that. It really hurt Rachel. Rachel's young, and she doesn't defend herself really well. When you're on Coral's bad side, it sucks, you don't even want to be around her. No one needs that drama.

In finals, Rachel and I were tight as hell. We would always be around each other. We talked all the time. We were cool. And then we got here, and she didn't like me because the rest of the girls didn't like me. It was sort of like a feud.

She would make smarta** comments to me. I didn't feel betrayed, but I just felt nothing for her. I stuck up for her with Coral, but then she'd turn on me and make all these comments. She would try to act cool in front of her friends by being mean to me. She'd say to Lori, "Mike did this, Mike did that." Whatever, dude.**

—Mike

MIKE

The guys became absolute brothers.

NICOLE

I think the boys mixed well. Malik is happy-go-lucky, Mike's always making a joke, and Kevin's a yes man. Perfect.

MIKE

There was a time when all the guys were cool as hell and the girls were whatever with the guys. We went out all the time looking for other girls we could hang out with.

LORI

The boys thought they were being so positive, but every time I was with them they'd say, "I just want to have fun. I don't want to be like them," meaning Coral and Nicole. Well, that sounds negative to me.

CORAL

All those little boys did was go to the gym and play on the basketball court. That means they're positive? Tell them to be quiet. Tell them I said so. We did just fine without them in the beginning, but we found each other in the end.

KEVIN

I hated the house for about three months. It was the most negative atmosphere. Because of two people! I wasn't scared to come to the house, I just didn't want to. If the girls want to sit around and yell and talk about how much life sucks, I'm not going to tell them not to do that. It's their free will.

In public, everywhere we went, people asked us why the girls were so bitchy. They'd ask what the girls' problems were. If I had a dime for every time someone said that, I'd be in Hawaii.

MALIK
Our positive energy spread us around New York. Their negative energy kept them at home.

Nicole didn't want to leave the house unless she wanted to go shopping. All the girls did was read magazines and talk crap about magazines. It's boring. It's not my idea of fun. The boys would be feeling claustrophobic in the house. We'd want to get out and see the city, not sit around and hear all the little bickering. In interviews, the directors would ask us why we didn't confront the girls. Well, that's not our job. My theory was that we should lead by example. Kill them with kindness. I tried to be generous.

THE MIZ

MIKE
Every Sunday when I was in high school, we'd watch wrestling on pay-per-view. All of my friends love wrestling. I developed the character of the Miz. I couldn't even tell you exactly when the character originated. But all of my friends at home call me Miz or Mizzo.

When I'm the Miz, Mike no longer exists. When the adrenaline rush comes, I'm on full go. My voice changes and so do my eyes and my stance.

When someone talks smack to Mike and Mike gets aggravated, the Miz will come out. It's like Superman or a split personality, Eminem/Slim Shady, whatever you want to call it. It's the lunatic bad form of Mike.

If I ever become a professional wrestler, I'll have the character down to his essence. I'm working on it. I look in the mirror and practice faces the Miz makes. I do voices, formulate comebacks. It's all about talking trash.

KEVIN
Yeah, I might have thought having an alter ego was weird if I didn't really like Mike. The Miz would come and pin me at 4 AM. I was really tolerant. The girls in the house just couldn't take the Miz, but in time they all learned how to deal with it. Better to deal with it than to try and change Mike. Is he the Miz in regular life? Yeah, he's probably Miz-ing out right now.

CORAL
The Miz was definitely the eighth roommate. When Mike becomes the Miz, your whole day is ruined. He could be the Miz for hours at a time. At first it was really freakin' annoying. Mike and I had serious issues in the beginning. I hated when he chewed, so I definitely hated it when he ran the house screaming with a wrestling belt in his hand. That Miz thing is real. He is not just playing. But eventually, Lori and I joined in. When the Miz came out, Cocoa Loco and Teriyaki Terror emerged.

Do I wish our fight hadn't happened? No, I'm glad it happened. All the touches and love and hugs and kisses, that's all surface. But through the arguing, I learned more about him. In fact, I might know him better than other people in the house did.

Yes, I think viewers are going to see me as the bad guy. It's like being on the playground and fighting with the popular kid. No one wants to fight with the popular kid. Those were black issues I was talking about. I don't think everybody is going to able to relate. I know people from where I come from will understand. Is there a possibility I'm wrong? Sure. Will I watch the show and think I might be crazy? Maybe, but I doubt it.

I can't imagine being the only African-American in the house. Viewers will see we're not all the same. There will be three very different African-Americans in the house. It's good. If there was just one, then he'd speak for all of us. This is better.

I don't know if viewers will know I'm half-white. I don't think it matters. In America you're seen one way or the other. I'm treated as an African-American. That's how I feel and that's how I'm treated. People look at skin color. Most definitely my mother is treated differently from me in the world. It doesn't make me mad, it's just how it is.

I have white brothers and sisters. My mom did a really good job. She made sure I had black dolls. She picked my hair out. I feel I have a good balance between black and white.

MALIK AND NICOLE

NICOLE

I know it's gonna look like I liked Malik, or that we liked each other. It really wasn't what our thing was about. I think he thought I was nice-looking; I don't think he thought we were going to hook up. And I was never seriously interested in him. Please! I'm hopelessly devoted to Bobby.

Malik and I talked about issues I feel very passionately about. We talked about the state of the black community, hip-hop. We had very intense conversations. That's why he upset me so much when he broke what I consider to be a code.

What's the code that Malik broke? He talked behind my back and smiled to my face. He flat-out lied to my face. My big thing is trust. I don't like being disrespected. Yes, my expectations were higher for him than they would be for most other people. That's because he projects something higher. He gives off the impression that he has a higher belief system, moral grounding. But it's not true. I know brothers who walk the walk and talk the talk. I want him to stand up for what he says he believes in. My standards were high for him, so maybe it's my fault I was disappointed.

MALIK

Nicole and I did our share of exchanging battle words. It felt like she was holding her ideas above mine, above everyone else's.

I feel I was right. I was valid. Nicole got mad at me for getting Kevin in the middle of it. Well, Kevin and I are close. He's white, so I'm not supposed to talk to him? She felt I wasn't supposed to talk to anyone else about our issues. Well, Kevin *heard* her talking. He's my friend. What is he supposed to do? Nicole had a wall. She didn't want to let Kevin in and she didn't want to let me in. I'd ask her about her life experience, and she didn't want to share it. I really tried.

KEVIN
I think Malik handled the whole thing incredibly well. Malik and Nicole had been fighting a lot before the big blowout. A lot of Malik's beliefs are open-minded. He doesn't look at race or gender, he just looks at people. I don't think Nicole could deal with that much open-mindedness— especially from an African-American man.

Nicole's got a double standard. She's constantly hypocritical. She gives but can't take. She wanted to end their friendship because Malik talked to me about the situation. She told me she's lost touch with best friends in the past. You can't go through life forcing people to believe what you believe. Take people for who they are. She didn't even give Malik three strikes. Only one. It was embarrassing to have Nicole screaming in my face. When someone's going irate like that, the best thing to do is let them get it out.

I hope it is shown that Nicole was really closed-minded toward Malik. I really don't think she realized what she was doing. She never listened. When Malik was talking, she'd be formulating her next phrase. For a week or two, she was treating him completely unfairly. When you're in a new environment—especially a closed one like a *Real World* house—you need to try and open your mind and see where people are coming from.

LORI
I hated Nicole and Malik's fighting. I thought it was really stupid. I don't believe in staying so angry at somebody for so long. It was just unnecessary negativity that really caused discomfort in the house. Did it affect me? Yes. If there's tension around me, I'm going to feel it. The seven of us could never hang out together. It sucked.

CORAL
Nicole felt that Malik went behind her back. She also felt that Malik was a big fake person who was misrepresenting his identity by being pro-black but having white friends. That's all I know.

MIKE
Oh man, Nicole would never talk to any of the guys. She wouldn't even say "hi" to us. She was so childish. She'd put her head down when she saw us. I thought she didn't like me because I hung out with Malik and Kevin. We never sat down and had one deep conversation. It was one of those day-to-day kind of relationships. I've talked to her on the phone since the show ended, and she sounds happy, like a totally different person.

NICOLE'S HOUSE MEETING

NICOLE

It was getting into an argument with Mike that propelled me toward organizing the house meeting. It was the fight we had before the HMV windows. I was asking him to give credit to my feelings, and I suddenly wondered, what about his feelings? Was I giving him credit?

The house meeting was not what I expected it to be. I didn't realize I was going to be so emotional. I was pretty embarrassed. To let my feelings go is a big deal for me—especially around people I don't trust. I wanted to apologize to everybody, but especially to Lori and Rachel, people who hadn't been directly involved in whatever conflicts I'd had. Really, I'd only had beef with Malik and Kevin.

After, I felt kind of empty. I'm not used to letting it all out. It was worth it, though, because the house had a positive vibe. I felt like a big dark cloud had been lifted from the house. I don't think the big dark cloud was all me—it takes two people to argue—but I think I had created an enemy-versus-enemy atmosphere. I still think my anger toward Malik was valid, but bad energy creates more bad energy, and I had to let it all go.

I was so happy that all the roommates were appreciative of the meeting. They all thanked me. I appreciated their being mature like that. I really didn't do it for the roommates. I did it for me. I couldn't take the negativity back to Atlanta. I'm so glad I didn't have to.

MIKE

I was in awe of Nicole at her meeting. I went up there waiting for her to accuse me of making too much noise late at night. But I was blown away. It was a whole other side of Nicole I hadn't seen. Actually, there were a couple of instances when Nicole really shocked me. For instance, she was always the most respectful of my friends. Whereas Coral gave attitude to my friends, Nicole was the opposite. It was like she sensed their discomfort and tried to ease it.

I think Nicole never felt she was in her environment. When Coral's uncomfortable, she goes into strong-bitch mode. She acts like she's better than you. When Nicole's uncomfortable, she's quiet and negative. I think she basically never could get beyond that.

RACHEL

Looking back on it, I think Nicole's house meeting was a bunch of crap. She knew she was the reason the house had split in half, and she felt bad. She claimed she was finished with fighting. Well, after that house meeting, she'd still yell at me— only what she'd yell was that she didn't want to fight anymore! I think she wanted to _look_ like everything was ending on a good note. But there was no real good note. She was just holding all of her anger in, and she didn't want to express it anymore.

RUSSELL HELDT

This is the first season of *The Real World* when we had three African-American house members and two are of the same sex. I've worked on this show for years and I've noticed that the African-American cast members often feel alienated from the house. Once, in an interview with Teck from Hawaii, I asked him why he was always leaving. He said, "I don't have anyone to roll with." He explained that Matt and Colin could relate to each other automatically. They started at the same place. With a black guy meeting a white guy, they have to work to get to the same point. He wanted to hang out with someone with common experience.

I think it's often the case that the sole black person or gay person on the show feels he or she has to *represent* and then has mixed feelings about *representing*. The Caucasian people, the white kids, they never worry. I would love to put six minorities and one white person on the show and see what happens.

There's this fear of coming off as the "angry black man or woman." Nicole, after she got in that fight with Kevin, went into a confessional and cried about letting down black women. Teck felt similarly after he got mad at Ruthie for throwing the glass. He didn't want to come off as "angry."

I could watch the fight and agree with both sides. If I heard Nicole explain it, I'd think she was right. And if I were watching Malik, I'd think he was right.

It'll be interesting to see how the audience responds.

We were well aware that in-house crushes are good TV, so we'd make fun of the fact that this "romance" would be dragged out for *much* longer than it actually took place.

—Lori

dating

dating nyc style

LORI

Dating in New York, it didn't happen. I guess I'm picky. Or maybe it's that the type of guy I like doesn't live in New York. I couldn't find people I was attracted to. Maybe I should go to Virginia or something. The typical guy I likes is personable, someone you don't have to baby-sit at a party, someone who's interested in my friends and family, witty and well-read, sarcastic, animated but knows how to relax. I want someone who likes to do things other than watch TV. A lot of times I've gone out with guys where that's all we did: watch hours and hours of TV. It sucks. It makes you feel like you have nothing to say.

I spent a lot of time with the guy from Harry Winston. I would talk to him for hours at a time. We had a secret friendship, I'd say. I had a big crush on him, and it seemed that the feelings were mutual. He's the description of my ideal guy, a total guy, just gorgeous and so funny and nice and smart and silly. He was such a good package. Except for the fact that he was "almost married."

MIKE

New York women don't come out until the spring-time. I swear, in the winter they're hibernating. We were so disappointed in the beginning. I kept asking our boss, Devin, "Where are all the women?" He told me to wait until spring. Well, spring came around, and I almost got whiplash. On the street, my head would just go back and forth. Some of the women in the city are *fine*.

The cameras did not do wonders for my dating life. When we went to Boston to see Lori's singing group, I met a girl. She asked me if I wanted to come home with her. I said, "Yes, please." I went to her house and there were no cameras following me. Thank God. We started doing stuff, when the camera people paged me. I had to tell them where I was. The cameras showed up. *Bang.* She wouldn't do anything. She didn't want to look like a slut. *Aargh!*

Then I met this beautiful girl Shawna. She didn't want to do stuff on TV. I'd hang out with her—let's say we'd watch a movie and then start fooling around. Well, the minute we started, the cameras called.

Ohio girls are fun. I brought a woman up from Parma. We had full-on sex in the house in my bed. There were only three people who had sex in the house. For five months, four people did not have sex. The only people who had sex were me, Malik, and Nicole. Imagine how backed up the others are!

CORAL

My whole dating experience consisted of *absolutely nothing*. Nothing, I tell you! If you're single, do not go to New York. You'll die single. That's why there are so many blue-haired ladies in apartment complexes. Not only are the guys not interested, they're rude. They don't buy you drinks at bars. Do you know how many clubs I went to? I went to all of them, but there's nobody in them. Period. It was frustrating. We'd go out and look all cute and meet nobody. And if you did meet someone cute, there was something wrong with them. Either they had girlfriends, or lived with their parents, or wanted to get into the entertainment business and were after the cameras.

My game is lame, I guess. Oh well.

I actually ended a long relationship right before the show started. It was two years of crap, a terrible relationship. He treated me worse than anybody ever has. He was really controlling. He'd tell me what I could and couldn't wear. I wasn't myself in that relationship. I cooked for him, I cleaned for him, I served him food, and he treated me like crap. He slept with other women and wouldn't tell me about it until he wanted to rub salt in my wounds. He did stuff so bad to me, I feel bad for the next person I get involved with. My scars aren't scars. They're still open wounds. Everything you can think of, I went through with that guy.

This is obviously the abridged version of the relationship. But I can say that the most important thing in the world is not to settle. You need to feel good in your relationship. The rebuilding process after the relationship is so much harder than the relationship itself. It jacks you up and it takes so long to be OK again. Girls, if you're in crappy relationships that make you feel bad, get out now!

Kevin and Beth

KEVIN

I dated Beth, but she really didn't want to be on the show. She's a model and she felt it would be negative for her career. Beth was really nervous about how she might be portrayed. When you're starting to date someone, you don't fully trust him or her. She didn't know if I was saying bad stuff about her to the camera. Plus, I would be able to tell the cameras my side and she wouldn't be able to. She also knew I didn't want a serious relationship. I told her that from the beginning. So I think that made her not want to participate in the project.

We did stuff without the camera. We went to Central Park and to the movies and to museums. We hung out a lot at Nell's. For a span of two months, we'd go there every Sunday night. Mike was kind of dating her friend Shawna, so it was like going out in high school—in a group.

LORI

I don't know much about Kevin and Beth's relationship, but dating with no expectations or commitments? I don't know about that. I'm territorial. Kevin wouldn't call her back. I'd be like, "Damn, she's not mad you didn't call?" I think I only would have been jealous if she looked anything like me, but she doesn't. She's a very nice girl, though, really nice.

Lori and Kevin

LORI

I'm afraid of looking like a big a** on television. I wanted him and he didn't really want me.

In the beginning, Kevin and I were arguing about hooking up. We both wanted to. He thought we should wait. We were in the techno room at the Limelight and we were dancing without the cameras. He said: "Let's kiss, tonight." He pulled my arm, and we went to a dark corner on the other side of the room and we kissed. It was an OK kiss. He's a bit frigid in my opinion. It was a little more mechanical than I would have liked. His tongue is too pokey or

something. We stopped kissing when we saw the cameras coming. I liked him for a lot longer than he realized, even after a not-great kiss. I was all jealous of him on Valentine's Day when he was sending flowers to a girl back home.

If there's anyting I want to get out, it's this: I've grown to love Kevin as a fantastic friend, but he was sending me some seriously mixed messages the first two weeks. He really was. He knew I liked him and our flirtation was fun, so he just kept it up and talked about us definitely getting together one day. He felt the beginning would be a bad time. He would draw me in, then push me away, and this happened very often. You can ask Coral, she was keeping her eye out. I ended up looking like a fool, but the audience has to understand, I wasn't sure what was going on. I liked the kid, and he acted as if he liked me back more than half the time. It all stopped when I stopped playing along and just let it go.

I have to say that even though it helped to get over him real fast, it took away a very fun and colorful part of our friendship for a while. The flirting was a cool thing to have every day, and I was really bored when it stopped. Luckily, after some bumpy times, we became true friends and then fake-flirting began, which was pretty much us making fun of ourselves. Our famous line together was "That's so first-week," if ever we were sitting together or doing anything together.

We were well aware that in-house crushes are good TV, so we make fun of the fact that this "romance" would be dragged out for *much* longer than it actually took place.

KEVIN

I just didn't like Lori that way. She's not my type at all. My type is probably more athletic, someone who really takes care of her body and doesn't wear that much makeup. There was stuff about her that wasn't physically attractive to me. I know this is a weirdo thing, and I get it from my dad, but I'm really, really into hands. Lori does not have well-kept hands.

I flirt with everyone and yeah, after three days in casting, I said that if I could see myself with anybody, it would be Lori. I also said I never thought that would happen.

The truth is, we ended up hooking up throughout the show. We kissed four or five times during the season. It got to where we'd just play around, kiss on the lips. Just fun.

Lori's the type of girl I like hanging out with, but it's kind of like hanging out with a guy. She and I are really sarcastic; we have almost dry, dehydrated humor. She's really smart. We enjoy people-watching together, making fun of people on the street. I don't like that she is really dramatic—she can really overplay stuff in her life. She wants a problem in her life at all times to occupy her thoughts. If there isn't drama in her life, she's not happy. As long as I'm not involved in the drama, I'm happy.

A couple of weeks into the show Lori and I realized we could never date, but we make really good friends. Every time she comes to me with her dramas about boys, I have to tell her not to worry about it, to calm down.

MIKE

Lori and Kevin, it wasn't going to happen. Kevin just didn't like her like that. He's really picky. He likes a woman to fix herself up, but doesn't like a lot of makeup. Lori was always coming into Kevin's bed. She'd have a couple of drinks in her, straddle him and be like, "Kevin, why don't you like me?" It was so funny.

CORAL

Kevin and Lori! That was the longest short-lived relationship of all time!

CREW CRUSHES

LORI

It was a rare experience that we could talk about the crew, so if we ever had a chance—if there wasn't a camera around—that's what we talked about.

Rachel, Coral, and I each had our little crushes on crew members. Rachel would get mad if her guy miked me or Coral. I'd get mad if my guy miked Coral or Rachel. And so on and so on. Once my guy couldn't get Coral's mike on and she basically had to pull her shirt all the way up and have her boobs in his face. She was taunting me while it was happening, screaming "Look at what's happening to me." Of course, my guy couldn't say anything.

I was just way too verbal about liking my crew member. That's how I am. I'm not subtle. I'm not patient. I knew I couldn't be with him, but I would call the bat-phone and ask when I could hook up with him. I'd be like, "What's the rule? Five months?"

Rachel and Coral weren't as dumb about their crushes as I was. I thought about mine all the time. I went to bed thinking about my guy. I took him into my head and went to sleep with him. It was pathetic.

But viewers will have no idea how our crew crushes affected our lives in the house. We'd be bummed if our crew crushes had the day off. It was like being at camp and getting obsessed with the cute older counselors, except you can't talk to them at all. You don't know if they have girlfriends. You don't know if they actually find you really annoying. You don't know anything.

CORAL

We had to make up names for our crew crushes so we could talk about them when they were around. We called them our "cheese sandwiches." We'd say, "Did you have a cheese sandwich

today?" That meant, "Did you see your crush today?" It's unfortunate, because we thought they were so cute and hot, yet we knew nothing about them. They were just sweaty guys with packs on their backs. That should show you how desperate we were. We couldn't meet any guys in New York!

BRET ALPHIN, PRODUCTION ASSISTANT

As a production assistant for *The Real World,* you do anything and everything. In our world, PA means "practically anything." We had to put mikes on the cast, drive them to their interviews once a week. There was a lot of interaction—not talking, but we'd exchange smiles.

Anybody who has seen the show or knows Lori personally realizes that she's gorgeous and a great, great person. Obviously, I was flattered by her attraction. But I didn't want to get in trouble. I was scared my bosses would think I'd done stuff to encourage her. I'd ask other PAs to mike her. Basically, I just avoided the whole situation.

EATING

Of course, it wasn't always easy. She did an entire confessional about how I was the perfect boyfriend, someone who would only listen, wouldn't talk back, and would go anywhere she wanted. She said if I could just kiss her once a month, it'd be fine. Watching somebody talk about you like that—on a TV monitor—is crazy weird!

Do I think Lori's beautiful? Of course. Who wouldn't? But my contract forbids me to think of her like that. I didn't know about the first *Real World* with Becky and the director, but I saw the Seattle season with David and Kira. I was paranoid! If you're on staff and you affect the story in any way, you're a liability—at least that's how I saw it. If I was a producer, I wouldn't want me around.

I'm 24, and I feel I can relate to the cast. I think it gave them reassurance to have PAs their age. We can relate to what they're going through. Being my age and working on the show is so exciting. I grew up watching *The Real World*. Do I ever want to be on the other side of the camera? No. I feel for them. It's hard to do what they do.

KISS AND TELL

LORI

Here's a misconception we had about production. We didn't realize the cameras in the bedrooms had night vision. We thought that when the lights were out and there were no cameras in the room, that it was a free-for-all. Kevin was a victim of this misconception. During the last week of the season, on the day we called Kegger Kevin Day, Mike brought two girlfriends over. Well, these girls went into the boys' room and got in bed with Kevin. The three of them fooled around! There was stuff going on under the covers and everything.

RACHEL

I have a secret. I think Coral and Adam (from *Road Rules*) hooked up in the Hamptons. I was on the Internet one day and Coral had left her instant messages on screen. There was a buddy window from Adam saying, "That night was really special. I know you don't want to talk about it, but I do." I didn't mean to see it, I really didn't. But there it was! And I never said anything to anyone about it because Coral had gotten so pissed at me for speculating about her and Adam to Nicole.

RACHEL ON DATING

RACHEL

I haven't been on an actual date in New York. I didn't meet anyone in New York I could imagine continuously dating. Everyone I hooked up with was either leaving right away, or came from home, or was Blair.

I miss the whole stage of sharing looks with someone and punching someone and blushing and cute uncomfortable silences. Everyone I was with in New York, I had to leave after two days.

There will be an episode with that guy Gabe in it, and that's really funny to me. His girlfriend is going to love that! Gabe and I met when I was in college. I just had a huge crush on him. I was all excited just to talk to him on the phone! He called when he was in Europe, and I was so thrilled. Then, he e-mailed me the next day saying that he'd recently gotten back together with an ex-girlfriend.

It was good. It was really soft. Blair is a really good kisser. We're not going to have a relationship or anything, but I know it's something we both had thought about, so it was cool to see what it was like.

It's kinda funny. I still have a crush on him, but I have a crush on a lot of boys, ones who *don't* have girlfriends. I also have this huge crush on another guy in a band, Steve. No deal is made of him on the show, but that's not because I don't like him. I wouldn't kiss any of the guys I kissed if I didn't like them. I want to hang out with Steve for real. He was only in town for three days and then they had to continue touring.

Blair was the one person I got really close to at finals. We weren't supposed to talk to each other between finals and going to New York, but I talked to Blair every day. It was so helpful. He kept me grounded. He had a girlfriend, but it was pretty obvious to me that there were feelings between us. If someone is off-limits, I don't chase after them. I try to downplay it. I don't like to talk about guys or relationships unless they're real. I tried not to say something about Blair or anybody else in front of the camera unless it was discussed first. Obviously, I was attracted to him and he to me. I was so upset we didn't get on a show together. He was the one person I wanted to spend the whole time with.

I'm used to getting a lot of affection, and Kevin was the only person who gave me hugs and affection in the house. OK, Mike would have given it to me, but I didn't want it from him.

With Blair, it's just nice and cuddly. Seeing him in the Hamptons was the first time I saw him girlfriend-free. He told me that he'd wanted to kiss me before, but that he was in a relationship. So, we had a little kiss when we were in the New York house before we went to the Hamptons. And then, once we were in the Hamptons, we decided we should just get it over with. We were standing in our bathroom. I don't think I had a mike on. The cameras didn't follow us. It's not like we were sneaking around. It's just we found ourselves alone and were like: *We should see what it's like, get it over with.*

I've been single a little bit too long. I feel like I'm good by myself and I think you should be good by yourself before you're in a relationship. I think I'm ready now, but it's taken a bit of time.

THE BACK STORY

The truth is, I was emotionally traumatized by my ex-boyfriend Justin. Justin and I started dating when I was a junior in high school and he was a senior. We spent the whole summer together, and then the next year he was at the University of Missouri. I am a good girlfriend. I don't need someone with me 24/7. I don't get jealous or mad. I'm cool.

I started screaming at him and my mom came downstairs and started screaming at him for putting me through hell and said she knew it was about another girl. She said that no one acts that way unless there's another girl. He denied it.

I went to Florida with Justin's family for his grandparents' anniversary. But during spring break, he freaked out on me. He told me he didn't know how he felt. And I was really feeling more sure about him! I cared about him so much! His grandfather died, and I went to the funeral and when he was crying, I cried. I had to bite my inner cheek to stop myself from crying.

He came back after spring break and told me he was all messed up and unsure about his feelings. He didn't know if I was the one. He said there wasn't someone else. It came out of nowhere, and I freaked out. I was hysterical. I was having a lot of problems in high school at the time, mainly because I was ready to get out. It was the last straw for me. We tried to have a talk about the whole thing, and he just clammed up. He literally stared at me for two and half hours, crying.

We decided it was OK. I knew it wasn't working, but I kept thinking things would get better. So he came back for my prom. It was horrible. He wouldn't touch me when we danced, it was miserable. And then, the day after graduation, we broke up. I'd kind of had a weaning period, so I was better than I had been during spring break.

Two weeks later, I found out he had a new girlfriend. She was in his dorm, and they'd been together the whole time. And guess where they went to school? The University of Missouri. That's where I was going to college.

At school, I saw them together all the time. I was even in a class with her. She's a really annoying personality. And she talked horrible smack about me.

Basically, the only way I got over Justin was to distance myself from him. And I really distanced myself from him. I got away. I went to New York. And now I don't care about him at all. I didn't talk to him for three months, and recently when I did talk to him, I felt nothing. I don't think he cares about my being on the show. That's how he is about a lot of stuff—indifferent. But, maybe he won't be so indifferent when he hears all the smack *I'm* talking.

JISELA AND MALIK
(AND KEVIN AND LORI)

JISELA

This is how it all went down. The first time I visited New York, I was with some friends. We actually ran into Mike. We literally *ran* into each other. He took a corner at the same time as we did. He was all rude, saying, "Watch it." I was actually gonna take a swing at him, and then I realized it was Mike. He invited us back to the house and we all went out.

Here's the truth. Malik was not my first choice. Kevin was actually my first choice. I wanted Kevin. Kevin and I hooked up at a club. I knew about Lori liking Kevin and I was like, "Damn, I don't want Lori getting all emotional on me."

Kevin was like, "Let's keep it between us so there's no drama." I said, "You like me, I like you, let's do it." We went to a corner of the club and made out. Kevin and I were all physical. I would never want to pursue anything deep with him. I don't pursue anything deep with anybody.

Then, a couple weeks later, I was instant-messaging with Tom from the Casting Special and Malik. Tom was going to New York. I decided I was going to go to New York too. It sounded so fun. I called Sophia and asked her if I could stay with her.

We surprised the *Real World*–ers and just showed up. They thought I was so crazy and spontaneous. I love the guys, and the guys were really happy to see me. At that time, they were having a huge problem with the girls.

At this point, Kevin's dad was in town so he couldn't hang out with us. We went to a club. We were hanging out and Malik was whispering to me that he liked me. There were two *Real World* groupies in the bathroom. They were going nuts for Malik, saying, "the guy with the big 'fro is so cute." I left the bathroom and told Malik. And then one of the girls was kicking it to him. I am territorial and see all the guys as my

guys. I don't share them, unless I approve of the girl. I thought that girl was groupie style, so I went and pulled Malik over and gave him a kiss.

The next day, I was determined to take the guys to a strip club. I thought poor little Mike was really going through it with the girls in the house, he needed to hang out at a strip club. I invited everybody to come with us. I was like, "Nicole, you're welcome to come." And she started bashing the strip club. I told her off. Rachel caught the whole conversation and was like, "I've never heard anyone talk back to Nicole." I didn't even see it as a confrontation. I guess no one had stepped up to her in any way. I mean, I had just invited her. All she had to say was no. At the strip club, Rachel wanted to leave early. The crew followed her out and left with her.

The minute the crew left, we went nuts. With the cameras gone, the strippers were willing to come over to us. It was in the middle of a lapdance that Malik kissed me. It was our first official kiss. It was like a French kiss. That's the weirdest thing I've done—kiss someone while we're getting lapdances. It was an intense bond.

The cameras came back, and after a while we decided to leave. Malik and I were totally making out on the way home. Then we got home and went in the bathroom and locked the door. The cameras couldn't find us. The whole night was me and Malik making out. That night, I bunked with Malik and Sophia bunked with Mike. Malik and I basically hooked up. We had sex. Go ahead and write that we used protection, because I'm very adamant about that.

Now, I don't make excuses for the things that I do, but it was a mistake. The truth is, had Kevin been around that night, he would have been my love interest, and not Malik.

The next night, we went to Chelsea's. We were having a good time. Kevin was with his girlfriend, Beth, and his dad. Lori and Mike were there and a bunch of Malik's friends. I didn't want to be with Malik a lot. I didn't want anyone to know we'd had sex. Then Mike and I decided to get on the bar and start stripping. It was fun. When we got home, Kevin was going on about how he'd hooked up with Beth on the sly at Chelsea's. Malik was taking his friends home. Kevin and I slept in the same bed. Kevin and I kissed that night. I was thinking, *Oh well, wish you were there yesterday.*

The night I left, Malik and I kissed good-bye—no big deal. It was the day before his interview. I told him, "Don't tell them we had sex." I told Malik not to confess it. I thought if he didn't say it, the producers couldn't prove it. They could have Mike saying "I think they had sex" all they wanted, but it still wouldn't be proof. Well, the next day I talked to Malik and he says he "accidentally" told them. I'm like, *accidentally, accidentally, how does that happen?* He says he broke. Malik is really weak as far as people manipulating him and getting him to do things. I told him not to tell, yet he folded in a second.

I was so mad. I couldn't have the world thinking that Malik and I were anything. There's nothing wrong with Malik, but I just knew what the outcome would be. I'd convince myself that I liked him, but then I'd end up totally turned off. I would push him away and ruin it. I want a boyfriend more than anything, but my personality won't allow me to have one. I test anything that limits me. So on the phone I told Malik we were just friends. He was like, "That's cool, that's cool."

Well, then, this punk is over there telling his roommates a different story. I'm getting e-mails from Kevin saying he's happy to hear about me and Malik. What are you happy to hear about, because I sure as hell don't know.

Part of me wanted to like Malik. I thought maybe I could work myself into liking him. He was going to fly me to New York, but then the Hamptons thing ended up happening. So I came to that. I arrived early, so we could have a first date. Immediately, I started to feel claustrophobic. His being all over me literally made me feel physically ill. And the cameras didn't help at all.

started hugging. And then we started talking about the way Kevin kisses. We had a twenty-minute conversation about technique and how he kisses too fast.

The next day, Malik was doing his interview. I snuck in to the room next to his interview, stuck my ear to the wall and eavesdropped. I didn't like how his interview was going at all! He looked depressed and they were asking questions about me. I realized I going to look like the biggest bitch in the world, all trifling. It made me nuts.

That night, we went to Chelsea's and got wasted. I purposefully started drifting away from Malik. I was feeling really weird. All the roommates were making a big deal about me and Malik as this couple. I felt the need to tell everyone the truth. I took everybody alone to tell them.

When we got home, I pulled Lori into the bathroom. Mike came in. I said, "Look, I can kiss anybody, it's no big deal." To prove it, Mike and I kissed on the lips. It actually got a little raunchy in there. Lori and I started talking about our chests, and showed them to Mike. Anyway, Mike left and Lori and I started talking. We bonded because she was upset that people were still making a big deal about her and Kevin. I was upset about the big deal over me and Malik. We

Then I got interviewed. I was asked about "the romance" between me and Malik. I was like, "What romance?" I was feeling so uncomfortable, and I realized I obviously couldn't make myself like Malik and I shouldn't stop being myself for anybody. That night, I slept in Malik's bed, but I shoved him to the side.

The next day, Malik and I went to get a bite to eat. He wasn't miked at the time. I told him, "I don't know what you're telling your roommates, but they're acting like we're a couple. I need to come clean. I don't see me and you being a couple. I'm not going to change the way I am. Don't think I'm about to be your wife or your girlfriend." When

Malik gave me no sign of being hurt, no nothing, it made me realize even more that he wasn't the guy for me. Come on, man. React!

That night, all the other guests flew in. Blair and I went into the confession room. When we got there, Lori and Kevin were already in there. I asked, "What are y'all doing?" Lori said, "I'm teaching Kevin how to kiss." Kevin asked if Lori and I had kissed yet. We told them we'd show them how to kiss. We kissed. Lori told me I was a good kisser. I thought the same of her. We all ended up kissing each other. I kissed Kevin. She kissed Blair. Lori kissed Kevin.

The next morning, Kevin asked me if Malik was OK with it. I said, he has to be OK with it; he's not my man. In the Hamptons, I made a point to room with Patrice. Malik was surprised. "You're not going to room with me?" he asked. The whole weekend, I was pushing Malik away. I wanted to show everybody that he and I were nothing. That weekend, I had the same conversation with Malik twenty times. "We're just friends. Tell your roommates to stop treating me like I'm your girlfriend." Malik is so corny. Had I known, I never would have gotten into it with him.

But here's the part where it got really nasty. Lemme tell my side of the story, cause I know those little bitches didn't know what was going on. I had a camcorder and I was videotaping. It was fun fun, la la. Production had given us tapes, and I figured if I asked for a lot of tapes, I could steal one without anybody noticing. I planned to steal this one where I was joking about all the guys being dorks. I had a different "dork name" for all of them. I called Kevin "business dork," Mike "pimp dork," and Malik "cornball dork." Well, Malik got the camera, and even though we weren't supposed to, he went and rewound the tape. He saw the part when I'm calling everyone a dork, including him. And he went and told everybody.

Lemme tell you about that bitch Coral. She's a straight-out instigator. After Malik told everyone,

she came up to me and told me what I did was wrong. She was out of line. But then I took the guys aside and talked to them. Mike told me he didn't care. Kevin told me he thought I was low-class. Low-class? He thought I had to act a certain way because I was Malik's guest. Well, I think it's low-class to invite someone over and expect them to kiss you're a**.

The next night, I left. The next time I talked to Malik was on the Internet. He made a joke about how I called him a cornball. I said to him, "Your sobbing is not going to make me like you." Then, he told me it didn't matter because the whole time in the Hamptons, he had another girl paging him. I don't care who's on the pager! He didn't understand how much I didn't care.

Basically, everything went wrong. They can all kiss my a**. I'll probably speak to Mike again. And Lori is mad cool. I'll talk to her again. Kevin, I'm totally disappointed in. And as far as Malik goes, I'd like to forget about him completely.

MALIK

Jisela and I became really good friends when she came out for the *Road Rules* wrap party. She and Sophia are really cool, party going, open-minded. All they wanted to do was have fun. When she found out the boys were having problems, she gave us lots of advice. We were hanging out a lot. Definitely, she's naturally flirtatious. We were all "I love you" all the time.

There was no reason to pursue stuff, because we're so different. We stayed friends. We've been talking a lot, still. Was I hurt at all? No, I really wasn't hurt. I was a little disappointed in the fact that she started treating me differently before she talked to me about it. But I accepted it. I was content. In the Hamptons, Maria—she's so sweet—was paging me every day. I never had any reason to trip over Jisela, because I know that I had something better waiting.

People were saying stuff to Jisela like "You guys make a good couple." Because she's so against relationships, that was the kind of thing she hated to hear. She told me not to show affection to her in public. Yeah, we had sex, but I wasn't supposed to tell. Mike made a big deal of it. He said he wasn't afraid to have sex on national television, so why was I?

Jisela was all worried about portrayal. In the beginning, she'd try to drag me away from the cameras and sneak a kiss in. I'd just laugh. If they want to film you, they're there. I just went with whatever she wanted. I really didn't care.

In the Hamptons, she just didn't want us to be seen in this Bobby-and-Nicole-always-being-together

kind of way. I'm way more affectionate than she is. I like to always be cuddling and doing nice little things. She's just not that way. As for me, I think I do want a relationship. In fact, the whole time I was in New York, I was talking to this girl Maria, letting her know what was going on. We've been really close and attracted to each other for a year, but now we have the idea that we'll be together.

CORAL

Jisela is not Malik's type. She lives a lifestyle that Malik can't deal with. I think Malik was hurt. He liked Jisela's energy. She wasn't all naggy. We were glad she was hanging around at first. But then it seemed like she enjoyed being on our show more than she enjoyed being with Malik. I wouldn't say she wanted more camera time, but she just wanted to be in the mix of things, in the pool. Her time on *Road Rules* had ended unexpectedly, and she wasn't done. Malik thought it was all about him, and I'm sure on some level, it was. No one would have guessed they'd get together. If I see something shady, I'm going to be leaning more toward Malik's side. Malik's my boy and I'll protect him.

LORI

Honestly, I never got the full story on Jisela and Malik. Hearing Malik talk, it sounded like they were really mushy together. According to Jisela, it was only Malik who was acting like that and not her. She felt it made her look bad.

Right before the Hamptons, Kevin and I felt bad. We felt there was going to be this plot line about us,

but there was no kiss. We thought it made the crew look bad that they'd missed our actual kiss. We wanted to kiss on camera for the crew. We got into the confessional and decided to kiss for the camera. But, we couldn't do it. We kept laughing. Kevin and I kissed, but it wasn't a very romantic kiss. It was a very instructional, this-is-how-to-do-it kiss.

Jisela and I had been joking about how Kevin can't kiss. So, when she came in she was like, "Lori, let's show Kevin how to kiss," I really didn't want it on tape. We turned off the tape. But in the control room they have a live feed of the confessional, so they saw it anyway. I hope it's not on the show. I told all my friends and my family. It's not a big deal. I don't know what my teachers from my Catholic high school are going to think, but oh well.

KEVIN

Malik and Jisela, I'm still so confused about that. I've heard that Jisela just wanted to get back on TV or just wanted the airtime. Malik loves her as a person, but he falls in love really easily and he's got a lot of girls at home. I know Jisela doesn't want to settle down at all. Their communication was not good at all. She flipped out about the whole deal.

I thought Jisela was a cool girl and I liked kissing her. I didn't really want to kiss her after she and Malik started messing around, but she acted like it was no big deal.

I still think that video showed a lack of class on her part. Malik and I were hiding out in the bathroom. He told me Jisela was tripping out. We had the video she was taking. I suggested we rewind it and check it out.

Then the director came up to us asking why we had Jisela's camera. It really freaked Malik and me out. I didn't know that Jisela had gone and tattled, told the director we were rewinding. I got really paranoid that maybe she was a mole or something. She was acting so creepy, my mind started playing tricks on me.

We thought Jisela was our girl. I didn't feel betrayed by her, but I don't fully understand her. She seems like a pretty complex person. I think she needs to grow up. She was pouting the whole time in the Hamptons. A free trip to one of the best places! She was trying to make it like a soap opera.

MIKE

Jisela is a girl version of a player—a girl version of me, you could say. I think she liked both Malik and Kevin. Maybe Malik liked her a little bit more than she liked him. Sometimes that happens. I asked him if they were a couple, and he said, "Nah, we're cool." And, yeah, he was trying to give her some romance in the Hamptons. But Jisela hates romance. It was miscommunication. They both talked to me about it. She'd be saying she liked him as a friend. He'd be putting candles in the room and trying to get all sexy. But that didn't mean he wanted her to be his only girl. She misinterpreted. They're both my dawgs.

RACHEL

Maybe I'm a jealous person, but I didn't think Jisela should come have come and taken over our show. She had her show! So she got kicked off...does she have to invade ours? I think it's completely ridiculous that Jisela came to the Hamptons. She was invited for a nice weekend, not to cause controversy! At that point, we were all really protective of each other. You don't come in to our group like that and treat anybody as horribly as she treated Malik. She doesn't seem like a nice person.

NICOLE AND BOBBY

NICOLE

Bobby knew my friend Candace's boyfriend. Three years back, we went on a double date. Since then, we've been kicking it, just hanging out at each other's houses.

I've always liked him a lot. Over the years we've seen each other here and there—gone to the movies, talked on the phone for seven hours at a time. We made out for the first time in the fall of '99. The making out was good. Some guys, they can rub all over you and you feel nothing. Bobby touches me and I go nuts. His kissing me means the world to me.

We never became a couple, because he's really into his work. I've been wanting to be his girlfriend since the second time I saw him. It just never happened. He was really excited for me when he found out I was going to be on *The Real World*. He wanted to be part of my life, and this is part of my life, so he was cool with it.

really into me. A: He came to New York for me. B: He took care of me when I was inebriated. Yeah, I was frustrated by the visit. Bobby is not as public as I am. He didn't want to kiss on-camera. I vocalized how upset that made me.

In the Hamptons, there were no cameras in the bedrooms. That was the first time I had sex in four years. Sex is one of the best gifts you can give to somebody. I knew I had to wait for Bobby. I gave Bobby a gift that meant a lot to both of us. I trusted him on many levels. I cried in front of him. And I was around him without makeup on. That was huge for me. I have my own self-esteem issues. A person you really like accepting you with your hair all wrapped up in a scarf—that means a lot.

In the Hamptons, we took a lot of naps, but didn't really take naps if you know what I mean. He's so sweet. He'd be rubbing my arm and rubbing my back and kissing my forehead. Yeah, he didn't kiss me at the airport but he's not comfortable with the public. *He didn't sign up for the show.*

What do I like about Bobby? Everything. I relate to him on so many different levels—religion, music, everything. He's so intelligent. Oh, and he's fine and sexy. He's everything I want in a guy.

I found what I wanted. There's no need to look any further. If he wanted me to move to Detroit, I'd pack my bags and move right now. He's all I-need-to-get-my-business-together and such and such. He feels he's not ready to be boyfriend and girlfriend yet. It's hard to be around someone when you feel stronger than he does. People in the house expect me to be mad at him for not liking me as much as I like him. It's not his fault he doesn't feel as strongly as I do. At least he's honest about it. If he doesn't feel the same way, he doesn't feel the same way. Anyway, I know his feelings are growing.

The first visit was really wonderful except that I threw up like a fool. The visit proved to me that he was

I hope the show doesn't make it look like Bobby's a bad guy. He can't be blamed for not liking me as much. He's not trying to play me, he's always been honest. He'd never do anything to hurt me. I do things to hurt myself sometimes, but that's my responsibility. I love him. He doesn't know that, but I love him. I guess it's kind of obvious.

BOBBY

I've known Nicole a little over three years. We met through a mutual friend back in college. When we first met, she was kinda shy in front of me. When we'd get together, she'd just be all quiet and nonchalant. She wouldn't give me direct eye contact. But then she started loosening up. Now I guess you could say she's pretty loose around me.

As a person, she's what most guys would look for. She's intelligent. She has a good sense of humor. To me, that's the perfect girl. She's beautiful. She's a beautiful person.

She's had a very interesting life. That she's gotten to where she is, not having been influenced by surrounding factors, is really remarkable to me. She has a lot going for her right now. Her whole persona, her whole character...people will want to see her.

The first time I visited her in New York, it was a beautiful feeling. I hadn't seen her in a year. The year before, I was in my senior year at school, so I was real busy. We never saw each other, but we never lost contact. Seeing her again was like a breath of fresh air. I'd kinda forgotten how she looked. I'd forgotten how beautiful she was.

There was never a point when I wasn't into Nicole. There have just been certain times in my life where my workload was overwhelming. I'm a chemical engineer. I've got financial situations. I'm 22, but I feel like I'm 30. Like Nicole, I've experienced a lot in 22 years. I've also tried to make the best of a bad situation. While we were separated, I don't think I'd been thinking about her as much as she was thinking about me. And I say that only because she claimed she was thinking about me hour to hour.

The *Real World* environment was different from how I expected. There were certain moments I really thought were invasions of privacy. I had no idea they'd take it to that level. At first, I was really uncomfortable but then I got readjusted. The other roommates were cool. Well, on the surface they were cool. I think one of the most real was Mike. But he too seemed like he was trying a lot to be the center of attention. He was doing crazy things. Probably the fakest, right offhand, was Coral. My firsthand experience was when she told Nicole I was trying to make a pass at her.

I didn't get time to associate or bond with the other roommates. I couldn't really say who I liked, but I can say that everyone was really fake. They just seemed like they were overdoing it.

Honestly, I wasn't there long enough to get to know anyone. I was there for one reason only: to rekindle things with Nicole and make up for some lost time. I had a lot of anxiety about not having seen her in a while. I wasn't exactly thinking about her as a girlfriend. We had a lot of catching up to do. She'd grown up a lot in the past couple of years. I wanted to start everything over again and see what happened.

It wasn't really a disaster, our first night. Things happen. That's normal. She's not really a drinker. She doesn't know her tolerance. It was all in the heat of the moment. It was an evening I won't ever forget. In a way, it was good I drank, because it kept me feeling freer. Between the Dom P and the martinis, I didn't feel too weird sleeping in a room with cameras.

I'm not into broadcasting my business. Millions of people are going to be watching this. Once you become a professional, there are certain things you want to keep private. So I didn't feel comfortable. I'd never had a camera in my face all the time.

The first trip to New York was like a flash to me. I got there. I popped the champagne. She threw up in the garbage. I went home.

The second trip I was thinking we'd have more time. A whole lotta things happened in the Hamptons. She was anticipating it and I was anticipating it. I don't know everything that was going through her head. I think she was holding back on me a bit, not telling me everything she wanted to happen.

A lot of things went on in the Hamptons that I probably shouldn't discuss. Most of that time I spent with Nicole. We had some romance going on. Probably the most romantic part was when we were lying in the hammock with the breeze. There are things that happened behind closed doors I can't discuss.

Right now, life is good. Nicole and I have become closer through this whole ordeal; we're a lot closer than we used to be. We're slowly moving into the couple stage. I like to take it one step at a time.

I want her to do whatever makes her happy. If she wants to move to Detroit, OK. As long as she's happy, I'm happy. I don't want to interrupt her career path. Hypothetically, if her job is somewhere else, we'll just keep doing a long-distance relationship. It makes it tougher. It's more expensive. But I think if people are really willing to commit, a few miles shouldn't stop you.

NICOLE

Coral's petty. I wouldn't trust her a minute around Bobby. She made a comment that he was like, "Yo, wassup?" to her. Well, I was there when that happened. Please. Then she called him "that short motherf**ker." Honestly, I think she thinks all guys want her. I wish I had confidence like that.

LORI

I'm happy that Nicole is happy, but I think she can do better. I think she deserves somebody who will serve her hand and foot. I don't understand why she thinks Bobby is perfect and why she'll do just about anything for him. It was frustrating to watch. He'd say stuff like "Go get me this." And she'd go and get it. He was the opposite of chivalrous. It sucked to see. It pissed me off.

JISELA

I totally do not like Nicole at all. Until she's happy with herself, she won't be happy with anybody else. Bobby looked like Pootie Tang to me. For the record, let me tell you: homeboy had a wad of money in his pocket and he didn't chip in for any of the liquor. I watched him walk all over Nicole. He ordered her around. I was totally disappointed in her. She gave us this speech about not using the words *ghetto* and *nappy*. Hey, I'm from the ghetto, I'm from the barrio, don't censor me. I was not hearing it. She can put that stuff past her roommates, but not me.

CORAL

I hope Nicole comes into her own in terms of that crap. Bobby treated her just very aloof. He was slimy. He wasn't genuine. I think he wasn't into the whole group scene and I can respect that. Guys like Bobby, I've been there. Guys like Bobby try to talk to girls like me and Nicole a million times a day. That game is old. It's difficult for me to tell her to leave him alone or change it up. She likes him just the way he is. If that's what she wants, I'm sure Bobby will appreciate it. He'll treat her like crap and then eventually she'll realize she's too good for him—but it'll be too late. That's how it works. Well, no thanks.

MIKE

Nicole denied she and Bobby had sex, but we could hear it. It was *boom boom boom* in the hall, not to mention her moaning and groaning. Nicole hadn't had a** in four years. All right, dude! The last person you'd think would do something, did something. I was so proud of her.

I think it's great. She's in love with the guy. He is a cool cat, definitely. If he bent down on one knee and asked her to marry him, she would. It was so funny. Right after we'd been listening to them in the bedroom, he came into the kitchen with his hair all messed up, and got a couple of sandwiches. We were all, "Aww, he just got her some food!" She worked her mojo.

We were seven people who'd never worked at a record company before. Plus, we were bringing our dilemmas from the house into the office. I was always conscious of the people at the office thinking we didn't really "deserve" the jobs. It was kind of embarrassing.

—Coral

working

DEVIN LASKER, Regional Marketing Director, Arista Records, Northeast

I actually tried out for *The Real World* seven years ago. I wanted to be on the London season. I didn't make the show, but I remained in contact with Mary-Ellis and Jon. They called me last year and said they were thinking of having the cast work at a record label. I asked L. A. Reid, and he was totally into it. And that's how the whole thing happened.

ADAM LOWENBERG, Vice President of Marketing, Arista

When Devin first approached me, I thought that this could be amazing. I thought it would be a way to expose Arista to the country, show people how a record company functions. Personally, I was nervous and apprehensive. Knowing that whatever we might say had the potential to be on-camera! Also, I didn't want to put any of our artists in a compromised position. Certainly, there were a couple of moments during the season when I thought, *Oh boy. What have we done?*

MALIK

DEVIN

I've never met a nicer, more kindhearted person than Malik. Anything we asked him to do, he did it. He always wanted to go above and beyond. He wanted to help with mailings. He wanted to do anything. He is a really sweet person, a really great human being. We offered him a job, but he turned us down. I completely understood. He would have had to pack up his life and put everything else on hold. I wanted him to know that we recognized his hard work and talent. There will be other jobs offered to him.

KEVIN

ADAM

Kevin's a great kid. He's someone I'd hire in a second. He just had a sense about him. He cared about his work. I could see Kevin being very successful in whatever he does. I don't think he was a yes man. Well, toward the end, I realized he had some of that aim-to-please attitude. We heard the girls say that the guys were kissing our a**es. It didn't really feel that way. It just took the girls a longer time to work up to it.

CORAL

ADAM

In the beginning, I wasn't sure of what to make of Coral. She seemed standoffish, not very forthcoming. Then, with the Outkast incident, she really stepped it up. She felt that Devin and I took this seriously. She started becoming more interested and more communicative. Of the seven of them, the most progress was made with her. I wish we'd had more time with her. She's an absolute sweetheart and a hard worker.

MIKE

DEVIN

Mike was very into the job. He was really into the rock music. He was very enthusiastic. He's a friendly guy. I don't think there's a mean bone in his body. My favorite thing with Mike was the night he got to meet From Zero at CBGB. He was incredibly passionate about the music.

ADAM

What the girls consider a** kissing, I see as something that you need to do. You need to ask your bosses questions. You have to show that the enthusiasm is there. I'm not always going to come to you. I have a ton of other things going on. I would hire all three of the guys, and I'd have to think about the four girls. It would depend on the position.

NICOLE

ADAM

Rock music was something Nicole wasn't interested in. She made it clear it was hard for her to get excited about something she didn't like. She admitted to being closed-minded. On a couple of occasions she did show sparks—like during the focus groups for Koffee Brown. Every now and then, there'd be a flicker of interest, but that was it.

LORI

DEVIN

I never got a good read on Lori. I could never tell if she really enjoyed the job or hated it. In general, I thought she was a nice person. I heard one song of hers and I thought it was incredible. Singing is her passion, so she should follow it. I definitely think she could have put more into it here in terms of recording, but that's OK.

RACHEL

DEVIN

I asked Adam, "Of all the kids, who do you know the least?" We both said, "Rachel." She never opened up. She's young. She never engaged us in conversation. What she did workwise was good. She seems to have artistic talent. It's unfortunate I never got to know her, because she seems like a sweet girl.

KEVIN

The experience at Arista was unbelievable. I couldn't have dreamed of getting a better job. We made so many connections. Devin and Adam are invaluable contacts. Malik and I both got job offers. I think we have bright futures and they know that.

MALIK

Arista's a big dope family. We got treated like cousins. It was awesome. I can't wait to come back to New York and kick it with them. The girls' bad attitude at work didn't surprise me. It was the theme of the season. They were upset because we had to go to work. Nicole didn't like it because she didn't like the music. Well, I didn't like the music sometimes. You still have to do your job. Whatever. Life's too short to be bitter and upset. Be happy. It would have been a lot easier if the girls had put on a different attitude.

CORAL

Our job in the beginning stank. It got better in the end, when we actually had stuff to do. It was hard. We were seven people who'd never worked at a record company before. Plus, we were bringing our dilemmas from the house into the office. I was always conscious of the people at the office thinking we didn't really "deserve" the jobs. It was kind of embarrassing.

MIKE

Arista was the best job I ever had. It was so much fun. The people who worked there were so great. It's like a family. And it was so much rock! I've always had the dream of being in a heavy-metal band. When I'm in the shower, I imagine myself with the mike in my hand singing for the crowds.

Arista was a money job. We've learned so much about the music industry. We can promote any band. If I ever want to start a band, I know the way to go about it.

LORI

I liked my bosses. I thought they were cool. But it didn't feel like we had a real job. I understood the importance of what we were doing, but that job didn't fit my personality type. We didn't do anything. We just annoyed people.

THE OUTKAST TICKETS

DEVIN

When you're an employee of a record company, there are certain perks that go along with the job. The Outkast show was sold out. It was a really hard ticket to get. We thought that as a reward for the kids working so hard, we'd get them tickets. Coral and Nicole, we didn't see them doing any work. Lori and Rachel were at the office with the guys, they were showing us their work. Had Coral and Nicole been there that day, they probably would have gotten the tickets. But when they weren't there, it made the decision that much easier. Adam and I are usually pretty fair and nice. But did I feel bad? No. I kinda felt bad for a second once Coral stopped slacking. But maybe if the Outkast thing hadn't happened, she might not have come around. Who knows?

THE KISS-A** POSTER

LORI

Honestly, I have changed my opinion about Mike being a kiss-a**. Looking back, I think he was just really enthusiastic about work and that's how he is about everything. I just am not the kind of person to go up to the bosses and say "I love my job." Mike is that kind of person. Malik and Kevin, now, that's a different story. They were not like that in regular life, always kissing butt. Every two seconds they were thanking the bosses for the opportunity. Who does that? It's just very strange. Now, I think the one person who I made an effort to call a kiss-a** was the only guy who wasn't a kiss-a**.

LORI'S SINGING

LORI

As far as singing is concerned, I do feel I capitalized on my time in New York. I did what I could. Being a singer is all I know how to do. I hope people aren't going to make fun of me for it. If people don't want to hear my voice, well screw 'em, turn the damn channel.

When you're at home, in your normal home, you sing all the time. OK, of course, I probably sing more than other people. I got to the house and all of a sudden I couldn't sing anywhere without it looking like I was performing for the cameras or annoying my roommates. I can't not sing. It's something I have to do. It's very therapeutic and it's very fun.

Everyone else in the house did annoying things, but my singing seemed bigger. There were only two or three incidents when the singing was annoying, and those will probably all be on the show. I even had a talk with Kevin about it. Kevin taught me early on to ask whether people minded. I had to lock myself in the confessional, basically a hot closet, to keep my sanity—pretty ironic. Malik had headphones, so he didn't have to annoy everyone with his deejaying. I wasn't as lucky.

After the show stopped taping, that guy Nicky from Arista hooked me up with a producer, a guy in Long Island named Alan. He was thinking I'm going to be the next big pop star. I definitely have those fun fantasies of being a Britney-like pop star. But I don't know how much faith I have in the pop world in terms of how long it's going to last, and what it all means. I am interested in being a singer, in the music, not being part of a musical creation that features me.

I want to be involved with people who are passionate about music. I want to make money, believe me, but not in that fast way. I'd rather be a Björk than a Britney. I want to do fun stuff. If I were to be so lucky that after the show airs, someone out there wants to use me for a chorus—like Gwen Stefani singing the chorus for that Eve song—that would be great. But I don't want to be part of something totally manufactured and fake and all about names and labels.

Honestly, I've always felt a little uncomfortable with the people on *The Real World* who want to be musicians, which is kinda ironic since that's who I am. It just seems so contrived. I just hate thinking I'm going to look like an aspiring musician who will never make it. I'm afraid that the song I recorded with Nicky—we called it "The Tankee Song"—is going to be our season's answer to David from New Orleans' "Come On Be My Baby Tonight."

Let me just clarify that neither of us ever planned to make "The Tankee Song" into an actual song at all. Ever. The song is a joke among the roommates because it is obviously so lame. "I'll work my tankee for ya" was just something we would scream out in mutual mockery. It's just annoying because I've already called myself out, but once that crap airs, people will make fun of this song that they think I consider as "proud work."

NYC

Being in New York
definitely changed
me. Being around
that much culture
and diversity made
me realize what a
small world I have.

—Nicole

nyc 24/7

MAGGIE ZELTNER,
Producer's Assistant

When we go to other cities, people get really excited we're there. New Yorkers don't care. We were just another film crew blocking the streets. Yeah, there were fans coming around all the time. They'd just swarm in front of the house—usually 13-year-olds coming here after school.

FINDING REAL ESTATE IN NYC

TRACY CHAPLIN,
Coordinating Producer

We made our first trip to New York the first week of August. We walked through all the neighborhoods trying to get a feel for them. We toyed with the idea of Williamsburg, Brooklyn. But in the end, we decided we needed to stay in Manhattan. We wanted the cast to have that New York City feeling the second they got on the street.

I don't know how many miles I walked, looking for rent signs, checking out different neighborhoods. I looked at sixty properties—from vacant warehouses to incredible Central Park West apartments. It's amazing what you see. A real estate agent showed me a place for $10.8 million, $80,000 a month!

I narrowed the search down to six spaces: a warehouse in Nolita, an old commercial building in Hell's Kitchen, a commercial space on Union Square, an apartment on the Upper East Side, and a loft in Tribeca. 632 Hudson Street was probably the weirdest find. In some respects, the cast could have moved right in. It had a very old-country European feel. The only problem was the vertical nature of the space. We usually want horizontal space as opposed to vertical space, only because it's easier for the crew not to have to go up the stairs.

We ended up choosing the space in Hell's Kitchen because we felt it would be best for production. Four weeks into it, the whole deal fell apart. It was a disaster. Thankfully, 632 Hudson was still available. We got in on December 1— barely enough time to do production. The only major construction to do was knocking down the wall between the office and the bedroom.

We had seven weeks to rebuild the house, construction included. It was the shortest build-out we've had since Boston. During that time, we had to pick out all the furniture and paint. It's very important when we're choosing colors that the rooms be very identifiable to viewers, so they recognize where the roommates are immediately when they're in the house. This year, we decided

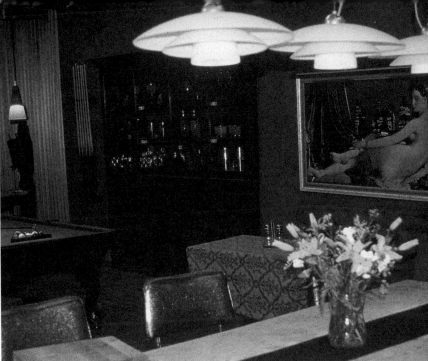

to go with a monochromatic scheme. We worked with Ikea again and they gave us permission to customize their furnishings. We took pieces we thought were appropriate for the rooms and painted or reupholstered them.

I think it was a week before the cast arrived that we figured out we wouldn't make it. We were working literally around the clock. The art department was here during the day, the technical people were here later in the day, and the lighting department worked all night long.

The casts from both *The Real World* and *Road Rules* actually moved in two days later than they were supposed to. They were already in New York staying in hotels. We literally had them in thirteen different hotels so that they couldn't talk to one another.

It was the most difficult and most trying time, having the casts in New York yet not having the house ready! I hope to never repeat that.

The offices for the crew were directly underneath the cast's house. The fact that the cast passed by our door every day was quite a challenge. We tried to soundproof as much as possible. All doors and windows in the crew floor had to be shut. The cast was always trying to get into our space. They broke the code to the door more than once!

HUDSON

CORAL'S FAVORITES

BREAKFAST CEREAL
Lucky Charms

COCKTAIL
Bloody Caesar

CANDY
Red Vines

FOOD
Steak

COFFEE
Just gimme a damn cup of coffee!

T-SHIRT
My "Kick A**" shirt

JEANS
My 501s hands down

SCENT
Eternity and Cartier

CAR
A Jag

STORE
Any shoe store

DANCE MOVE
The Coral dance

EXPRESSION
Are you ready to rock?

HAIR STYLE
Something with good hairspray

SNEAKERS
Pumas and Converse

MAGAZINE
Vibe or *Vogue*

BOOK
Cruddy, The Martian Chronicles

MOVIE
Purple Rain

TELEVISION SHOW
The Practice

HOUR
Night owl

LORI'S FAVORITES

BREAKFAST CEREAL
Honey Bunches of Oats

COCKTAIL
Bloody Caesar

CANDY
Twizzlers

FOOD
Lobster

COFFEE
Dunkin' Donuts French Vanilla

T-SHIRT
My Bostonian-made Britney Spears shirt

JEANS
Diesel

SCENT
Acqua di Gio/Cool Water/Lilacs (Body Shop)

CAR
Subaru Outback

STORE
Wet Seal, Express, Contempo, Bang Bang

DANCE MOVE
Popstar pops

EXPRESSION
A mumbled, disgruntled "not"

HAIR STYLE
Long, black, pin-straight, parted in the middle

SNEAKERS
New Balance (all terrain)

MAGAZINE
Cosmopolitan

BOOK
Beach Music

MOVIE
When Dreams May Come, Bridget Jones' Diary

TELEVISION SHOW
Friends

HOUR
10 PM

SONG TO DO KARAOKE TO
"Criminal," Fiona Apple

ACTOR/ACTRESS
Kevin Spacey, Julia Roberts

SINGER
Björk, Tori Amos, Ani DiFranco

REAL WORLD-ER (PAST OR PRESENT)
Janet and Nathan from Seattle

ROAD RULER (PAST OR PRESENT)
Theo, RR9

FANTASY JOB:
New host of *Wild On, E!*

BEST DRESSED
Nicole

WORST DRESSED
Malik

BEST DANCER
Mike

WORST DANCER
Kevin

BEST COOK
Coral

WORST COOK
Lori

CLEANEST
Coral

MESSIEST
Malik

MOST DILIGENT
Coral

BIGGEST PROCRASTINATOR
Rachel

BEST SMELLING
Kevin

WORST SMELLING
Malik

SONG TO DO KARAOKE TO
Any song that Mike karaokes to

ACTOR/ACTRESS
Samuel L. Jackson/Angelina Jolie

SINGER
Amel Larrieux

REAL WORLD–ER (PAST OR PRESENT)
Melissa and her bag of rice

ROAD RULER (PAST OR PRESENT)
Adam

FANTASY JOB
I want to work my ass off and reap the benefits.

BEST DRESSED
Nicole

WORST DRESSED
Rachel

BEST DANCER
Lori

WORST DANCER
Kevin

BEST COOK
Me

WORST COOK
Mike

CLEANEST
Me

MESSIEST
Rachel

MOST DILIGENT
Kevin

BIGGEST PROCRASTINATOR
Malik

BEST SMELLING
Kevin

WORST SMELLING
Malik

NICOLE'S FAVORITES

BREAKFAST CEREAL
Smart Start

COCKTAIL
Virgin frozen Margarita

CANDY
SourPatch Kids

FOOD
Garden burgers

COFFEE
I hate coffee

T-SHIRT
My Harlem shirt ($11)

JEANS
My bikini-cut jeans (nice and tight)

SCENT
Pine-Sol

CAR
Honda Passport in silver

STORE
Emporium on Broadway

DANCE MOVE
Anything where you don't sweat

EXPRESSION
"How 'bout that"

HAIR STYLE
My '70s flippy hair

SNEAKERS
Yeah, right

MAGAZINE
The Source and *Cosmopolitan*

BOOK
The Alchemist

MOVIE
Love Jones

TELEVISION SHOW
The X-Files and *Seinfield*

HOUR OF THE DAY
8 PM

SONG TO DO KARAOKE TO
"That's the Way Love Goes" Janet Jackson

ACTOR/ACTRESS
Denzel Washington/Halle Berry

SINGER
Maxwell

REAL WORLD–ER (PAST OR PRESENT)
Kevin

ROAD RULER (PAST OR PRESENT)
Theo

FANTASY JOB
Wife, mother, teacher

BEST DRESSED
Me

WORST DRESSED
Malik

BEST DANCER
Mike

WORST DANCER
Kevin

BEST COOK
Coral

WORST COOK
Me

CLEANEST
Coral

MESSIEST
Rachel

MOST DILIGENT
Depends on the situation

BIGGEST PROCRASTINATOR
Rachel

BEST SMELLING
Kevin

WORST SMELLING
Malik

KEVIN'S FAVORITES

BREAKFAST CEREAL
Cocoa Pebbles

COCKTAIL
Crown and Coke

CANDY
Wintergreen Life Savers

FOOD
Gnocchi

COFFEE
Mocha with a shot of hazelnut

T-SHIRT
White v-neck

JEANS
Zara (dark)

SCENT
Bvlgari

CAR
Mercedes S–500 Black

STORE
Nordstrom

DANCE MOVE
C-walk (from WC)

EXPRESSION
"Don't take yourself or life too seriously."

HAIR STYLE
Mullet

SNEAKERS
Nike Air Max

MAGAZINE
Men's Health and *ESPN*

BOOK
Tuesdays with Morrie

MOVIE
Good Will Hunting

TELEVISION SHOW
Seinfeld

HOUR OF THE DAY
11 PM

SONG TO DO KARAOKE TO
"Build Me Up Buttercup," The Foundations

ACTOR/ACTRESS
Bill Murray/Alyssa Milano

SINGER
Billy Joel, Willie Nelson

REAL WORLD–ER (PAST OR PRESENT)
Aaron from LA and Malik

ROAD RULER (PAST OR PRESENT)
Sophia and Blair

FANTASY JOB
Hosting "College Gameday" for ESPN

BEST DRESSED
Me

WORST DRESSED
Rachel

BEST DANCER
Lori

WORST DANCER
Everyone else

BEST COOK
Coral

WORST COOK
Mike

CLEANEST
Coral

MESSIEST
Malik

MOST DILIGENT
Malik

BIGGEST PROCRASTINATOR
The whole house

BEST SMELLING
Coral

WORST SMELLING
Malik

MIKE'S FAVORITES

BREAKFAST CEREAL
Cocoa Puffs

COCKTAIL
Mandarin and Sprite

CANDY
Reese's Sticks

FOOD
I eat everything

COFFEE
I can't drink coffee. I'll bounce off walls.

T-SHIRT
My rock concert Cleveland Police shirt

JEANS
My Abercrombie & Fitch jeans

SCENT
Scent of a woman

CAR
Chrysler Prowler

STORE
WWF Store

DANCE MOVE
The body roll

HAIR STYLE
A girl in pig tails

SNEAKERS
New Balance

MAGAZINE
Maxim

BOOK
I can't remember the last time I read one I liked

MOVIE
Austin Powers 1 and *2* ("Yeah, baby")

TELEVISION SHOW
WWF's *Raw Is War*

HOUR
10 PM because it's party time

Producer Russell Heldt and cast members

SONGS TO DO KARAOKE TO
Any heavy metal song

ACTOR/ACTRESS
Jim Carrey/Kirsten Dunst

SINGER/ BAND
Disturbed, Pantera, From Zero,
Linkin Park

REAL WORLD–ER (PAST OR PRESENT)
The Miz

ROAD RULER (PAST OR PRESENT)
Blair

FANTASY JOB
Professional wrestler for WWF

BEST DRESSED
Nicole by far

WORST DRESSED
Everyone pulled their 'fits off nicely

BEST DANCER
Me then Lori

WORST DANCER
Kevin

BEST COOK
Coral

WORST COOK
Lori

CLEANEST
Coral

MESSIEST
Rachel

MOST DILIGENT
Nicole

PROCRASTINATOR
Rachel

BEST SMELLING
We all smelled so fresh

WORST SMELLING
None

TRIVIA

The water tank on top of the building was carried through the house piece by piece four days before the cast arrived.

The *Real World* house used to be an old sausage factory.

The cast didn't know this, but there's an elevator behind the bookcase.

The phone room is the only room original to the house. The hidden bookcase/Murphy bed was there when we moved in.

There is $45,000 worth of dead bugs on loan from a store in Soho.

RACHEL'S FAVORITES

BREAKFAST CEREAL
Smart Start (thanks to Nicole)

COCKTAIL
Strawberry daiquiri

CANDY
Sour Peach O's, before I realized they were not vegan

FOOD
Hummus

COFFEE
Hazelnut

T-SHIRT
Lori's black "rock" shirt

JEANS
My washed-out Diesels

SCENT
Tommy Boy... it transforms me to mush

CAR
Yellow Volkswagen Bug

STORE
Urban Outfitters, Delia's, thrift

DANCE MOVE
The head-, body-, and foot- nod, seen at good concerts

EXPRESSION
Shaking my head, throwing my hands up while squealing

HAIR STYLE
Mine

MAGAZINE
Rolling Stone

BOOK
The World According to Garp

MOVIE
Cecil B. Demented, The Basketball Diaries

TELEVISION SHOW
Ally McBeal, The X-Flies

HOUR
Midnight

SONG TO DO KARAOKE TO
Anything that overpowers my bad singing voice

ACTOR/ACTRESS
John Cusack/Angelina Jolie

SINGER
Chris Conley of Saves the Day

REAL WORLD-ER (PAST OR PRESENT)
New Orleans Matt

ROAD RULER (PAST OR PRESENT)
Blair, of course

FANTASY JOB
Rock star

BEST DRESSED
Nicole

WORST DRESSED
Coral

BEST DANCER
Lori

WORST DANCER
Yeah, me

BEST COOK
Coral

WORST COOK
Mike—gross meaty sandwiches

CLEANEST
Coral, of course

MESSIEST
Duh, me

MOST DILIGENT
Coral

BIGGEST PROCRASTINATOR
Yeah, me again (do we see a trend here?)

BEST SMELLING
Kevin

WORST SMELLING
Malik

MALIK'S FAVORITES

BREAKFAST CEREAL
Cinnamon Toast Crunch

COCKTAIL
Southern Comfort

CANDY
Chocolate

FOOD
Home fries

COFFEE
No coffee. Thai ice tea

T-SHIRT
Bob Marley T-shirts

JEANS
I like my velour jumpsuit. Not jeans, but...

SCENT
Frankincense and myrrh

CAR
1969 Chevrolet Camaro

STORE
Phat Farm, Beat Street Records

DANCE MOVE
A slow wind from side to side

EXPRESSION
A smile

HAIRSTYLE
Afro and cornrows

SNEAKERS
And 1

MAGAZINE
Time Out NY

BOOK
The Autobiography of Malcolm X

MOVIE
Gandhi

TELEVISION SHOW
The Simpsons

HOUR
I'm so thankful for life, so every hour is great

SONG TO DO KARAOKE TO
"No Woman No Cry," Bob Marley

ACTOR/ACTRESS
Denzel Washington/Can't think of one

SINGER
Bob Marley, Peter Tosh

***REAL WORLD*-ER (PAST OR PRESENT)**
Melissa

ROAD RULER (PAST OR PRESENT)
Jisela, Sophia, Blair, Adam, Katie, Steve

FANTASY JOB
Musician and spiritual healer

BEST DRESSED
We all had different unique styles

WORST DRESSED
No one. Different strokes for different folks.

BEST DANCER
Mike, Lori, and Coral with her slow groove!

WORST DANCER
None

BEST COOK
Coral and me

WORST COOK
I thought Nicole ate weird food, but I wouldn't say she was a bad cook.

CLEANEST
Coral

MESSIEST
Rachel

MOST DILIGENT
All of us at times

BIGGEST PROCRASTINATOR
All of us at times

BEST SMELLING
I wouldn't say that anyone one of my roommates smelled well, because I never went around smelling fools.

WORST SMELLING
I noticed that Nicole used to get sweat stains in her armpits, so I tried to avoid smelling her.

Casting is a learning process for me…It's like opening up a whole new world. I just feel like everyone has a different story. I can learn so much.

—Mike

coraL

Sending my tape in is kinda the first thing I've actually really *done*. I don't really ever commit myself and then see results. But now I'm just digging it because I was the kid in class who everyone said was smart but didn't apply herself. Well, now I'm applying myself! And I'm gonna get on some *Real World!*

FIRST AND MIDDLE NAME: Coral Jeanne

AGE: 21

BIRTHDATE: January 19, 1979

PRESENTLY LIVING IN: San Francisco, California

PARENTS: Tera and Joseph

SIBLINGS (NAMES AND AGES): Joseph, 36, half brother

WHAT IS YOUR ETHNIC BACKGROUND? Creole

NAME OF HIGH SCHOOL: Holy Names High

NAME OF COLLEGE (YEARS COMPLETED AND MAJORS):
City College of San Francisco, San Francisco State,
1/2 year child development

OTHER EDUCATION: School of hard knocks!

WHERE DO YOU WORK? DESCRIBE YOUR JOB HISTORY:
I am a nanny. My jobs have been scattered: police
cadet, real estate, sales, record promotions.

WHAT IS YOUR ULTIMATE CAREER GOAL?
I haven't decided yet. I want to make people's lives
better in some way.

**WHAT KIND OF PRESSURE DO YOU FEEL ABOUT MAKING DECISIONS
ABOUT YOUR FUTURE? WHO'S PUTTING THAT PRESSURE ON YOU?**
I get some pressure from my father to finish school, but
I hate school. He wants me to go into business or
computers. I feel the pressure, but I go with my heart.

WHAT ARTISTIC TALENTS DO YOU HAVE? HOW SKILLED ARE YOU?
I can't play anything and my singing voice isn't all
that great, so I guess I just love it from afar.

WHAT ABOUT YOU WILL MAKE YOU AN INTERESTING ROOMMATE?
I'm always there, I am funny, honest, and people like
me. I have a lot going on, I'm never boring or dry,
and I get all up in what I'm doing. I'm outgoing and
open, very uninhibited and free.

HOW WOULD SOMEONE DESCRIBE YOUR BEST TRAITS?
Honest and genuine, sweet, caring, funny, outgoing
and I always have my friend's back.

HOW WOULD SOMEONE YOU DESCRIBE YOUR WORST TRAITS?
I am nosy. I talk about people. I'm abrasive. I'm too
honest and moody, and I'm late for everything.

DESCRIBE YOUR MOST EMBARRASSING MOMENT IN LIFE.
I came home from a great date with the man of my
dreams. He walked me to my door and I invited him
in. But when I went to turn on the light switch, nothing
happened. My damn lights had been shut off for
nonpayment of the bill.

**DO YOU HAVE A BOYFRIEND OR GIRLFRIEND? HOW LONG HAVE YOU
BEEN TOGETHER? WHERE DO YOU SEE THE RELATIONSHIP GOING?**
I don't have a special someone. I broke up with my
boyfriend six months ago because he was stupid and
began to annoy me. He started treating me like
property and calling me too much. We yelled a lot and
I saw the RED FLAG!! So I put my turbo boosters on
and got the hell up out of there.

WHAT QUALITIES DO YOU SEEK IN A MATE?
Honesty, kindness, a home (alone), no children,
college-educated, driven, mastery of the English
spoken word, sensitivity, sexual compatibility, fun.

**HOW IMPORTANT IS SEX TO YOU? DO YOU HAVE IT ONLY WHEN
YOU'RE IN A RELATIONSHIP?**
Sex is important because it is something you share
with…blah blah blah. In the past, I have only slept
with "boyfriends," but I'm branching out!

DESCRIBE YOUR FANTASY DATE:
I just want to laugh and hold hands. I really don't
care where we go.

WHAT DO YOU DO FOR FUN?
I ride horseback and dance my ass off.

DO YOU PLAY ANY SPORTS? DESCRIBE YOUR ATHLETIC ABILITY.
I don't play any sports. I can't play any sports.

DESCRIBE A TYPICAL FRIDAY OR SATURDAY NIGHT:
I'm at home watching a rented movie or at my
cousin's house talking crap or doing hair. I need that
time to get ready for a new week.

**WHAT WAS THE LAST UNUSUAL, EXCITING, OR SPONTANEOUS
OUTING YOU INSTIGATED FOR YOU AND YOUR FRIENDS?**
We went to a nude beach. That night we went to a
gay bar and danced 'til we dropped. The lights came
on and we went to an after-party and danced until
we dropped again.

DO YOU LIKE TRAVELING?
I love to travel, but the worst trip was to Germany.
Everybody treated me like crap and never helped me,
so I was lost the whole time. The food made me so
sick. I had to go to the German hospital where they
gave me a shot that burned for hours.

**OTHER THAN A BOYFRIEND OR GIRLFRIEND, WHO IS THE MOST
IMPORTANT PERSON IN YOUR LIFE RIGHT NOW?**
My cousin Jasmine. She is smart, funny, giving and
kind. She is always there for me. She never lies to
me or deceives me. She listens and talks back to me
when I need to hear it.

WHAT ARE SOME WAYS YOU HAVE TREATED SOMEONE WHO HAS BEEN IMPORTANT TO YOU THAT YOU ARE PROUD OF?
Jasmine calls me the advice queen. I listen to her and I don't judge her. She can call on me any time and I will be there.

WHAT ARE SOME OF THE WAYS YOU HAVE TREATED SOMEONE WHO HAS BEEN IMPORTANT TO YOU THAT YOU ARE EMBARRASSED BY?
After my ex, there was a boy in my life who bought me a lot of things and took me out all the time. I took advantage of him. I feel horrible about it. He cared about me, and I treated him like crap because I was mad at my ex.

DESCRIBE YOUR MOTHER:
She will give you the last of what she has. But don't cross her!

DESCRIBE YOUR FATHER:
My father wasn't around for about six years. He tries to be there for me and I let him sometimes.

DESCRIBE A QUALITY OR TRAIT THAT RUNS IN YOUR FAMILY:
Sense of humor. We have our own sarcastic way of telling jokes and joking around about other people.

WHAT IS THE MOST IMPORTANT ISSUE OR PROBLEM FACING YOU?
I am trying to find my place in the world. I feel like I'm not good at anything important. It's difficult not having a clear direction.

IS THERE ANY ISSUE, POLITICAL OR SOCIAL, THAT YOU'RE PASSIONATE ABOUT? HAVE YOU DONE ANYTHING ABOUT IT?
I am not political at all. I just wish we could talk about our problems instead of all the violence.

WHO ARE YOUR HEROES AND WHY?
My heroes are single mothers and fathers, homosexuals, sick people, grandmothers, doctors, people who work all night long or, wake up early, garbage men, volunteers, people who overcome addictions. The list goes on and on…

CASTING PREFERENCES

READ BOOKS
One book a month

SLEEP 8 HOURS
Never happens

WATCH TELEVISION DAILY
Love those judge shows

SHOP
Love it love it love it

GO OUT/PARTY
Need it need it need it

SPEND TIME WITH FRIENDS
Very important, but hard

SPEND TIME ALONE
Every time I can

BALANCE WORK/STUDY
Every day

TALK ON THE PHONE
Too much

COOK
If I have to

CLEAN
Got to

WRITE E-MAIL
Almost never

READ NEWSPAPERS
Never

PLAY WITH ANIMALS
I'm a cat person

STATE OPINIONS
Always

ASK OPINIONS
Always

CONFIDE IN YOUR PARENTS
Only my mother

VOLUNTEER
Not enough

PROCRASTINATE
Damn damn damn

EAT
Love to

GET DRUNK
Not often

DIET
Never

VOTE
I don't. I feel bad.

CRY
Try not to

LAUGH
All the time

INSTIGATE
Oops, did I do that?

CINEMA
Love it

THEATER
Small is better

CONCERTS
Love a good concert

CLUBS
Bigger is better

PARTIES
Small parties are my thang

SURF THE WEB
Almost never

DO YOU BELIEVE IN GOD? ARE YOU RELIGIOUS OR SPIRITUAL?
I know God is here in our lives and I pray and talk to him often. I am Islamic, but I believe all religions have something to give others.

WHAT ARE YOUR THOUGHTS ON PEOPLE WHO HAVE A DIFFERENT SEXUAL ORIENTATION FROM YOU?
I love people and respect our diversity.

DO YOU HAVE ANY HABITS WE SHOULD KNOW ABOUT?
I joke around and it's all in fun, but sometimes people get upset. I try to cut down on it, but it's funny and I can take it if someone talks about me.

WHAT BOTHERS YOU MOST ABOUT OTHER PEOPLE?
Stupidity and ignorance. I hate dumb-a** people. Read a book. Put some effort into your mind.

HOW DO YOU HANDLE CONFLICTS? DO YOU FEEL THAT THIS APPROACH IS EFFECTIVE?
I don't like to front people off if I don't have to. I can get loud and yell, but I always listen. I'm not fun to argue with, I admit, but I'm effective 99% of the time because I respect anger.

DO YOU EVER FEEL INTIMIDATED BY OTHER PEOPLE? WHY? HOW DO YOU REACT IN THESE MOMENTS?
Not often, but if I do I usually become friends with them. If you can intimidate me, you are one hell of a person and I want to know you.

HAVE YOU EVER INTERVENED TO STOP AN ARGUMENT OR FIGHT? IN YOUR OPINION, WHEN DOES AN ARGUMENT ESCALATE TO THE POINT WHERE IT SHOULD BE STOPPED?
I stop arguments when name calling begins. Forget that "words don't hurt" crap.

IF YOU COULD CHANGE ANY ONE THING ABOUT THE WAY YOU LOOK, WHAT WOULD THAT BE?
I wish I were taller and my lips were fuller. I try to go to the gym. But I get tired! Forget it!

IF YOU COULD CHANGE ANY ONE THING ABOUT YOUR PERSONALITY, WHAT WOULD THAT BE?
I wish I were more patient. I feel sorry for my kids, if I ever have any.

WHAT IS YOUR GREATEST FEAR AND WHY?
My greatest fear is being alone when I'm an old woman. You know what…forget that. My greatest fear is to die without having fallen in love for real. You become a better person when you are in love and you know yourself so much better. I want that.

IF YOU HAD ALADDIN'S LAMP AND THREE WISHES, WHAT WOULD THEY BE?
1) I wish everyone had money and food (no poverty). 2) I wish my mother could fall in love. 3) I wish for three more wishes.

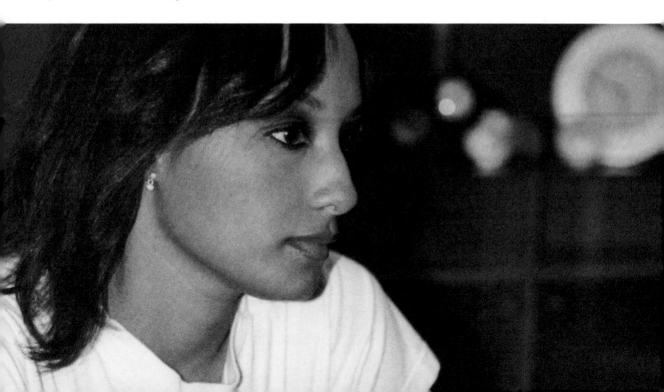

Kevin

When you get over something like cancer, you have to ask "Why? Why did God choose me?" I was with twenty people in the chemo ward who were dying, and it's not like I put more effort into sitting in a chair and getting chemo than they did. I made it. Why didn't they? I'd sit there and I'd pray, and I knew that something was helping me. I believe in God. You know, the doctors gave me a regimen and medicine, but they didn't do this.

FIRST AND MIDDLE NAME: Kevin Kelly

AGE: 22

BIRTHDATE: June 18, 1978

PRESENTLY LIVING IN: Austin, Texas

PARENTS: Cindy and Robert

SIBLINGS (NAMES AND AGES): Amanda, 31

WHAT IS YOUR ETHNIC BACKGROUND?
White. 85% Irish, 15% German heritage

NAME OF HIGH SCHOOL: West Lake High School

NAME OF COLLEGE (YEARS COMPLETED AND MAJORS):
The University of Texas at Austin,
broadcast journalism, minor in Spanish. 3 years.

OTHER EDUCATION:
Spanish at the University of Grenada.

WHERE DO YOU WORK? DESCRIBE YOUR JOB HISTORY:
Sports radio. I have been on-air for ESPN radio.

WHAT IS YOUR ULTIMATE CAREER GOAL?
To be happy! I would like to try acting, continue
broadcasting, and then venture into business. Like
most 22-year-olds, I want to do everything!!

**WHAT KIND OF PRESSURE DO YOU FEEL ABOUT MAKING DECISIONS
ABOUT YOUR FUTURE? WHO'S PUTTING THAT PRESSURE ON YOU?**
As a senior in college, I am feeling TONS of pres-
sure. I am putting it on myself. I want to have a plan.
I also feel pressure from senior girls to settle down
and get married. Message to those girls: NOT
GOING TO HAPPEN!!

WHAT ARTISTIC TALENTS DO YOU HAVE?
Not a lot! I think I can perform for anyone at any
time. I love writing and do it often

WHAT ABOUT YOU WILL MAKE YOU AN INTERESTING ROOMMATE?
Well, I am a big prankster and a constant smart-a**!
I always take a stand on issues. Sometimes I say
what's on my mind and put my foot in my mouth. I
also like to walk around somewhat naked.

HOW WOULD SOMEONE DESCRIBE YOUR BEST TRAITS?
Funny, nice, intelligent, and complex.

HOW WOULD SOMEONE DESCRIBE YOUR WORST TRAITS?
Cold at times, quick to judge, hostile at times.

DESCRIBE YOUR MOST EMBARRASSING MOMENT IN LIFE:
I e-mailed one of my best friends with a *graphic*
story detailing how I hooked up with this girl on a
hotel lobby couch. Somehow, I ended up sending it
to his entire address book. His parents read it and it
became this huge joke all over school.

**DO YOU HAVE A BOYFRIEND OR GIRLFRIEND? HOW LONG HAVE YOU
BEEN TOGETHER? WHERE DO YOU SEE THE RELATIONSHIP GOING?**
No girlfriend. I dated a girl for two years but she
treated me real bad. Since then, I have had trouble
trusting girls. I don't want to fall in love again until
the chemicals in my head even out. At my age, when
you fall in love, it runs your life.

WHAT QUALITIES DO YOU SEEK IN A MATE?
Independence, sweetness, looks, and intelligence.

**HOW IMPORTANT IS SEX TO YOU? DO YOU HAVE IT ONLY WHEN
YOU'RE IN A RELATIONSHIP?**
Important, but not vital. I only enjoy it when I'm in a
serious relationship.

DESCRIBE YOUR FANTASY DATE:
A bottle of red wine, some Chinese food, and relaxed
clothes. We go to a park and just talk and have fun. And
then we go home, make love, go to bed, and sleep.

WHAT DO YOU DO FOR FUN?
I love playing video games. I love to read or watch
international television. I don't like movies because
they take too long. And I visit sick kids and hang out
with them. It makes me feel better.

**DO YOU PLAY ANY SPORTS? DESCRIBE YOUR ATHLETIC ABILITY. I
AM VERY ATHLETIC.**
I play football, basketball, baseball, racquetball,
tennis, swimming, and volleyball. I love competition.

DESCRIBE A TYPICAL FRIDAY OR SATURDAY NIGHT:
Get all dressed up and go out with my friends and
hit on women. Usually, I go home with a smile.

**WHAT WAS THE LAST UNUSUAL, EXCITING, OR SPONTANEOUS
OUTING *YOU* INSTIGATED FOR YOU AND YOUR FRIENDS?**
I gathered all of my best friends and took us out to a
small town in Texas with a video camera. We messed
with the small-town people doing jacka** interviews
and weird scenes.

DO YOU LIKE TRAVELING?
I love it. My best trip was Europe over the summer. I
went to Spain, France, and Italy. It taught me how to
be truly independent. My worst trip was a road trip
to Colorado. We broke down five times. We were
stuck in Vernon, Texas. The car caught fire. We all
got the flu and couldn't ski. It sucked.

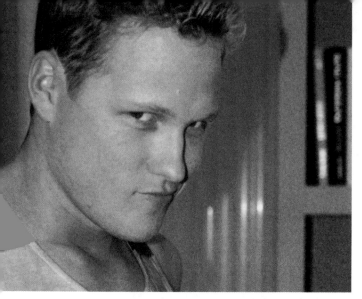

After being spared my life, I feel like I must give back. I talk to young kids and teenagers about self-detection and how to test their bodies. I also volunteer at a chemotherapy clinic.

WHO ARE YOUR HEROES AND WHY?
1) Jerry Seinfeld. He made me laugh when not much in life was funny to me. 2) Lance Armstrong. His courage and work ethic is unmatched.

DO YOU BELIEVE IN GOD? ARE YOU RELIGIOUS OR SPIRITUAL?
I do believe in God. I go to a Bible study every Sunday night. I still have many questions about the Bible and Christ.

WHAT ARE YOUR THOUGHTS ON PEOPLE WHO HAVE A DIFFERENT SEXUAL ORIENTATION FROM YOU?
It doesn't bother me as long as they don't hit on me. I don't know how I'd feel about living with a gay guy. I don't think gay people should get married.

DO YOU HAVE ANY HABITS WE SHOULD KNOW ABOUT?
I drink a little too much. I try to break most of my bad habits before they start.

WHAT BOTHERS YOU MOST ABOUT OTHER PEOPLE?
Little things, i.e. people who blink too much, bad hair, bad voice, bad laugh, dirtiness, stubbornness, flat-out ignorance. People who smell bad or have bad breath, close talkers, low talkers, high talkers.

HOW DO YOU HANDLE CONFLICTS? DO YOU FEEL THAT THIS APPROACH IS EFFECTIVE?
I usually try to step up and make a decision. If I don't care, then I step back and don't do jack.

DO YOU EVER FEEL INTIMIDATED BY OTHER PEOPLE? WHY? HOW DO YOU REACT IN THESE MOMENTS?
I don't usually feel intimidated. When I do, I either get defensive or I lay low.

HAVE YOU EVER INTERVENED TO STOP AN ARGUMENT OR FIGHT? IN YOUR OPINION, WHEN DOES AN ARGUMENT ESCALATE TO THE POINT WHERE IT SHOULD BE STOPPED?
If friends get too personal or if things start to get physical, then I will intervene.

IF YOU COULD CHANGE ANY ONE THING ABOUT THE WAY YOU LOOK, WHAT WOULD THAT BE?
I wish I had a darker complexion. Other than that, I am very happy with what God gave me.

OTHER THAN A BOYFRIEND OR GIRLFRIEND, WHO IS THE MOST IMPORTANT PERSON IN YOUR LIFE RIGHT NOW?
At this point in my life, my dad is also the most important person in my life. I love him and my mom more than anything in the world. Also my four or five best friends. They mean the world to me.

WHAT ARE SOME WAYS YOU HAVE TREATED SOMEONE WHO HAS BEEN IMPORTANT TO YOU THAT YOU ARE PROUD OF?
For the most part I have treated my friends well. I listen to them and really care about their lives. I like to do things for them that go unnoticed. I have also had some special relationships with cancer victims. That's a fraternity like no other.

WHAT ARE SOME OF THE WAYS YOU HAVE TREATED SOMEONE WHO HAS BEEN IMPORTANT TO YOU THAT YOU ARE EMBARRASSED BY?
I haven't treated my mom *nearly* as well as I should. I am too caught up in my own life. Oh, I also kissed one of my best friends, ex-girlfriends. That *killed* me.

DESCRIBE YOUR MOTHER:
Nurturing, sweet, and emotional. She can also be neurotic and quick to judge.

DESCRIBE YOUR FATHER?
Responsible and caring, but he has a quick temper!

DESCRIBE A QUALITY OR TRAIT THAT RUNS IN YOUR FAMILY:
Uncanny and witty. Also, short-tempered.

WHAT IS THE MOST IMPORTANT ISSUE OR PROBLEM FACING YOU?
Staying healthy physically, and mentally keeping a good perspective. I need to remember not to get mad at small things. I'm also trying to find Christ.

IS THERE ANY ISSUE, POLITICAL OR SOCIAL, THAT YOU'RE PASSIONATE ABOUT? HAVE YOU DONE ANYTHING ABOUT IT?
I have made it a passion to spread cancer awareness.

IF YOU COULD CHANGE ANY ONE THING ABOUT YOUR PERSONALITY, WHAT WOULD THAT BE?

Patience is truly a virtue. I don't have enough of it.

WHAT IS YOUR GREATEST FEAR AND WHY?

That I will get sick again or someone I love will. I also fear not succeeding at whatever I end up doing.

IF YOU HAD ALADDIN'S LAMP AND THREE WISHES, WHAT WOULD THEY BE?

1) To end suffering for all children. 2) To give my parents everything they want. 3) To be on *The Real World!* (Seriously!)

CASTING PREFERENCES

READ BOOKS
Not enough

SLEEP 8 HOURS
Need it, don't get it

WATCH TELEVISION DAILY
Sex and the City, Seinfeld

SHOP
Love it

GO OUT/PARTY
A must

SPEND TIME WITH FRIENDS
My favorite besides sex

SPEND TIME ALONE
Always enjoyed it

BALANCE WORK/STUDY
Not enough

TALK ON THE PHONE
Hate it

COOK
Do it a lot for a male

CLEAN
Hate it

WRITE E-MAIL
Best way to communicate

READ NEWSPAPERS
Sports, news, entertainment

PLAY WITH ANIMALS
Overrated

STATE OPINIONS
Always

ASK OPINIONS
Helps reassure yourself

CONFIDE IN YOUR PARENTS
Rarely do it

VOLUNTEER
I enjoy it

PROCRASTINATE
Fight it every day

EAT
Love it

GET DRUNK
I do it too much

DIET
Don't need to

VOTE
People should vote

CRY
A lot

LAUGH
A must

INSTIGATE
Too often

CINEMA
Not a big fan

THEATER
I like certain theater

CONCERTS
Not too many

CLUBS
Every once in a while

PARTIES
Love them

SURF THE WEB
All the time

RAchel

I do like the fact that I'm nice. I don't like to make people mad. I'm not good in back-and-forth arguments. I don't think of things to say fast enough. I can think of a thousand comebacks when I'm alone, but when I'm actually trying to tell someone off, nothing comes out. I don't like it when girls get all prissy and hold grudges and all. I don't put up with that.

FIRST AND MIDDLE NAME: Rachel Laura

AGE: 18

BIRTHDATE: October 31, 1982

PRESENTLY LIVING IN: Columbia, Missouri

PARENTS: Judith

SIBLINGS (NAMES AND AGES):
Corel and Beth, in their 30s; Andrew, 21; and Cory, 20

WHAT IS YOUR ETHNIC BACKGROUND? I am Caucasian.

NAME OF HIGH SCHOOL: Carl Sandburg High School

NAME OF COLLEGE (YEARS COMPLETED AND MAJORS):
University of Missouri, freshman, prejournalism

OTHER EDUCATION: Nope.

WHERE DO YOU WORK? DESCRIBE YOUR JOB HISTORY:
I just was hired to be a desk attendant in my dorm. I have also worked as a cashier, a computer design specialist, and a waitress.

WHAT IS YOUR ULTIMATE CAREER GOAL?
I hope to be a TV producer and freelance writer.

WHAT KIND OF PRESSURE DO YOU FEEL ABOUT MAKING DECISIONS ABOUT YOUR FUTURE? WHO'S PUTTING THAT PRESSURE ON YOU?
I am putting pressure on myself to figure out what I want to do. I don't want to be slaving away at a boring job under fluorescent bulbs that buzz and flicker.

WHAT ARTISTIC TALENTS DO YOU HAVE?
I am very creative in that I make endless collages out of cut-up magazine pages. I am also learning guitar. Mainly, though, I am a writer with a passion for journalistic writing, as well as poetry and short stories.

WHAT ABOUT YOU WILL MAKE YOU AN INTERESTING ROOMMATE?
I like to decorate everything with my unique style. I tend to be a bit on the messy side and I hate it when someone makes a comment about that. I will clean when I want to clean.

HOW WOULD SOMEONE DESCRIBE YOUR BEST TRAITS?
They would say, "Rachel is a funny girl. She is unique in both her style and views. She always looks out for others. Her smile lights up a room."

HOW WOULD SOMEONE DESCRIBE YOUR WORST TRAITS?
They would laugh and say, "Rachel can get really really loud sometimes. She doesn't want to get down on herself, so she refrains from thinking really deeply."

DESCRIBE YOUR MOST EMBARRASSING MOMENT IN LIFE.
I was at summer camp and we were having a dress-up dinner. As I was walking down the stairs, I tripped and fell face-first. I skid across the ground in front of 150 campers and my dress came up over my head revealing my satin underwear.

DO YOU HAVE A BOYFRIEND OR GIRLFRIEND? HOW LONG HAVE YOU BEEN TOGETHER? WHERE DO YOU SEE THE RELATIONSHIP GOING?
I am messed up. I have been in love and I have put my trust entirely into someone and all I have is a broken soul and a head that thinks way too much.

WHAT QUALITIES DO YOU SEEK IN A MATE?
I love curly/spiky hair and black artsy glasses. They should be intelligent, tactful, ambitious, loving, and truthful.

HOW IMPORTANT IS SEX TO YOU? DO YOU HAVE IT ONLY WHEN YOU'RE IN A RELATIONSHIP?
I am a virgin. Sex right now is not that important to me, although I do talk about it lots. I am not saying that I am going to wait until marriage, but so far I have not felt it a needed part of any relationship.

DESCRIBE YOUR FANTASY DATE:
I would like to go out with Tobey Maguire, Beck, or Billie Joe Armstrong. I don't care what happens as long as I was with one of them.

WHAT DO YOU DO FOR FUN?
I like to listen to music, shop, talk online, hang out with my friends, sleep, go out to dinner, go to parties, get coffee, and see concerts. I also like to "liberate" small lawn ornaments like gnomes and geese.

DO YOU PLAY ANY SPORTS? DESCRIBE YOUR ATHLETIC ABILITY.
I am decent in basketball, volleyball, football, swimming, tennis, badminton, and baseball. I am the slowest runner I know and I have no foot/eye coordination.

DESCRIBE A TYPICAL FRIDAY OR SATURDAY NIGHT:
We get dressed up, stand around a tapped keg, and smile at all the hot boys. Pathetic, huh?

WHAT WAS THE LAST UNUSUAL, EXCITING, OR SPONTANEOUS OUTING *YOU* INSTIGATED FOR YOU AND YOUR FRIENDS?
Last Saturday night we had nothing to do, so I suggested we go over to the hospital. We rode the elevators up to the parking garage's top floor, found some wheelchairs and went rolling down the ramps.

DO YOU LIKE TRAVELING?
I like traveling, but get homesick. When my mom and I went to Las Vegas and L.A. for two weeks. I cried every day because I missed my boyfriend.

OTHER THAN A BOYFRIEND OR GIRLFRIEND, WHO IS THE MOST IMPORTANT PERSON IN YOUR LIFE RIGHT NOW?
My best friend is the most important person to me. She is so driven to be her own person, it gives me strength.

WHAT ARE SOME WAYS YOU HAVE TREATED SOMEONE WHO HAS BEEN IMPORTANT TO YOU THAT YOU ARE PROUD OF?
I try to treat everyone I care about with honesty and respect.

WHAT ARE SOME OF THE WAYS YOU HAVE TREATED SOMEONE WHO HAS BEEN IMPORTANT TO YOU THAT YOU ARE EMBARRASSED BY?
I had a close friend who was suffering from an eating disorder. I watched her get thinner and thinner, but I couldn't say anything to her because I was frightened she'd push me away.

DESCRIBE YOUR MOTHER:
She has always shown me all the love she can give while keeping me on a very short leash.

DESCRIBE YOUR FATHER?
Not there and couldn't care less. That's my dad.

DESCRIBE A QUALITY OR TRAIT THAT RUNS IN YOUR FAMILY:
My family is so loud! It doesn't matter if we are all happy, sad, or indifferent, we will scream at each other. We rock the foundation at a family gathering.

WHAT IS THE MOST IMPORTANT ISSUE OR PROBLEM FACING YOU?
I live a pretty sheltered life, so I can't say I'm facing any important issues. Right now I am focusing on college grades. That's my main problem.

IS THERE ANY ISSUE, POLITICAL OR SOCIAL, THAT YOU'RE PASSIONATE ABOUT? HAVE YOU DONE ANYTHING ABOUT IT?
I wish I felt passionate about something, but I don't. I always feel like a bad person when these questions come up.

WHO ARE YOUR HEROES AND WHY?
My hero is my mother. She always put everything other than me second. I hope that someday I can do that for another human being.

DO YOU BELIEVE IN GOD? ARE YOU RELIGIOUS OR SPIRITUAL?
I am a Methodist who believes in God and attends church once in a while. I say my prayers every night before I go to sleep.

WHAT ARE YOUR THOUGHTS ON PEOPLE WHO HAVE A DIFFERENT SEXUAL ORIENTATION FROM YOU?
I don't want to see two gay men or two gay women going at it in public, but then again I don't want to see two straight people doing that.

DO YOU HAVE ANY HABITS WE SHOULD KNOW ABOUT?
Ha! I'm perfect. Oh, wait…

WHAT BOTHERS YOU MOST ABOUT OTHER PEOPLE? WHAT DOESN'T BOTHER ME MOST ABOUT OTHER PEOPLE?
I hate when people lie. I hate when stupid people ask stupid questions. I hate when people are hypocritical. I hate when people walk around with their chins in the air or sticks up their a**es.

HOW DO YOU HANDLE CONFLICTS? DO YOU FEEL THAT THIS APPROACH IS EFFECTIVE?
I usually don't get into it with the person right on the spot. I will trash-talk them to myself or others as practice. It seems to work well for me.

DO YOU EVER FEEL INTIMIDATED BY OTHER PEOPLE? WHY? HOW DO YOU REACT IN THESE MOMENTS?
I do feel intimidated by people a lot. The "perfect" little sorority girl here stares you down and you feel like less of a person. It makes me uneasy, but then I think: *I have so much more going on behind my face than you can ever hope to have.* I am learning to hold my head up high.

CASTING

READ BOOKS
Have to be in the mood

SLEEP 8 HOURS
Not pleasant otherwise

WATCH TELEVISION DAILY
Dawson's Creek, Friends, and *Angel*

SHOP
My stress release!

GO OUT/PARTY
Weekends

SPEND TIME WITH FRIENDS
Constantly

SPEND TIME ALONE
Some

BALANCE WORK/STUDY
I do a decent job

TALK ON THE PHONE
Prefer on-line

COOK
Yeah right!

CLEAN
Ha!

WRITE E-MAIL
All the time

READ NEWSPAPERS
Entertainment sections

PLAY WITH ANIMALS
Never had any!

STATE OPINIONS
If I feel like it

ASK OPINIONS
Always a good thing

CONFIDE IN YOUR PARENTS
Tell my mom lots

VOLUNTEER
Sometimes

PROCRASTINATE
My devil

EAT
Love food!

GET DRUNK
Not so much

DIET
Never

VOTE
Was always too young

CRY
I'm a faucet

LAUGH
Nothing I like more

INSTIGATE
I want to know everything

CINEMA
Not lovey, dovey movies!

THEATER
When I have the $

CONCERTS
Obsessed with music

CLUBS
Love!

PARTIES
Love to!

SURF THE WEB
I'm always on-line

HAVE YOU EVER INTERVENED TO STOP AN ARGUMENT OR FIGHT? IN YOUR OPINION, WHEN DOES AN ARGUMENT ESCALATE TO THE POINT WHERE IT SHOULD BE STOPPED?
I never have stepped in to stop anything. I am usually the bystander in the corner trying to cover up my laughter.

IF YOU COULD CHANGE ANY ONE THING ABOUT THE WAY YOU LOOK, WHAT WOULD THAT BE?
One thing, ha! Umm…I guess if I had to pick just one, it would be my flat head.

IF YOU COULD CHANGE ANY ONE THING ABOUT YOUR PERSONALITY, WHAT WOULD THAT BE?
I wish I was better at dealing with people when they are down or in trouble. Some of my friends are depressive and I don't know what to say to make them happy—if that is even possible.

WHAT IS YOUR GREATEST FEAR AND WHY?
I am very frightened of dying a slow, debilitating, and painful death. I am scared of knowing how much time I have left on earth and realizing that I cannot do anything to save myself.

IF YOU HAD ALADDIN'S LAMP AND THREE WISHES, WHAT WOULD THEY BE?
1) Can I please have fifty million dollars? 2) Can I live 'til I am 100, happily? 3) Can I please be happy?

Malik

Everyone tells me that New York's got this fast pace, this aggressive attitude. That doesn't sound like me. I'm way more laid-back. I'm chill. I'm like *Hey, yo, what's up*, like trying to take it all in. I like flatlands. I like to see the sky. I think New York's gonna be hard to get used to.

FIRST AND MIDDLE NAME: Malik

AGE: 23

BIRTHDATE: March 29, 1977

PRESENTLY LIVING IN: Berkeley, California

PARENTS: Peggy

SIBLINGS (NAMES AND AGES): Nikki, 30

WHAT IS YOUR ETHNIC BACKGROUND?
My mother is English, German, and Irish. My father is African-American.

NAME OF HIGH SCHOOL: Berkeley High School

NAME OF COLLEGE (YEARS COMPLETED AND MAJORS):
UC Berkeley, five years, ethnic studies

OTHER EDUCATION:
Martial arts. I have been taking tai chi for two years.

WHERE DO YOU WORK? DESCRIBE YOUR JOB HISTORY?
I earn money as a DJ. I've worked at a video store and a skateboard shop.

WHAT IS YOUR ULTIMATE CAREER GOAL?
My passions involve music and writing. I'm writing the lyrics to my own album, *Low Income, High Maintenance.* I would also like to write screenplays.

WHAT KIND OF PRESSURE DO YOU FEEL ABOUT MAKING DECISIONS ABOUT YOUR FUTURE? WHO'S PUTTING THAT PRESSURE ON YOU?
I put pressure on myself to try to cater my music to a diverse population of listeners.

WHAT ARTISTIC TALENTS DO YOU HAVE?
I have been writing poetry and raps as well as stories since I was a child.

WHAT ABOUT YOU WILL MAKE YOU AN INTERESTING ROOMMATE?
I love to talk and I'm always willing to share my experiences, but I'm also a good listener.

HOW WOULD SOMEONE DESCRIBE YOUR BEST TRAITS?
A lot of people who know me have not had the same opportunity to go to college. As a result, many of them talk about me as being hella smarter than they are. They say I'm generous. My close friends say they love to talk to me because I'm understanding and a good listener. My friends tell me I don't have problems adjusting to new people or social situations, saying I appear happy and comfortable wherever I go. They see me as a leader.

HOW WOULD SOMEONE DESCRIBE YOUR WORST TRAITS?
My best friend says sometimes I'm just too nice and I am willing to take on added stress or commitments for friends even when I'm too busy. Sometimes I talk too much.

DESCRIBE YOUR MOST EMBARRASSING MOMENT IN LIFE.
The first time I had sex was with a girl who was younger but had more sexual experience than I. I was so nervous because not only, my first time, but my mom and sister were in the next room. I was so scared that the girl had to do everything, including putting on the condom. It was humiliating.

DO YOU HAVE A BOYFRIEND OR GIRLFRIEND? HOW LONG HAVE YOU BEEN TOGETHER? WHERE DO YOU SEE THE RELATIONSHIP GOING?
I broke up with my girlfriend in the summer of 1999. I loved the fact that she was a beautiful dancer and artist, but she was very judgmental. I hate to argue, but what I hated even more was her attitude. Currently, I am trying to stay single.

WHAT QUALITIES DO YOU SEEK IN A MATE?
My next girlfriend has to be my friend before we start getting involved. I'm looking for a woman who isn't judgmental, yet has opinions of her own. I love to dance and hope she does too. I don't have any racial or ethnic preferences.

HOW IMPORTANT IS SEX TO YOU? DO YOU HAVE IT ONLY WHEN YOU'RE IN A RELATIONSHIP?
Sex is important because it involves sharing yourself with someone while both are in a more vulnerable state, being naked and close to each other. I have sex only with women I've grown to trust.

DESCRIBE YOUR FANTASY DATE:
We cook a wonderful vegetarian meal, watch the sunset while holding each other wrapped in a blanket. Then we dance until the early morning, watch the sunrise, and fall asleep in each other's arms.

WHAT DO YOU DO FOR FUN?
I have so much fun deejaying. When I need to get out of the house or away from the turntables, I play sports or skateboard.

DO YOU PLAY ANY SPORTS? DESCRIBE YOUR ATHLETIC ABILITY.
I have been playing sports since I was 5 years old. First I played soccer, then baseball, and finally basketball. I love it so much, and am a pretty good shooter. I'm still trying to dunk the ball.

DESCRIBE A TYPICAL FRIDAY OR SATURDAY NIGHT:
Usually I deejay at a party. Or I go dancing to music or to a show to hear one of my favorite artists.

WHAT WAS THE LAST UNUSUAL, EXCITING, OR SPONTANEOUS OUTING *YOU* INSTIGATED FOR YOU AND YOUR FRIENDS?
I planned an outing where we went to see the poet Saul Williams perform. We danced until 2, even though I had classes at 8 the next morning.

DO YOU LIKE TRAVELING?
I had a great time going up north to see Reggae on the River. The worst trip I ever took was to Los Angeles. The car overheated and we had to be towed 130 miles.

OTHER THAN A BOYFRIEND OR GIRLFRIEND, WHO IS THE MOST IMPORTANT PERSON IN YOUR LIFE RIGHT NOW?
My mother means so much to me. I have so much respect for her and how she gives unselfishly continues to pursue her own goals and dreams.

WHAT ARE SOME WAYS YOU HAVE TREATED SOMEONE WHO HAS BEEN IMPORTANT TO YOU THAT YOU ARE PROUD OF?
I'm proud of the little things I've done for my mom to make her feel happier. Cleaning, making food, running the dogs, moving heavy things, or buying

something I think she will like. Other times it's just talking to her, giving her a back massage, or getting her out of the house.

WHAT ARE SOME OF THE WAYS YOU HAVE TREATED SOMEONE WHO HAS BEEN IMPORTANT TO YOU THAT YOU ARE EMBARRASSED BY?
I feel like I take for granted the special things my mom does for me every day. When I feel overloaded with responsibilities, sometimes she'll ask me to do something and I'll get mad.

DESCRIBE YOUR MOTHER:
She is caring. She says how she feels. I think this is good, but others could perceive it as bossy.

DESCRIBE YOUR FATHER:
Absent. He's never been in my life.

DESCRIBE A QUALITY OR TRAIT THAT RUNS IN YOUR FAMILY:
Communication and sometimes lack thereof.

WHAT IS THE MOST IMPORTANT ISSUE OR PROBLEM FACING YOU?
I've been looking at racial/gender discrimination and social inequality. Music and education are two careers I would like to pursue that can act as a way to change the inequalities that exist.

IS THERE ANY ISSUE, POLITICAL OR SOCIAL, THAT YOU'RE PASSIONATE ABOUT? HAVE YOU DONE ANYTHING ABOUT IT?
I would like to continue helping children learn to read, write, and increase their chances at going on to pursue college.

WHO ARE YOUR HEROES AND WHY?
Gandhi, Malcolm X, Martin Luther King, Harriet Tubman, Peter Tosh, and Jesus. They all died for what they believed in, but more importantly their beliefs were tied to changing the world to make it a better place.

DO YOU BELIEVE IN GOD? ARE YOU RELIGIOUS OR SPIRITUAL?
I do believe in God, though I don't identify with any formal religious services.

WHAT ARE YOUR THOUGHTS ON PEOPLE WHO HAVE A DIFFERENT SEXUAL ORIENTATION FROM YOU?
Being from Berkeley has opened me up to all different types of people.

DO YOU HAVE ANY HABITS WE SHOULD KNOW ABOUT?
Music is my main habit.

WHAT BOTHERS YOU MOST ABOUT OTHER PEOPLE?
Lack of an open mind when it comes to other people's beliefs, cultures, goals, etc....

HOW DO YOU HANDLE CONFLICTS? DO YOU FEEL THAT THIS APPROACH IS EFFECTIVE?
Communication has always been my first method of solving conflicts. Sometimes it's better to allow space to cool off if communication isn't working.

DO YOU EVER FEEL INTIMIDATED BY OTHER PEOPLE? WHY? HOW DO YOU REACT IN THESE MOMENTS?
Sometimes, but usually only with women I like. It usually doesn't last.

HAVE YOU EVER INTERVENED TO STOP AN ARGUMENT OR FIGHT? IN YOUR OPINION, WHEN DOES AN ARGUMENT ESCALATE TO THE POINT WHERE IT SHOULD BE STOPPED?
When people begin to say or act disrespectful to one another—that's when I begin to intervene.

IF YOU COULD CHANGE ANY ONE THING ABOUT THE WAY YOU LOOK, WHAT WOULD THAT BE?
I don't have a well-defined six-pack.

IF YOU COULD CHANGE ANY ONE THING ABOUT YOUR PERSONALITY, WHAT WOULD THAT BE?
I wish I could better control my emotional responses to certain situations.

WHAT IS YOUR GREATEST FEAR AND WHY?
Death, because I'll never know what happens after I die.

IF YOU HAD ALADDIN'S LAMP AND THREE WISHES, WHAT WOULD THEY BE?
1) World peace and equality achieved through music. 2) A woman president or a president who could move me like Jesse Jackson or lead like Gandhi. 3) People aren't judged by their race, ethnicity or gender.

CASTING PREFERENCES

READ BOOKS
Love to

SLEEP 8 HOURS
Usually 4-6

WATCH TELEVISION DAILY
Sports, MTV, *The Simpsons*

SHOP
Record shopping!

GO OUT/PARTY
At least once a week

SPEND TIME WITH FRIENDS
Every day

SPEND TIME ALONE
Enjoy it

BALANCE WORK/STUDY
It's hard

TALK ON THE PHONE
Not too long

COOK
Like to

CLEAN
Least favorite chore

WRITE E-MAIL
To friends out of town

READ NEWSPAPERS
The New York Times—I try

PLAY WITH ANIMALS
Every day I train my puppy

STATE OPINIONS
Like to, but don't disrespect

ASK OPINIONS
I ask a lot of questions

CONFIDE IN YOUR PARENTS
My mom

VOLUNTEER
Always willing

PROCRASTINATE
Yes, but I get it done.

EAT
Vegetarian

GET DRUNK
Not a big drinker

DIET
Healty

VOTE
For the lesser evil

CRY
Not often

LAUGH
The best remedy

INSTIGATE
Never

CINEMA
Love movies

THEATER
Love acting

CONCERTS
Love live shows

CLUBS
I work at them

PARTIES
Love to throw them

SURF THE WEB
Mostly for research

LORi

I've always been attracted to a strong jawline in a man. I also like the neck. Whenever I see a guy, I look at the back of his neck to see if I'm attracted to him. Another weird thing: I am really drawn to a guy's wrists. This I don't understand about myself. Where did it come from? If a guy's wrists are too thin or lanky, I'm turned off somehow. What's the deal with that?

FIRST AND MIDDLE NAME: Lori

AGE: 21

BIRTHDATE: March 11, 1979

PRESENTLY LIVING IN: Chestnut Hill, Massachusetts

PARENTS: Jeane and Rogelio

SIBLINGS (NAMES AND AGES): Kim, 24 and Terri, 27

WHAT IS YOUR ETHNIC BACKGROUND?
Half Filipino, quarter Irish, quarter Italian

NAME OF HIGH SCHOOL:
Oak Knoll School of the Holy Child Jesus.

NAME OF COLLEGE (YEARS COMPLETED AND MAJORS):
Boston College, completed three years, currently
a first-semester senior, human development,
music minor

OTHER EDUCATION: No

WHERE DO YOU WORK? DESCRIBE YOUR JOB HISTORY?
I'm the business manager of the Bostonians
Collegiate acapella group. I've been a hostess,
buser, waitress, head secretary, and a temp.

WHAT IS YOUR ULTIMATE CAREER GOAL?
My ultimate career goals have varied from
meteorologist to makeup artist to a singer (either a
pop artist, lead singer in a band, or female recording
artist in electronic compositions). Honestly, I have no
ultimate goal, but I do want to be financially
comfortable enough to support a family one day.

**WHAT KIND OF PRESSURE DO YOU FEEL ABOUT MAKING DECISIONS
ABOUT YOUR FUTURE? WHO'S PUTTING THAT PRESSURE ON YOU?**
Well, my father is eager to have me be financially
independent which I could NOT be farther from. He
teases, but never scolds. I need to figure out where
I'm gonna live when I graduate—HUGE PRESSURE!

WHAT ARTISTIC TALENTS DO YOU HAVE?
I used to paint pretty damn well, but I've lost that
skill entirely—no more sense of proportion. I dance.
I'm much better at parties. I sing.

WHAT ABOUT YOU WILL MAKE YOU AN INTERESTING ROOMMATE?
"Interesting" is the broadest adjective on earth. I'm
relatively easy to live with, even with people unlike
myself, but after a while my boiling distaste for those
unlike me lends to colorful interactions.

HOW WOULD SOMEONE DESCRIBE YOUR BEST TRAITS?
My best friend says she believes I have an ancient wis-
dom, an inherent understanding of the world around me.

HOW WOULD SOMEONE DESCRIBE YOUR WORST TRAITS?
I do know when I'm wrong, but I don't believe that
happens very often. I hate to lose a fight; I won't. I'm
defensive, apparently. I need the limelight. I whine a
bit (maybe more than a bit). I get these waves of
insecurity. I'm quick to judge, even if I don't admit it.

DESCRIBE YOUR MOST EMBARRASSING MOMENT IN LIFE.
I went to visit my high school boyfriend in boarding
school. Girls were not allowed in the rooms. A dorm
parent caught us in his room, and let's just say he
lost all campus privileges. I was asked to leave
immediately, never to return.

**DO YOU HAVE A BOYFRIEND OR GIRLFRIEND? HOW LONG HAVE YOU
BEEN TOGETHER? WHERE DO YOU SEE THE RELATIONSHIP GOING?**
Boyfriend: Matt. We've been together six months. It's
not going anywhere far. He's beautiful—absolute
stud, academically brilliant, motivated, silly, sweet.

WHAT QUALITIES DO YOU SEEK IN A MATE?
My sense of humor: crude, sarcastic, overdramatic,
witty, and an appreciation for my passions. I want
someone who won't let me knock him around.

**HOW IMPORTANT IS SEX TO YOU? DO YOU HAVE IT ONLY WHEN
YOU'RE IN A RELATIONSHIP?**
Sex is pretty important. I've tried casual sex outside a
relationship. It's only fun when you care for the guy.

DESCRIBE YOUR FANTASY DATE:
Hmm, cheesy fantasies make me nervous! I'd say
that a hot and funny guy and I hit McDonald's and
then go to a dog or cat show (when you play with
the animals, not watch them jog in a circle).

WHAT DO YOU DO FOR FUN?
I like to watch obscene amounts of TV, go to movies,
have a couple of drinks. I like to go out and try to
get guys to look at me from across the room. I like
to pretend I'm prettier than I am. When I feel like
that, I get more attention. Weird twist: I don't like
being approached. Just checked out.

DO YOU PLAY ANY SPORTS? DESCRIBE YOUR ATHLETIC ABILITY.
Ha! Good one!

DESCRIBE A TYPICAL FRIDAY OR SATURDAY NIGHT:
Well, I used to go to bars, but my boyfriend and
most of my friends are under 21.

**WHAT WAS THE LAST UNUSUAL, EXCITING, OR SPONTANEOUS
OUTING *YOU* INSTIGATED FOR YOU AND YOUR FRIENDS?**
I'm quite lazy. I rarely instigate exciting outings. I'm
usually dragged along.

CASTING PREFERENCES

READ BOOKS
Wish I read more

SLEEP 8 HOURS
More if possible

WATCH TELEVISION DAILY
Friends, Frasier, Ally McBeal

SHOP
Not often. Hate spending $.

GO OUT/PARTY
Like to

SPEND TIME WITH FRIENDS
60% of my friends

SPEND TIME ALONE
40%—very important

BALANCE WORK/STUDY
Just study

TALK ON THE PHONE
I love the phone

COOK
Nope

CLEAN
Not much

WRITE E-MAIL
All the time

READ NEWSPAPERS
No

PLAY WITH ANIMALS
Whenever I can

STATE OPINIONS
Too much

ASK OPINIONS
Not enough

CONFIDE IN YOUR PARENTS
None to Dad, a lot to Mom

VOLUNTEER
Nope

PROCRASTINATE
Way too much

EAT
All the time

GET DRUNK
Friday and Saturday

DIET
Never

VOTE
I don't

CRY
Enough to keep me refreshed

LAUGH
As much as possible

INSTIGATE
Too much

CINEMA
Love it

THEATER
Not in a while

CONCERTS
Not often

CLUBS
Nope

PARTIES
When I can

SURF THE WEB
Not much at all

DO YOU LIKE TRAVELING?
Honestly, I like being places but traveling to them, not so much of a fan. I get groggy and tense. I'd like to travel to tropical places. I've got the tropics in my blood…literally.

OTHER THAN A BOYFRIEND OR GIRLFRIEND, WHO IS THE MOST IMPORTANT PERSON IN YOUR LIFE RIGHT NOW:
Kim, my sister. She is pure beauty and goodness. She is the only person I know who can love life and be optimistic yet fully comprehending her own dark side. She's completely considerate, unfathomably intuitive and utterly fun loving.

WHAT ARE SOME WAYS YOU HAVE TREATED SOMEONE WHO HAS BEEN IMPORTANT TO YOU THAT YOU ARE PROUD OF?
I adore my friend Laura. If she is upset, I'll drop everything to go take care of her. I'll do her any favor if she'd ever ask.

WHAT ARE SOME OF THE WAYS YOU HAVE TREATED SOMEONE WHO HAS BEEN IMPORTANT TO YOU THAT YOU ARE EMBARRASSED BY?
I don't spend enough time with a family friend who has treated me really well and is now older and needing of my attention. I don't know why I don't go and see her more!

DESCRIBE YOUR MOTHER:
My mom is my friend. I joke around with her and tease her. We have a good time. She's also very brave. She's a survivor.

DESCRIBE YOUR FATHER:
He loves me unconditionally, but sometimes I feel like he doesn't know me.

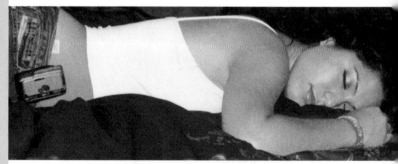

DESCRIBE A QUALITY OR TRAIT THAT RUNS IN YOUR FAMILY.
The best at whatever we do! My mom's the best nurse. My father is the best anesthesiologist. Terri is the best writer and dancer. Kim is the most compassionate and social. And I'm the best singer!

WHAT IS THE MOST IMPORTANT ISSUE OR PROBLEM FACING YOU?

I need to start deciding on a path for my future. Other than that, I am unbelievably fortunate. I've had a wonderful life. (This is why I don't understand why I'm so unhappy so often.)

IS THERE ANY ISSUE, POLITICAL OR SOCIAL, THAT YOU'RE PASSION-ATE ABOUT? HAVE YOU DONE ANYTHING ABOUT IT?

I despise homophobes, especially if they hate gay people because they think God told them so.

WHO ARE YOUR HEROES AND WHY?

No famous heroes. Mom. She's independent and loves unconditionally. She's a sage. Always has the right answer and the best advice.

DO YOU BELIEVE IN GOD? ARE YOU RELIGIOUS OR SPIRITUAL?

My relationship with God is between me and God. I hate formal prayers and services. I hate when people think that by sitting in a pew, they're "good" people. Be good to people, be good to yourself, and tell God what's up every once in a while.

WHAT ARE YOUR THOUGHTS ON PEOPLE WHO HAVE A DIFFFRFNT SEXUAL ORIENTATION FROM YOU?

The same as I feel about people who have my same sexual orientation. Actually, they're a lot braver than we are. They admit to who they are. That's rare.

DO YOU HAVE ANY HABITS WE SHOULD KNOW ABOUT?

I eat an obscene amount of beef jerky with pickles and yogurt and iced tea.

WHAT BOTHERS YOU MOST ABOUT OTHER PEOPLE?

When people think you're insulting them when you're totally not, when people do not think before they speak, when people are condescending, when people don't hear you out.

HOW DO YOU HANDLE CONFLICTS? DO YOU FEEL THAT THIS APPROACH IS EFFECTIVE?

It depends. Conflicts with family, I cry to myself. With girls, I let it fester inside. With guys, I bitch them out immediately. Absolutely none of these means are effective.

DO YOU EVER FEEL INTIMIDATED BY OTHER PEOPLE? WHY? HOW DO YOU REACT IN THESE MOMENTS?

Are you kidding? If anyone says "no" to this question, mark them down as a liar. I'm only intimidated by people I want to impress. Usually, I try to make them laugh and end up bombing.

HAVE YOU EVER INTERVENED TO STOP AN ARGUMENT OR FIGHT? IN YOUR OPINION, WHEN DOES AN ARGUMENT ESCALATE TO THE POINT WHERE IT SHOULD BE STOPPED?

No. I like fights. I let them go. Great drama. I'm talking about verbal fights, not physical ones.

IF YOU COULD CHANGE ANY ONE THING ABOUT THE WAY YOU LOOK, WHAT WOULD THAT BE?

I would like a longer torso.

IF YOU COULD CHANGE ANY ONE THING ABOUT YOUR PERSONALITY, WHAT WOULD THAT BE?

I would like to care less about what people think of me. It's exhausting.

WHAT IS YOUR GREATEST FEAR AND WHY?

That something awful will happen to my sisters or that someone whom I love dies without their knowing how I feel.

IF YOU HAD ALADDIN'S LAMP AND THREE WISHES, WHAT WOULD THEY BE?

1) The ability to touch someone and temporarily alleviate their pain long enough for them to sleep soundly. 2) The ability to move things with my mind. 3) To speak every language fluently.

MiKE

Casting is a learning process for me. When I got out of high school, I felt like I knew everything. I felt like I'd been through everything. Then I went to college, and I looked around and was like: *wow!* But then I got used to everything there, and again felt I knew everything. But, now I'm here, and it's like opening up a whole new world. I just feel like everyone has a different story. I can learn so much.

FIRST AND MIDDLE NAME: Mike

AGE: 19

BIRTHDATE: October 8, 1980

PRESENTLY LIVING IN: Oxford, Ohio

PARENTS: Barbara and George

SIBLINGS (NAMES AND AGES): None

WHAT IS YOUR ETHNIC BACKGROUND? Caucasian

NAME OF HIGH SCHOOL: Normandy High School

NAME OF COLLEGE (YEARS COMPLETED AND MAJORS)
Miami University of Ohio (one, business)

OTHER EDUCATION: No

WHERE DO YOU WORK? DESCRIBE YOUR JOB HISTORY:
I am a bouncer. During the summer I run my mom's
Mr. Hero Sub Shop. I also work part-time at
Abercrombie & Fitch. I like to keep myself busy.

WHAT IS YOUR ULTIMATE CAREER GOAL?
I would love to own business. However, if I get on
one of the shows, that goal would then change to
becoming an actor/model or VJ.

**WHAT KIND OF PRESSURE DO YOU FEEL ABOUT MAKING DECISIONS
ABOUT YOUR FUTURE? WHO'S PUTTING THAT PRESSURE ON YOU?**
My friends and family think so highly of me, I feel I
can't let them down. Getting good grades in college
is a big pressure builder.

WHAT ARTISTIC TALENTS DO YOU HAVE?
I love to dance. I have never taken any classes, but I
guarantee I can do any move. I love the reaction from
girls when they see I got skills and how I will tear
them up. Musically, I can't play an instrument. But, I
love to sing (even though my voice isn't the best!).

WHAT ABOUT YOU WILL MAKE YOU AN INTERESTING ROOMMATE?
There's never a dull moment with me. I have no
inhibitions. I'm honest and I speak my mind. I do
things that people normally wouldn't do.

HOW WOULD SOMEONE DESCRIBE YOUR BEST TRAITS?
I'm outgoing and fun to be around. I will give my
opinion on all subjects. I can talk about any subject
and not feel embarrassed. I will listen to a person
and give them my advice on the subject.

HOW WOULD SOMEONE DESCRIBE YOUR WORST TRAITS?
I'm a BIG flirt. I'm very persistent. I have to know
everything. I hate when people start a sentence, then
say "Oh, wait, never mind." I find that to be annoying
since I have to know everything.

DESCRIBE YOUR MOST EMBARRASSING MOMENT IN LIFE.
I met this gorgeous girl. She invited me to sleep over
because her parents were out of town. I was thinking
I was gonna get busy! I ate a big dinner and left to
go to her house. When I got there, I was in a cold
sweat. I was sick. I ended up puking all over her
bathroom—on the walls, floors, and just everywhere!

**DO YOU HAVE A BOYFRIEND OR GIRLFRIEND? HOW LONG HAVE YOU
BEEN TOGETHER? WHERE DO YOU SEE THE RELATIONSHIP GOING?**
I am currently playing the field. I figure I am just 20
years old and I'm not getting married until around
28. Why do I need a serious relationship now? I
should have fun. The last two relationships I had, the
girls lied and cheated and were not trustworthy at all.
That really hurt. So now I am going to have some fun.

WHAT QUALITIES DO YOU SEEK IN A MATE?
She has to be gorgeous or else I will find something
physically wrong with her. A good personality can
bring out beauty as well. She must have an awesome
personality where we can talk for hours without
getting bored. Humor is a plus. *Trustworthy.*

**HOW IMPORTANT IS SEX TO YOU? DO YOU HAVE IT ONLY WHEN
YOU'RE IN A RELATIONSHIP?**
I love sex, but I am safe about it.

DESCRIBE YOUR FANTASY DATE:
To take Britney Spears or Mandy Moore or Christina
Aguilera out to a nice dinner. Then to a romantic
spot for a walk and talk. Put a slow song on in the
car and slow-dance under the stars.

WHAT DO YOU DO FOR FUN?
I go to dance clubs all the time. They're good places
to meet people. Girls don't usually see a white boy
who can dance. I'm the type of guy who will go up
to a beautiful girl and start talking to her and get her
number. I hate when guys say "Wow, that girl is hot,"
and want to talk to her, but don't. I say "Just do it."

DO YOU PLAY ANY SPORTS? DESCRIBE YOUR ATHLETIC ABILITY.
In high school I was captain of the baseball and
cross country teams. In college, I play some
intramural sports and I am in the boxing club. I
love working out and keeping my body in shape.

DESCRIBE A TYPICAL FRIDAY OR SATURDAY NIGHT:
The other night we started with some games (beep
pong, caps, etc.). Then we hit some parties with
dancing. At about 12:30 AM, we went to a bar
uptown. Then we go to a late night somewhere.

WHAT WAS THE LAST UNUSUAL, EXCITING, OR SPONTANEOUS OUTING YOU INSTIGATED FOR YOU AND YOUR FRIENDS?

Well, since every guy is a big fan of girls making out…I always seem to persuade girls who say "We would never!" to make out. I got two girls to do it just the other night for a party.

DO YOU LIKE TRAVELING?

My friends and I go on a lot of road trips. My favorite trip was Cancún. It's one big party 24-7, how could you not have fun? Bikinis everywhere!

OTHER THAN A BOYFRIEND OR GIRLFRIEND, WHO IS THE MOST IMPORTANT PERSON IN YOUR LIFE RIGHT NOW?

My roommate Mike, because any time we need each other we are always there. He is always 100% behind me whenever I say I am going to do something. I like that I can tell him anything and he won't make me feel stupid.

WHAT ARE SOME WAYS YOU HAVE TREATED SOMEONE WHO HAS BEEN IMPORTANT TO YOU THAT YOU ARE PROUD OF?

I drove my girlfriend at the time home from school, which is eight hours away. Then two weeks later I made the same eight-hour trip for her birthday.

WHAT ARE SOME OF THE WAYS YOU HAVE TREATED SOMEONE WHO HAS BEEN IMPORTANT TO YOU THAT YOU ARE EMBARRASSED BY?

I really haven't done anything to embarrass a friend really bad. I try to live life without regrets.

DESCRIBE YOUR MOTHER:

My mom is a hard worker, but she's also big on attention with her looks.

DESCRIBE YOUR FATHER:

My dad can be argumentative and jumpy, especially with money and me. He's also very outgoing and too nice. People always want to be around him. They say I have my mom's looks and his personality, a good combination.

DESCRIBE A QUALITY OR TRAIT THAT RUNS IN YOUR FAMILY:

We are all outgoing and love being the center of attention. We all love people knowing our names and wanting to be around us.

WHAT IS THE MOST IMPORTANT ISSUE OR PROBLEM FACING YOU?

What's going to happen to me in the future? Am I going to succeed in everything I do? Will I make my parents proud? I just hope I do everything I've ever wanted to do; so that I can look back on my life and know I lived it to the fullest.

IS THERE ANY ISSUE, POLITICAL OR SOCIAL, THAT YOU'RE PASSIONATE ABOUT? HAVE YOU DONE ANYTHING ABOUT IT?

Music and dancing always put me in a good mood, which is why I'm so passionate about it.

WHO ARE YOUR HEROES AND WHY?

My Uncle Nick, because he used to be a professional boxer but got hit in the head. He suffered an aneurysm and went into a coma. He's out of the coma, but in a wheelchair. He is trying to walk again. Imagine going from being a babe magnet to a wheelchair and never losing faith in walking again!

DO YOU BELIEVE IN GOD? ARE YOU RELIGIOUS OR SPIRITUAL?

Yes, but I don't think you need to go to church for God to see you believe in him. A lot of church stuff is about money. I believe that some religions deprive people of having fun and there is no reason for it.

WHAT ARE YOUR THOUGHTS ON PEOPLE WHO HAVE A DIFFERENT SEXUAL ORIENTATION FROM YOU?

I'm straight. But, if people want to be gay, have fun! I've never known a gay person, though.

WHAT BOTHERS YOU MOST ABOUT OTHER PEOPLE?

I can't stand when people walk away from arguments. It's like they don't want to solve the problem. They get so mad that they walk away, which solves nothing. Plus, people who argue their views but don't listen to yours. That's a sign of ignorance.

HOW DO YOU HANDLE CONFLICTS? DO YOU FEEL THAT THIS APPROACH IS EFFECTIVE?

I like to talk things out. I think fighting is the worst way to solve problems.

DO YOU EVER FEEL INTIMIDATED BY OTHER PEOPLE? WHY? HOW DO YOU REACT IN THESE MOMENTS?

People who are smarter than I am intimidate me.

HAVE YOU EVER INTERVENED TO STOP AN ARGUMENT OR FIGHT? IN YOUR OPINION, WHEN DOES AN ARGUMENT ESCALATE TO THE POINT WHERE IT SHOULD BE STOPPED?

Of course, I'm a bouncer at a bar. Usually it's when people are yelling at each other and eyeing each other that I jump in and stop a fight.

IF YOU COULD CHANGE ANY ONE THING ABOUT THE WAY YOU LOOK, WHAT WOULD THAT BE?

Maybe make my skin tan year round. I am pretty confident in the way I look. If I changed something about me, I wouldn't be me anymore!

IF YOU COULD CHANGE ANY ONE THING ABOUT YOUR PERSONALITY, WHAT WOULD THAT BE?

Not a damn thing! I have a unique personality, and this isn't just coming from me. People tell me this!

WHAT IS YOUR GREATEST FEAR AND WHY?

Not making the most out of my life and looking back and regretting it. I know when I'm older I will not be able to do the things I can do now.

IF YOU HAD ALADDIN'S LAMP AND THREE WISHES, WHAT WOULD THEY BE?

1) To read people's minds because I always wonder what people are really thinking. 2) To be rich—not just with money, but with life and love. 3) To be able to stop time, because I am in no rush to get older.

CASTING PREFERENCES

READ BOOKS
For school

SLEEP 8 HOURS
6-8 usually

WATCH TELEVISION DAILY
TRL, SportsCenter

SHOP
Occasionally

GO OUT/PARTY
Yes!

SPEND TIME WITH FRIENDS
I live in a frat. Always.

SPEND TIME ALONE
When neeeded

BALANCE WORK/STUDY
All the time

TALK ON THE PHONE
Who doesn't?

COOK
When I have to

CLEAN
Very neat

WRITE E-MAIL
When I have to

READ NEWSPAPERS
Sports

PLAY WITH ANIMALS
My dog, Tasha

STATE OPINIONS
All the time

ASK OPINIONS
All the time

CONFIDE IN YOUR PARENTS
Not really

VOLUNTEER
Sometimes

PROCRASTINATE
Yes, but I get things done

EAT
Love to!

GET DRUNK
I drink socially

DIET
Never

VOTE
Yes. I need to have my say

CRY
Not really

LAUGH
All the time

INSTIGATE
I do

CINEMA
Sometimes to relax

THEATER
Never invited

CONCERTS
All the time

CLUBS
Love to dance

PARTIES
Oh yeah

SURF THE WEB
Sometimes

Nicole

I truly feel I'm a queen. I feel like my life is simple and beautiful. I see my body as a temple. That is why I don't eat meat or dairy. I feel hypocritical when I drink. I see myself as valuable, and that's why I like to decorate my body. Makeup is how I decorate my temple, you know what I'm saying. It's like a house with no paint! You want to paint the house! The house is still a house, but it needs decorations. And it helps me feel like a queen mentally and spiritually and emotionally. And I'm all those things.

FIRST AND MIDDLE NAME: Nicole

AGE: 22

BIRTHDATE: August 25, 1978

PRESENTLY LIVING IN: Atlanta, Georgia

PARENTS: Edith and Willie

SIBLINGS (NAMES AND AGES): Melissa (21), Kathi, Craig, James, Vicki, Jennifer, and Terry (not sure of ages…)

WHAT IS YOUR ETHNIC BACKGROUND?
My mother is white. My father is black.

NAME OF HIGH SCHOOL: Benson High School

NAME OF COLLEGE (YEARS COMPLETED AND MAJORS:
Morris Brown (three years), sociology major

OTHER EDUCATION: No

WHERE DO YOU WORK? DESCRIBE YOUR JOB HISTORY:
Right now I'm working at being a 4.0 student. I saved money from this summer working at a youth center.

WHAT IS YOUR ULTIMATE CAREER GOAL?
I want to work in an inner-city youth center as a youth counselor. I also want to be a wife and mother, but chances of that happening are pretty slim (at least the way things look now!).

WHAT KIND OF PRESSURE DO YOU FEEL ABOUT MAKING DECISIONS ABOUT YOUR FUTURE? WHO'S PUTTING THAT PRESSURE ON YOU?
I am the only one in my family to go to college, to not have kids, to not do drugs, to move out of state or even out of the city. My nieces look up to me as the one who holds the future. If I get pregnant or drop out, I would crush their hopes. When I make A's, it's not only for me.

WHAT ARTISTIC TALENTS DO YOU HAVE?
I am a wonderful makeup artist. I love makeup. I don't do it for money, only on myself and my friends.

WHAT ABOUT YOU WILL MAKE YOU AN INTERESTING ROOMMATE?
I'm sure people in the house will judge me when I walk in. But I'm the opposite of everything they first think I am. People will tune in every week and see a new side of me. I'm ninety people in one body.

HOW WOULD SOMEONE DESCRIBE YOUR BEST TRAITS?
"A walking nerve." I'm a sweet, good-hearted person. I'm intelligent and can break down a topic.

HOW WOULD SOMEONE DESCRIBE YOUR WORST TRAITS?
I knock on wood too much. I'm not superstitious, but I can't help it. I run my mouth way too much.

DESCRIBE YOUR MOST EMBARRASSING MOMENT IN LIFE:
I went to a BBQ with my friend Candice. It was a lot of cute New York/Boston guys. I had this cute outfit on. Well, on the train there, I started my period and had to put on a pad. The pad was so big, and the guys noticed. They were like "Yo, do Shorty got a sock in her pants?" I turned red like a bottle of ketchup.

DO YOU HAVE A BOYFRIEND OR GIRLFRIEND? HOW LONG HAVE YOU BEEN TOGETHER? WHERE DO YOU SEE THE RELATIONSHIP GOING?
No, I don't have a boyfriend, thanks for asking. I haven't had a boyfriend in three years. Man, I'm telling you! I've been looking, but I only attract guys who are 40 and up or have thirty gold teeth. I just want a cool dude who's down. But I'm destined to be lonely. I hope I can get some nice action on the show.

WHAT QUALITIES DO YOU SEEK IN A MATE?
Style sense of humor, good skin, at least one vintage jacket, a pair of boots, no white shoes, has to like hip-hop.

HOW IMPORTANT IS SEX TO YOU? DO YOU HAVE IT ONLY WHEN YOU'RE IN A RELATIONSHIP?
I think about sex maybe ninety-six times a day. The last time I had sex was October '97. Yes, that's right! It's been three years! And I'm not celibate by choice. It's by force. I love sex. I just can't find nobody to have it with. I'm telling you when I find a worthy guy I'm going to whip it on him like an Amazonian. You need to feel sorry for the next dude who gets a piece.

DESCRIBE YOUR FANTASY DATE:
Yo, my fantasy date would be with this boy named Bobby. He is so fine. He looks better than Maxwell and D'Angelo. I would show up naked to his house and we would have wild, passionate, call-the-cops-can't-find-your-panties-the-next-morning-What's-my-name-and-address?-sex.

WHAT DO YOU DO FOR FUN?
Listen to hip-hop and dream about boyz. I make up fake situations in my head and wish I had a boyfriend who loved me. I also think about sex a lot. So 98% of the time I'm either doing one of those two activities.

DO YOU PLAY ANY SPORTS? DESCRIBE YOUR ATHLETIC ABILITY.
I have to take two gym classes this year! I'm not that good, but you still can't tell me nothing. I'm competitive, so I try to beat all the people in my badminton class. But it's the twenty-first century, so who cares about badminton?

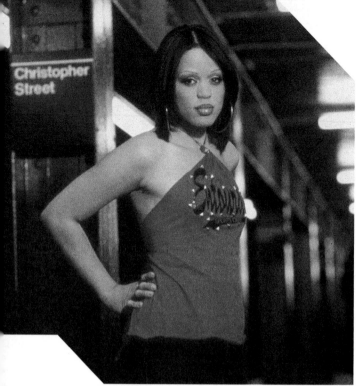

Christopher Street

DESCRIBE A TYPICAL FRIDAY OR SATURDAY NIGHT:
I'm a geek, so before I'm going to go out, I got to hit the books. So, I'll be working stilettos and fake eyelashes, reading my schoolbooks. I'll go out with my friend Candice, hit a club, dance, talk about how much we hate guys from the South, get home, and cry 'cause I'm lonely!

WHAT WAS THE LAST UNUSUAL, EXCITING, OR SPONTANEOUS OUTING *YOU* INSTIGATED FOR YOU AND YOUR FRIENDS?
Me and my friend Candice went to IHOP with a wannabe "Wu Tang"/"The Lox" group of guys. I had met them walking to class one day and was like "Can we hook up one day?" We did and it was me and my friend and three dudes on a date!

DO YOU LIKE TRAVELING?
Getting up extra early to glue on my eyelashes before a trip is not my idea of fun! I want to see D.C., Philly, and New York. I also want to see Jamaica, but I ain't Grizzly Adams, so I'm not that excited about traveling.

OTHER THAN A BOYFRIEND OR GIRLFRIEND, WHO IS THE MOST IMPORTANT PERSON IN YOUR LIFE RIGHT NOW?
I am the most important person in my life. I spend more time by myself than with anyone else. Besides me, it would have to be my nieces Mariah and Alona. They are my world and I would die for them.

WHAT ARE SOME WAYS YOU HAVE TREATED SOMEONE WHO HAS BEEN IMPORTANT TO YOU THAT YOU ARE PROUD OF?
I tell my nieces I love them and that they are sweet and beautiful.

WHAT ARE SOME OF THE WAYS YOU HAVE TREATED SOMEONE WHO HAS BEEN IMPORTANT TO YOU THAT YOU ARE EMBARRASSED BY?
My sister and I fought and fell out of touch for about three years. I missed a lot of her life. It wasn't until I got to college that I let all my baggage go and forgave her. We still aren't as close as we were, but we're taking baby steps.

DESCRIBE YOUR MOTHER:
A loving person who wanted nothing more than to be a good mother and provider for her kids, but who has sometimes let men get in the way.

DESCRIBE YOUR FATHER:
I don't know what my dad is like. I saw him for the first time last year.

DESCRIBE A QUALITY OR TRAIT THAT RUNS IN YOUR FAMILY:
We all like cottage cheese. I don't eat it anymore, because I'm a vegan.

WHAT IS THE MOST IMPORTANT ISSUE OR PROBLEM FACING YOU?
My nieces! I don't want my nieces to live through what my sister and I went through.

IS THERE ANY ISSUE, POLITICAL OR SOCIAL, THAT YOU'RE PASSIONATE ABOUT? HAVE YOU DONE ANYTHING ABOUT IT?
I'm passionate about kids. I'm also passionate about the Black community and the issues that face them.

WHO ARE YOUR HEROES AND WHY?
Oprah Winfrey. She was poor and Black and people told her she couldn't do it. People told me I was poor and dirty. I love proving them wrong!

DO YOU BELIEVE IN GOD? ARE YOU RELIGIOUS OR SPIRITUAL?
I don't believe in religion. I live by the rules of karma. Everything I do on a daily basis is regulated by karma.

WHAT ARE YOUR THOUGHTS ON PEOPLE WHO HAVE A DIFFERENT SEXUAL ORIENTATION FROM YOU?
I love the opposite sex. I love men. I can see why men love men. Men are sexy. I don't judge people. That's not my place.

DO YOU HAVE ANY HABITS WE SHOULD KNOW ABOUT?
I'm a vegan.

WHAT BOTHERS YOU MOST ABOUT OTHER PEOPLE?
When people judge others! I can't stand that. People see me and think, "Oh, she's a dumb party girl who wears makeup and sleeps around." Then they find

CASTING

READ BOOKS
Especially a good sex book!

SLEEP 8 HOURS
On a dream day

WATCH TELEVISION DAILY
Matlock, Blind Date, The X–Files

SHOP
Love clothes, but I'm poor

GO OUT/PARTY
Love good music and people

SPEND TIME WITH FRIENDS
Friends=family

SPEND TIME ALONE
My diary and a candle

BALANCE WORK/STUDY
Study is my top priority.

TALK ON THE PHONE
Yes lots

COOK
Laugh

CLEAN
I keep my space clean

WRITE E-MAIL
Write letters

READ NEWSPAPERS
Sports, job listings, coupons

PLAY WITH ANIMALS
I love cats

STATE OPINIONS
Yes. All need to be heard.

ASK OPINIONS
Not if I don't want to know.

CONFIDE IN YOUR PARENTS
Mom barely knows what college I go to.

VOLUNTEER
Don't talk. Help.

PROCRASTINATE
Better under pressure

EAT
I'm a picky vegan

GET DRUNK
Twice ever

DIET
Maintenance, not diet

VOTE
A must

CRY
Every week

LAUGH
Louder than anyone

INSTIGATE
Only if necessary. Wink!

CINEMA
Samuel L. Jackson, Spike Lee

THEATER
School plays are the stuff

CONCERTS
Often

CLUBS
With a college crowd

PARTIES
Often

SURF THE WEB
Too confusing

out that I have a 4.0 grade-point average, that I can school them on topics, that I have only had one partner sexually, that I study every night.

HOW DO YOU HANDLE CONFLICTS? DO YOU FEEL THAT THIS APPROACH IS EFFECTIVE?
I enjoy getting my point across. I listen as well as I talk. If conflict does arise, I will not use violence.

DO YOU EVER FEEL INTIMIDATED BY OTHER PEOPLE? WHY? HOW DO YOU REACT IN THESE MOMENTS?
I feel intimidated by males. It's getting better as I get older. In five years I will not be intimidated by males. That's a goal.

HAVE YOU EVER INTERVENED TO STOP AN ARGUMENT OR FIGHT? IN YOUR OPINION, WHEN DOES AN ARGUMENT ESCALATE TO THE POINT WHERE IT SHOULD BE STOPPED?
I stop fights whenever I see them. I'm a nonviolent chick, so if someone disrespects someone else's space, I will try to break it up. If I ever see a man hit a woman, that's it. I don't play mad.

IF YOU COULD CHANGE ANY ONE THING ABOUT THE WAY YOU LOOK, WHAT WOULD THAT BE?
Um, everything. First, my hair. Right now I'm growing out my perm (which for Black girls is a spiritual journey). So half my hair is perm, the other hair is new growth. And I want breasts! I'm an A cup if even that! I work with what I've got. I draw and color and glue. Go, Miracle bra!

IF YOU COULD CHANGE ANY ONE THING ABOUT YOUR PERSONALITY, WHAT WOULD THAT BE?
I love my personality. I'm the most loving, nicest person you'll ever meet. Honestly. If I could change anything, I'd be less of a pessimist and more positive.

WHAT IS YOUR GREATEST FEAR AND WHY?
My greatest fear is that I will never be happy. That I will never get married to a man I'm in love with.

IF YOU HAD ALADDIN'S LAMP AND THREE WISHES, WHAT WOULD THEY BE?
1) For this boy Bobby to fall deeply in love with me. 2) To be happy the rest of my life. 3) For no kids to have to suffer.

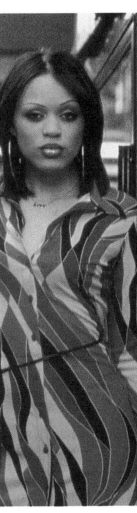

new orleans

When the cameras turned off, it got more personal. Those cameras always negate any real exchange. You always know what's being said is going out to the masses.

—Jamie

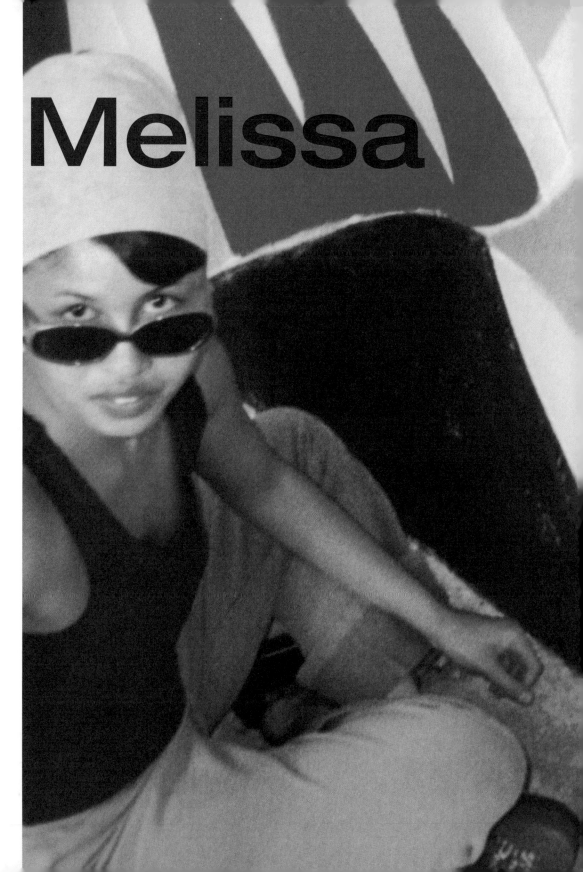

Melissa

I was all excited after I did *The Real World*. At the wrap party, we watched the show and I thought my character seemed cute! I was into it. But as I watched more episodes, I realized it was worse than I thought it was going to be.

There wasn't a lot of face-to-face-I'm-going-to-tell-you-how-I-feel-about-you in the house. No one was very up-front when we were together. But people were saying what they really thought in interviews. We would say stuff to the camera, go back home, and act like we never said it. I had no idea what people thought of me. To my face, they'd be *Goo-goo-ga-ga, Melissa you're so great and funny*. Who knew? It wasn't until I watched the show that I found out what people really felt.

I had my roommates on speed dial so I could call them up and ask them just what the hell they were talking about. In particular, I was really hurt by the episode about my father. My dad is my life. So it really hurt to see my close friend Jamie in a room talking to a camera about how my relationship with my dad was whack. I thought, *Who fed you that line?* Call me whatever you want, but don't talk about my dad. My dad was probably thinking I'd told Jamie that bad stuff! When we were living in the house, we didn't realize that we were narrating each other's stories.

I felt really alone after the show—especially when the book came out. I read last year's book and felt like I was blamed for a lot of stuff, all because I wanted to be famous. Matt would accuse me of wanting to be famous, and in the same breath say he was talking about deep stuff to get airtime. And David, you know, he thought that I was trying to become a star from the show, but I wasn't the one at my keyboard pretending to make rap videos every day! They had so much resentment toward me.

Time is the only thing that fixes everything. Take me and Kelley as an example. Our friendship is at this new blossoming point now. After the show there were a lot of rough conversations, a lot of "Girl, you said that about me, I said that about you." What can you do? We were on a show about not

getting along. The truth is, it's fine to be with the rest of my cast now. We don't have the Hawaii problem. Don't get me wrong—we're not like peas in a pod. But we're happy to see each other when we do.

Of all my cast mates, Jamie's the one who's been affected the least. He's so sincere. He's the only one who's totally unfazed. Not that he's indifferent, he's just OK with it. Jamie and I, we admire each other. Jamie is one of the top customers on my Web site. I still love seeing Danny and Julie. Matt I see, but we don't connect. When I see Matt, it's hey, how are you, whatever. It's no big thing. David, I don't deal with that. I don't need that negative baggage. I don't even have his phone number or e-mail address. He's a faded memory in my life and I don't care.

Kelley and Danny are lucky to be with people who knew them during the show. In the back of my mind, I think that everyone who wants to date me does so 'cause I was on *The Real World*. I went on date with a gay guy, thinking it was about me, and we sat down and he was like, "Tell me about Danny."

Yes, I am still boy-crazy. And, hell yeah, *The Real World* jacks up your love life. I have dated so much since the show. There have been a lot of fleeting relationships. Let me tell you, though, I'm so anti-commitment. I started dating somebody and we started calling each other boyfriend and girlfriend. I was like, Whoa! I can't do this! Hell no! There are just too many cute boys in L.A.

One of the greatest things to come from *The Real World* was my art. After the show, Lionel told me he believed in me as an artist with or without *The Real World*. He thought I could make a living from it. I was like, right! I grew up in a working-class home. I was sure I was always gonna have a boss. But Lionel helped me. And together we built a Web site, princessmelissa.com, with an art store. I run the site from my apartment in Los Angeles (that's where I moved after the show, by the way). The response to the site has been incredible.

At first, my workday would be like fourteen hours. I'd fill twenty-five orders in a good day, and some people would order every piece of my art. The whole apartment would be covered in packing materials! After I while, I realized I needed help. I found a distributor who deals with the credit card payments and sends out the artwork for me. It was the distributor's idea that I make my art into T-shirts. All of a sudden I was like, Oh my God, I have a legitimate business! I'm so happy that business is taking off, because it makes me feel *The Real World* wasn't in vain.

And I'm still painting. I paint furniture now. My kitchen table is sick! I painted 675 ladybugs. My arm hurt so bad. I love to take Ikea furniture and just paint it. I'm also working on a children's picture book, and I'd really love to paint children's rooms. Lots of moms love my work.

After the show, one of the first jobs I had was being a production assistant on the Jamie Foxx show. I was with comedians every day and they were telling me I should be a stand-up. I did the Groundlings, which is improv sketch comedy. I realized I don't do well interacting with other people's funniness. I realized I was better suited for stand-up. I took a class at the Improv. I'm not a joke teller, but I learned the techniques of delivery. I'm more of a storyteller. I've opened for Arsenio Hall three times now. He's really nice guy. Stand-up doesn't pay yet. I guess you know it's a passion when you don't get paid.

I love it when people come up to me and talk about my stand-up—much more than when they come up to me and call me the person otherwise known as *Real World* Melissa. *Real World* Melissa and I are the same person, but I've mellowed out a lot. I'm a homebody now. I light candles and listen to music and do my business. I'm not extrovert-at-a-bar-stripping-on-a-table Melissa. OK, I'm not a librarian, but I'm content with doing nothing. Back in the day, I was restless. I'm in my prime, but I'm sitting at home renting movies. I don't even drink anymore! I've got a life.

braces

My whole life, I wanted braces. My parents couldn't afford them. I used my *Real World* money to get braces. People were like, "Oh, were you self-conscious about how you looked on TV? That's why you got them?" No, I got them because I've always wanted them! I love them. I even go into an online chat room called "Adults with Braces."

FAVORITE MOMENT

Moving out! Just kidding. I have a few. My gallery opening, the stripper falling after she shifted all the weight of her weave onto one side trying to be sexy, and being honest about my feelings about David. After throwing chairs and announcing my disgust with him, a whole load of bricks was lifted off my shoulders. I am one of those brutally honest people that loses sleep over *not* expressing my true feelings.

LEAST FAVORITE MOMENT

The swamp boat. The whole nature aspect of it was already bad, but to throw in racist remarks—goodness, give me a break.

FASHION DISASTER

That ugly cream-colored sweater with the stripes that all the girls rotated. It was stolen from NOATV.

SOMEONE ELSE'S FASHION DISASTER

When Jamie wore one of Matt's loud floral shirts in an interview. I was cracking up!

FUNNIEST MOMENT

OK, it didn't end up on the show, but: My dad discovering that Julie had quite a full butt and saying he was going to call her "fine Mormosita…"

HOUSE OF SHAME

Bitching about the best (and most free) trip in the world.

I WISH THEY'D SHOWN

My parents' visit. So many people come up to me saying they saw the *Real World You Never Saw* video and loved Shorty and Mercy.

Jamie

My life has been really incredible. Karmically, I've really come into my own. Possibly because of the five-month Freudian therapy session that was my stay in the Belfort. But who knows?

It's really been a crazy year living in San Francisco. I've watched the rise and fall of the dot-com business. I really feel like I've been a part of history, watching massive scalable businesses crumble. I've witnessed this really crazy exodus out of Silicon Valley.

For my company, Soulgear, it's been a crazy run, teetering on the edge of success. It's been such a learning experience. Our company is going to stick around, but it's been rough. We needed to get back to the fundamentals of business—meaning you have to make more than you spend. Revolutionary concept, huh? Well, it's one that was thrown out during the Internet boom. We've switched our priorities around. For so many months, we were gunning to get funding. The reality of it was that had we gotten that funding, we would have burned through it on big offices. So it's OK.

I've learned not to process anything in life as good or bad or success or failure. It all just is. I'm learning a lot about witnessing the evolution of life from a place of choiceless awareness, of nonjudgment. I try to embrace everything that comes into form or fruition for what it is. That may sound really Buddhist, because it is.

With *The Real World,* I was so fearful of migrating to the shallow end, of falling prey to really silly ego stuff—wanting celebrity appeal and having the need to uphold an image. That stuff is limiting and shallow and the path to a really bad place. The best and most timely thing that happened to me after the show was falling in love with my girl-friend, Elizabeth. She's so pumped on life and love. She's in graduate school in Boulder, Colorado. We're doing the long-distance thing.

When you feel the immensity of love, you release yourself to it. Elizabeth provided me with a gateway of love and it was freaking mystical. I realized what was important. Now I can go to L.A. and party with all these peeps. It's fun, but it's a game and I see it as that.

I don't think anybody in our cast has fallen prey to all that. I was really happy talking to Danny. He's going into sports medicine and thought the *Dawson's Creek* thing he did was crap. He was being tantalized from all different sides, and he recognized it for what it was.

Things have been better with our cast after the show. After the cameras went off and we reoriented ourselves to our lives, I think people were able to own up to certain things. It got more personal. Those cameras always negate any real exchange. You always know what's being said is going out to the masses. Personally, I really am copacetic and kosher with my ex-room-mates. It did take a few conversations to get to that point. I think Kelley and I have really owned up to a lot.

I personally had a great time on the Challenge. Julie and I lived a good portion of a year together. Initially, when the filming started, I was the one person with whom she could be open and honest. And then, well, we did have it out a couple of times. Julie was going through so much at that time. She was a crazy volcano of emotions that would spew over at any time or any place. At the

time, she felt I was not being compassionate, but compassion does not always equal a shoulder to cry on. I wanted her to recognize that everything was going to be all right, that whatever she was going through with school and her parents would be OK. Julie's got a wonderful heart and it pains me to see how guilty she feels a lot of the time. I never wanted to be a mentor to Julie, but I do think there was some mentoring going on there. There was definitely a reciprocal student-teacher/teacher-student thing happening.

I definitely think *The Real World* has opened up some doors for me to show my talents. This year I created an adventure racing team. We do grueling races through hundreds of kilometers of terrain: kayaking, spelunking, canyoning, mountain biking, navigation orientation. We've gotten sponsored by some companies to do races in Brazil, Switzerland, and Vietnam. I'm participating in these events. It's very masochistic and grueling. But it's a massive test of my limits. I know humans are so much more than their physical, emotional, and mental limits. Doing these races, you surrender your body to so much abuse. It's a very *Survivor*-esque thing. It involves a lot of sleep deprivation, and when you can't sleep, things begin to surface: jealousy, impatience. It can be enlightening when your physical body is all f**ked up and you're at your weakest emotionally. It's a spiritual journey.

Maybe a few years out, I'd like to produce documentaries about expeditions or destination travel. I want to shoot crazy-a** off-the-wall expeditions. There are all these expedition film festivals I could participate in. It's an interesting blend of everything I enjoy.

The Real World was a great gig, but I'm trying to transcend it. My dad lived vicariously through me on the show. He got so happy and excited seeing

me bungee-jump off Victoria Falls. My mom also became a huge fan. She's the one who told me what was happening on it. I didn't feel the need to see it. I just didn't like watching myself. I didn't like the way I came off. In all my heart, with all my conviction, I have to say that I am not and was not racist and homophobic. I really feel that's how it seemed. I was the token white guy from an affluent suburb. A girl came up to me on the street and was like, "Oh, so you're the racist one?" People think that all I am is a hetero Republican big bad white man. It's just frustrating.

FAVORITE MOMENT

Well, I don't have any favorite moments from what aired, but I do have a favorite moment from being in New Orleans. It was when my dad visited. We went to this awesome gospel church in a black area. My dad has no rhythm and he's totally Catholic, but he was jamming out! It brought tears to my eyes. It was so beautiful.

LEAST FAVORITE MOMENT

I didn't care for the Kameelah Chaka-Zulu moment. Although I will say, after shooting the Challenge with Kameelah, she does have the warrior heart in her. We were awesome on the show together. We got past that initial stuff within the first few days.

FASHION DISASTER

My hair sometimes in my interviews. I don't know what I was thinking when I went into interviews like that. I was bad hair and zits. I guess I got complacent.

HOUSE OF SHAME

I regret not being more focused and mindful about my NOATV producer gig. I'm not a total idiot when it comes to creating things. I just didn't put any real effort into that.

FUNNIEST MOMENT

The house was a really funny place a lot of the time. It was hilarious, and none of that really got aired. But Elizabeth found the Challenge pretty funny. She laughed when I got body-slammed by James. He dominated my scene in the mud wrestling. That's the cool aspect of filming something like that—the ego building and ego smashing.

Julie

I'm really content. My life is very much where I want it to be. For the first time I feel complete liberation—socially, religiously, economically. It's a good feeling.

When we finished filming the Challenge, we all came back to Los Angeles. Production had gotten me a plane ticket home. I was standing there with a plane ticket to Wisconsin in my hand, and all of a sudden I thought to myself: Why am I going home? I decided to stay around for a while.

So what did I do? I got an apartment in Los Angeles near Melissa. Well, I liked being close to her, but I didn't like the city at all. Everyone was so fake, and the traffic.... I'd always dreamed of living in Southern California, but it wasn't what I'd imagined it would be. Really, I was having a hard time coping. Long story short, I was ready just to get out of town when I found out about Huntington Beach, which is about an hour south of L.A. It's a beautiful little community where people know each other. It's slower and not so crazy. I thought it was perfect. At the time, there was a lot of excitement in my life, and being somewhere that's chill was good for me. It still is.

Life after *The Real World* has been hectic. That's because I know this notoriety thing isn't going to last, and I take every speaking engagement, every gig I can—even if it means I'm on a plane once a week. It's better than having a nine-to-five.

I do college lectures; I do abstinence and antismoking campaigns; and I host a show on the Discovery Channel. The show is called *Electric Playground*. It's about video games and technology. I'm just a nerd. It's my fantasy to get paid to play and review video games!

It's so cool to work really hard on something you are proud of every week. I was in *The Real World* but I didn't work on it. I'm putting hard work into *Electric Playground*. I'm just proud of it. I love when it airs! I interview celebrities about video games. It's great to be on the flip side of the interview process. I did an interview with Richard Hatch from *Survivor* about the video game Quake. He recognized me from the show. I feel an immediate bond with people who've been on reality shows. It's like we're all in the club; we *know*.

If I got anything from being on *The Real World*, it's courage: courage to do what I want, to look at myself and the ugly things about myself and start dealing with them. Oh, and I think I got one more thing: a really deep appreciation for my family. I treated them like a** on the show. I epitomized the angry teenager. I made my parents look bad on national TV. That's the worst thing anybody can do. My parents have been nothing but supportive, and maybe I disagree with them on some issues, but does that mean I have to go on TV and have the world rally behind me?

I was a bad daughter last year and I will spend the rest of my life trying to make up for it. My parents think I was going through a phase, but I don't think there's any excuse for what I did. I apologize to them each and every day.

People tell me they respect how I was to my father, how they think he was out of line. When I hear that, it makes me cry. You should never yell at your parents. I'm so ashamed that I brought my family into the show at all. I think our relationship might be stronger as a result of it, but it brought so much hardship into my life.

I've lost so many friends because of the show. My best childhood friend, Joy, we don't even talk anymore. She visited me in New Orleans and found the whole thing creepy. And then I was freaking out after the show. If I hadn't gone on the show, we'd still be friends. I would take back the show to have that relationship back, to have my parents back.

Religiously, where am I? At the same place I've always been. I still go to Mormon church. I've got a cool ward right now. I've made a really good friend, Marissa, through church. She and I started a band together called Cherry Bomb Threat. It's punk rock. She sings and I play drums.

Yeah, the guitar thing was ruined for me from watching the show. I needed to get my aggression out, so I took up the drums. The band gives me a sense of family—something to wake up for. My drum set is in my room, so I literally wake up to it. It gives me energy for living. I love when people come up to me and talk to me about drumming. Actually, I love it when people come up to me and talk about anything but *The Real World*.

I'm still really good friends with Melissa. We hang out a lot. I don't really talk to the rest of my cast anymore. Every time we get together, it's like *Twin Peaks,* and I get a sick feeling in the pit of my stomach.

Kelley and I got into a little fight about something—no big drama, but we haven't spoken for a bit. I really like Kelley. I think she's one of the most logical, perceptive people I've ever met. I know we'll talk eventually, even though we're not in touch at the moment.

Matt? I don't know what his deal is, but he's changed about 180 degrees. He loves the fame. He truly loves it. He dresses so friggin' rock star, it's ridiculous. He talks like he's Woodrow Wilson, like the world should stop when his mouth opens. When we do lectures and we walk around the campus, his eyes comb the crowds looking to see if people recognize him. He's obsessed with it all.

And David, he's totally using *The Real World* to help his music career. I'd rather be playing in a little dirty dive club in nowheresville than have a CD in stores across the country that capitalizes on my *Real World* fame. When he goes to lectures, he brings a posse with him. It's humiliating for all of us.

The truth is we're all a little bit wacko right now. Jamie's on this spiritual quest for monkhood. He's always going into the desert and running around naked. Melissa and I, we've had a lot of hardships from the show. Everyone's got issues—that is, everyone except Danny. He is the same coming out as he was going in. When I want to stabilize myself, I call Danny. He's the most wonderful example of a human being. He's so sensible.

I'm happy now, but I'm not about being famous for the rest of my life. I plan on going back to school in San Diego. It's an hour away from where I am, and I love it there. The people are so chill. The kids are so cute. It's like paradise to me. I think I've always been meant to live in California. When I get off the plane, even if I'm at LAX, I step outside and breathe in the air. And I'm happy. It just smells right to me.

FAVORITE MOMENT
Danny, Melissa, and Kelley are standing on the porch looking like they're on a fashion magazine shoot. I go skateboarding by in a bright blue shirt and a red wig, and all of a sudden you hear this huge crash. I love that.

LEAST FAVORITE MOMENT
The fight with my dad and the fabricated kiss with Matt in the airport. I think both of us were wrapped up in what we thought our story line was going to be. That was an example of us acting for the cameras. We've both admitted it.

FUNNIEST MOMENT
When my brothers came to visit and they asked Danny who the gay one was and he said, "Well, I thought it was Matt."

FASHION DISASTER
Um, me—every day. I put so much time into packing my clothes for the show. I looked ridiculous. I didn't even brush my hair. I've changed my fashion a little. I'm a little more punk rock. I wear more black and wristbands and studded stuff and I'm not a blonde anymore. I watched myself dress like a 12-year-old girl for four months. "OK," I told myself, "it's time to go shopping."

HOUSE OF SHAME
How I acted with my parents. If there's anything I want readers to learn from me, it's this: don't be a stupid punk kid. Friends come and go. TV shows come and go. But blood is forever. It's a cliché, but I learned it the hard way.

Danny

Yes, I went through a period when I was really sick of *The Real World*. I bitched about the experience and the inconveniences it adds to your life. But, in the end, I can't say I'm not lucky. Life's been really good. I've been really fortunate.

After the show, I tried out the acting thing. It just wasn't me. I'm not an actor, and I just didn't feel comfortable with it. It was not what I wanted. I just didn't get into it. I did the gig on *Dawson's Creek* to get the experience, to meet real TV stars, and see the whole process—not many people get to see that. Going out to Los Angeles and going to movie premieres made me feel blessed. I also signed with a modeling agency in New York. That's also not a career I'd want, although it's definitely been nice financially. I did a Nautica runway show and a Gap.com shoot.

Really, the best thing has been doing the college speaking tours. I used to have this nightmarish fear of speaking in front of crowds, and now I've completely overcome it. I've gotten to travel far and wide. It's great. It does, of course, bring up some issues. One night I was speaking at Johns Hopkins, and this kid asked me, "How do you feel now that you've created the Danny type?" I was like, "What does that mean? The Danny type?"

He said, "You know, there's the *flaming type* and there's the *Danny* type which is the straight type. I could feel the heat blazing up my back. Because of the show, I'm a role model who's supposed to know what to say to something like that. In the beginning, I'd stress out when I said the wrong thing, feeling like I let the gay public down. I have to remind myself that I can't please every single person. I'd love to, but it's too much pressure.

One thing that's been really hard to deal with has been people's disappointment in me and Paul for not being advocates against the military. They don't understand. Paul's stance is that the military is not naturally bigoted. They don't necessarily want to keep gays out. But they can't let them in, because there's too much homophobia in the system. It would be dangerous. You can't just open the door and let gays in like that. It would be a disaster. People need to be patient. Our society needs to change before the military can.

The Real World has really affected my relationship with Paul. It's kind of weird having to live such a secretive existence. It's something out of a spy novel or something, it's weird. Where we live, people who work with Paul could see us. So, we have little contact with people. It can make us feel trapped.

Because I am recognized so often, we can't go to the grocery store together. If we go to movies, we buy tickets separately and sit apart. If we go to bars, we go to places where everyone's 50 and up. There's a lot of stress about what *could* happen. Sometimes, we worry about it too much. And then we pull back and check ourselves.

The good thing is that Paul's about to get out of the military, and we're starting over fresh. It's a whole new chapter of the book. We'll have a much easier life. We've made some major plans together, the main one being we're moving to the West Coast. Are we going to get married? Well, we have a weird thing about the use of the word "married." It's a word that's so old-school, and legally, for us, it's not possible. But we're bound to each other. We think about having a commitment ceremony. We want to pack up all our best friends and jet out to some remote place and have music and a really spiritual commitment ceremony.

Watching the show wore on Paul, understandably. And as the weeks went on, I got more and more annoyed by it. I got so sick of myself. It was like over and over again, I was saying, "Boo hoo, I'm in a relationship, but I feel weak." I was screaming at the television set, "Oh, get over it." Definitely, the show made for a stressful summer. But we got through it.

Our cast all gets along in a different way now. In the last book, I said some ridiculously awful things about Jamie. After the show aired, we started talking and I started to know him more. Now he's one of my favorite roommates. I think I feel like we're on the same level now. I did not expect that. Paul and I have been back to New Orleans to visit Kelley and Peter. And I love seeing Melissa. She cracks me up. Matt and David, I talk to probably the least.

In the fall, I'm going back to school for sports medicine therapy and massage therapy. I'm pretty psyched. It's something I thought about before the show started and now I'm going to continue. My goal is to have my own studio. And I'll keep up my Web site, countryto-concrete.com. Initially, it was a personal Web site, but now it's a gay community site. There are all these gay kids from 14 and up talking to each other about being in the closet. Older kids help them out. Oh, and I have guys meeting and hooking up on there. It's pretty funny.

The Real World has been awesome with my family. My parents really got to know me through the show. I think they realize they missed out on a lot. I think they want to make up for what's been lost. We talk so much more now. I talk to them on a real adult level, not a half-a** kind of way. The show changed everything for us. If you lie to your parents about something major like being gay, then it means the big picture is all a lie and everything you say has to fit into this big lie. It's a huge relief to be beyond that.

FAVORITE MOMENT

When I got the hell out! No, I'm kidding. OK, well, any point when we were in South Africa. That was incredible.

LEAST FAVORITE MOMENT

Creeping in the closet. I wish that moment could have been edited out.

WISH THEY'D SHOWN

I wish they'd put in my trip to Florida with Kelley, when we went streaking through the lobby in the middle of the night. The cops came and kicked us out.

HOUSE OF SHAME

That time I got pissed at David early on in the show about work. I don't even know why I cared. Being on camera can make you go off in ways you wouldn't normally.

FASHION DISASTER

Oh come on, the gray sweater. I'm so embarrassed about how much I wore that. Oh, and walking around with my hair looking like a rooster. I was too lazy to get up and get out of the house and go anywhere. I was such a sloth. And having a bunch of other sloths around me didn't help much.

SOMEONE ELSE'S FASHION DISASTER

Matt wearing a bunch of jacked-up crap. Just joking. There were also moments when I wondered what Julie was doing.

FUNNIEST MOMENT

Definitely the funniest moment of the show was when David had that stripper show and that poor girl slipped on her heel.

David

I don't have any regrets on how I acted on *The Real World*. I have none. I don't question things that I said. Everything happens for a reason. It's a card game, and you either fold or play your hand. Life dealt me some cards, and yeah, sometimes I act like an a**, but that's all part of it. I'm gonna win the game.

But, yeah, I think I've grown in many ways. Financially, everything's been a lot better. I think I also listen a lot more. I think I'm still strong-willed, but not as closed off to ideas. I'm very passionate about where I want to be, but I'm at the start gate and I recognize that. I've got my ears open. I'm focused, but I'm no longer so isolated. I take advice. I realize people have stuff to say to me.

I ended up signing with a manager I'd known for a long time. Actually, I've got a whole team of people around me. We decided to do the album first before we sign with a record company. Independent investors have put money into me. I've got the top producers. When we finally shop this album around, labels are going to have no choice but to drop mad cash.

Of course, people have their opinions. People ask what's up with me and Melissa. A couple of people actually asked if we were married now. A rumor that Melissa and I are married! Take that for what it's worth.

People on the street or in the mall, people who recognize me, they usually give me a good response. The first question is usually "How's your mom?" The second is: "When's your album coming out?"

Usually people come up to me and tell me how they loved it when I sang the anthem and when I played piano. They tell me I tore it up on the show. My manager and I were walking around a college campus, and this mob of people came up to us. They said, "Dave, you're a musical genius." Musical genius? My manager and I sat around marinating with that. We were dumbfounded.

Yeah, I'm just a *Real World*–er, but I've taken this thing to a whole other level. I've got real dough on my side. I don't go anywhere without my personal manager. I always have security. My manager insists I have it. It's not that I'm prone to fights, it's just a way of protecting the investment.

Our first single is called "La Fiesta." It's a bangin' track, but of course I'm biased. It's a dance joint with a little Spanish vibe. There are three record labels already interested. I can't name names, of course. Yeah, the single will sell cause I'm Dave from *The Real World,* but it'll also sell 'cause it's a hot single.

A couple months after the show, I performed the national anthem for the Tampa Bay Buccaneers. There were a couple of record labels in the stadium who came to talk to me after. People were calling me and things began to heat up.

Yes, people come up to me and ask me to sing the *squee-dabble* song or "Come On Be My Baby Tonight." As a matter of fact, it's gonna be on the album—just as an interlude, for the real listeners, the true fans.

It's a very tiring situation, recording and doing all my work. Is my mom into it? Well, yes, but she

feels my exhaustion. I'm still helping her out finan-cially. Everything I do has to go back to her. I send my money home quick, fast, and in a hurry. For my mom, seeing the show has been pretty good. Everybody approaches her in Chicago, all these strangers. At first she was freaked out by strangers coming up to her, but it's all compliments.

The response to my mother has been all good. I've gotten e-mails from mothers who say they hope their sons are as strong and caring for them as I am. Girls come up to me and call me a little player. Then they tell me they love the way I feel about my mother.

With the ladies, it's been interesting. I've had to learn a lot of things where ladies and women are concerned. It's great and lovely to have beautiful women coming up to me all the time, but I've been forced to grow up. I think there was a sense of immaturity to me when I was on the show. I was being me and having a good time, but I was kind of having Spring Break syndrome in the sense that I had no inhibitions. I don't regret the good times, but I learned that going from girl to girl is not exactly the best thing.

Now I have to look out for myself, protect myself. My producers tell me I have to be careful, that girls' motivations may not be so great. So I'm more selective now. Another thing I learned is that I can't be there for someone now, and it's really hard for people to understand that. My life is the studio and the gym and whatever gig I've got to do. I'm just focused, that's all.

Right now I'm not a celebrity. I've got notoriety but I'm not a celebrity. A celebrity is somebody who's famous for his profession, for what he wants to do. That's not me yet. But it will be. I do plan on going back to school. And I'm writing an opera. And I'm still working out. I'm gaining weight. Right now I'm 201 pounds, but I want to be 230 by winter. I definitely want to tip the scales. I think 230 would be hot.

I didn't watch the show. I figured since everyone and their cousin comes up to me on the street and gives me a recap, I didn't need to watch the show. I did watch the anthem show because of my mom, and yes, I cried. And, yeah, I saw the hot tub episode. I think it's been much better with my cast after the show. We're a family. When we see each other, it's a genuinely good time. I think we'll stay cool together.

crush

I've met a lot of ex-cast members. You know who I want to meet but haven't? Kaia! Girl, I love me some Kaia. I talked to her on the phone. Physically, aesthetically, to me, she's gorgeous. She's intelligent. She's very articulate. She makes for a great conversation. I don't know if she digs the buffed out R&B style/neo-soul guy, but I'd like to go to lunch with her. She's hot to me.

FAVORITE MOMENT

I personally love the hot tub thing. And I love the fashion thing.

LEAST FAVORITE MOMENT

There were some times I was like, *Ooh, ouch.* Sometimes I just didn't look right. There's one scene where Melissa's talking to me, and my shirt was inside out, my dew rag was off. That fifteen-second shot lasted forever for me.

FASHION DISASTER

I looked jacked-up for the whole show, and I'm OK with it. People are always asking me about the dew rags. People come up to me and say: "Dude, we watched that dew rag to death!" Oh man, I should have gotten more haircuts on the show, but I couldn't pay the fifteen bones for a cut. Other than that, I'm not a catwalk guy, so I liked how I looked. I rocked those tank tops. I always look like a scrub.

BIGGEST SHOCK

Watching it, nothing shocked me. Words are words. You brace yourself for the worst, but even if I had negative comments coming at me 24/7, I'm strong people.

FUNNIEST MOMENT

Probably during the fashion show, when the home-girl fell.

HOUSE OF SHAME

I don't regret anything.

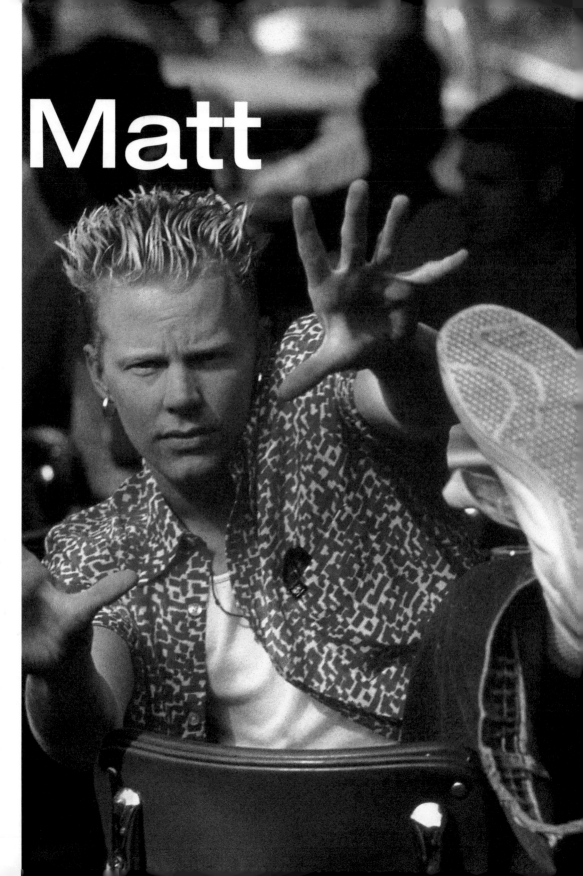

Matt

A year does a lot to smooth out some rough spots—both personally and with my cast. We've all worked hard at being friends, and I'm happy when I see them. That said, it's becoming more and more obvious that what we have in common is our *Real World* experience. We have this bond because we lived together, but we're very different people. I think there will always be an awkwardness and guilt surrounding our interactions. The things we said about each other during interviews can be haunting.

It's funny, the cast experiences something akin to sibling rivalry. There's all this competition: Who can be the most successful? Who can get the most press? It's hard to judge who's done the best, since we all have different goals. I mean, as far as happiness is concerned, I think I'm really really happy. I know Jamie's really happy, but I don't know about anyone else.

I actually went back to New Orleans to speak at a retreat at a monastery. I went back to the house. I thought it'd be slightly emotional, like going back to your old high school or dorm room. But I really felt nothing. The Belfort's all different looking. The grass is torn up. The sign is off. But the way the gate clanged, and the sound of the trolley...it all brought me back.

Have I changed? With time and each and every experience, I change. I'm still the same Matt. But when you go through something as textured as living in the *Real World* house, you can't help but change. I know the seven of us have all done a lot of thinking over the past year. Probably Melissa and Julie have to do the most thinking; they were on-air the most. They have to deal with the public knowing so much about them. They're called out on everything they do.

I'm happy with how I came off on the show. I poured myself into the experience emotionally and spiritually. I do feel somewhat betrayed that *all* of me wasn't shown. I don't think they really showed my spirituality and my creativity. But it's not like I roll around in bed every night worrying about it. One out of 220 minutes of our lives gets on TV.

After the show, I got back into my church, relaunched my Web site, and went back to being a student. When I'm in Atlanta, I do nothing but schoolwork and my Web site. And when I'm not working, I get on a plane and do talks. The way I see it, you gotta strike when the iron is hot. We have to capitalize on our fifteen minutes. One of the greatest things about the show is to be famous. I want to spread my word, and use my fame to a good regard.

Being famous changes everything. It's funny when I walk into a mall or anywhere kids are. Anybody there could know about my personal life! I've gotten to meet people I'd never get to meet before. Random people come and talk to me. A lot of people know who I am. It's like being the popular guy at a big school.

But as a whole, fame is not going to redirect my life. It's brought new insight and opportunity but fifteen years down the road, I'm not going to relish being Matt from *The Real World*. At least I hope not.

After I graduate, I'm moving to Arizona to become the webmaster for Lifeteen.com. I'll be providing literary and graphic content for the site. I'll also be the media consultant. I'm buying a motorcycle and I'm going to explore the Southwest and the West Coast on my bike.

Actually, I'm the national spokesperson for Life Teen, which is an international Catholic youth ministry. I speak at teen centers, high schools, universities. My message is that we have to trust our creator and seek God's will; when we do that, we'll experience the great adventure of life. When I introduced prayer and meditation into my life, the world opened up to me. And it's been pretty darn cool.

How did my family react to *The Real World*? They enjoyed the show. They had a lot of fun with it. They never had to walk around the grocery store with their heads down. I don't either.

I walk with my head high. I came out smelling like roses. I don't know exactly how my roommates feel, but I know every time Julie goes out in public, there's the possibility that she'll be confronted with how she dealt with her dad or losing her religion. I don't feel anything bad. I am happy with who I am and the edited version of me.

One thing that happened is a few weeks after the show, I saw this beautiful girl in a computer lab. She blatantly blew me off. It's funny. It's how I used to blow people off in New Orleans because I knew they were talking to me just because I was on *The Real World*. She blew me off because she knew why I'd approached her; she's pretty. Still, I did what Matt does, and gave her my Web site. She checked it out and called me. We had a date. Soon after, we went on vacation with her family to the beach in Charleston.

She's religious also. She's a spiritual girl. That's why we connected. It's not like Matt from *The Real World* got famous and bagged a hot chick. We really connected. No, I did not lose my virginity to Meredith. I'm still the virgin guy. Yeah, I've heard people say she looks like Julie. But that's not even true. There's been this whole made-up drama about how I was in denial about Julie and hooked up with someone just like her. I don't really know what to say to that.

Anyway, Meredith moved to New York City to pursue her modeling career. We decided to separate. But I'm in New York every other weekend and I'm going to move to New York for the summer. I'm going to live with friends and spend some time honing my skills in the digital realm.

Do I see any other girls now? Well, I'm very picky. That's a blessing and a curse. I would happily see another girl, but that's not my focus at all. Dating and going out to meet chicks are just not what I do. Oh, and I don't mean to use the word "chicks" in a demeaning way.

If I wanted readers to know one thing, I'd tell them not to be afraid to tap into the spiritual depths of their beings. We seek fleeting pleasures, but there's something really deep and real inside of us. Lift who you are to your highest level. Know that there's a reason you're where you are reading this book. We each can make a difference. Not a little difference, a big one. We all have an effect on everybody else. We can all impact the earth and society and we're foolish to think that's not the case.

FAVORITE MOMENT

I liked when we were at the airport. I liked watching our good-byes. To me, they seemed true and heartfelt.

LEAST FAVORITE MOMENT

I really can't think of one.

FUNNIEST MOMENT

The whole David and Melissa thing at work. When that happened, you could see us cracking up in the background.

HOUSE OF SHAME

Nothing, nothing I can think of. Oh, wait! I might as well bust this loose in the book. Julie was coming on to me that whole last week, telling me that we should have a final kiss at the airport, and that if I wanted to practice, she'd be in her room. Then at the airport, she turned her head when I went to kiss her. I feel like she sold me out. She was so low to have set me up like that. We did finally kiss after that. But, then on the Reunion, Julie announced that she denied me. I didn't bother correcting her. She'll have a different story, but I tell you this is the real thing.

FASHION DISASTER

None! I was the smoothest dresser in the house. I'm a smooth cat.

SOMEONE ELSE'S FASHION DISASTER

I don't know about fashion disaster but fashion monotony: Danny needs a new sweater!

BIGGEST SHOCK

No, we all wore our hearts on our sleeves. Even if something did catch me off guard, I tried to understand.

Kelley

Immediately after we stopped filming, I went home to Fayetteville. Everyone I love was there—Danny and Paul; my best friend, Renee; my parents. A day after being there, Danny and I got wickedly sick. We were violently ill, throwing up. Peter's a doctor, but he couldn't figure what was wrong with us. My mom—she's a couch doctor—thought it had to do with finally having all the pressure off us. We were just sick after what we'd been through.

Definitely after the show, we spazzed out for a while.

When cameras are on you, you're under so much stress and you don't even know it. You're using reserves that you don't even know are inside you. Whether you're thinking about the cameras on you or not, they become part of your psyche. I get up early now. I swear, I never got out of bed in that house. When you're asleep, it's the only time it's truly peaceful. And let's be real here. We get out of bed because we have something to do. We didn't have anything to do in the Belfort. Trying to create something to do each and every day can be tedious work.

After a week of my freaking out and decompressing, Peter came to pick me up in Fayetteville. I packed up all my stuff and drove back to New Orleans. Peter had found a new apartment for us. I got a job working with an online radio company called Fastband.com. It was on Bourbon Street and I had to interview people on the street. It was pretty crazy. Eventually, the company went under.

Meanwhile, the show started airing and all these people were calling from Los Angeles saying I was going to be a star. At first, it was really fun having people telling me I was the next big thing, talking circles around me. But in the back of my

head, I kept thinking, *I don't think I can act.* I went on these auditions I wasn't qualified for. I didn't know why I was doing it. I found it all pretty overwhelming and humiliating. It's a brutal industry and it's not something I want to do.

Of course, if Oprah calls, I'm still here, but I decided I wanted to have a real life. I'm going back to school to get my law degree. I have two semesters left and then I'm going to try and do law school, too. I think Peter and I are going to stay in New Orleans for the next two years. We haven't made any solid plans for the future, but eventually, the intention is to move back to California, which is where he's from.

It's really awkward living in New Orleans. Everyone here has seen the show...everyone. Julie didn't believe me that it was so bad. She came to visit me and totally panicked. Aside from the fame stuff, I like New Orleans more every day. I live three blocks away from the Belfort. It doesn't evoke any emotion in me. It's totally demolished now, anyway. I don't go to the places we used to go as a cast. For the most part, I've made it my own city. Hell, usually I'm out of town going to universities or traveling or seeing friends. Peter makes fun of me that I'm never in town for more than a week.

Things with Peter have been really good. We went through some hard times right after the show, but I think that happens in every relationship. Certainly, we all have our quirks. When the show was airing, I was nervous all the time. I had no idea week to week what was going to air. I was a wreck. Between being a full-time doctor and having me as a girlfriend, Peter really went through a lot. We both did. At one point when it was pretty bad, I sat my butt down in the closet and cried for a full hour. Sometimes you just have to get those feelings out.

guy. I'm so happy I have that friendship now. I'm unhappy I didn't have that friendship during the show, but you can't cry over spilled milk.

And with Melissa, things got so much better. It was really because of last year's book that we finally got it out in the open. We realized that there was something big between us: Julie. Melissa called me and read me things we'd said about each other. It was all, "Julie told me this" and "Julie told me that." We got Julie on the phone. She told us that she was just trying to help us get along. What? You tell one person the other person thinks crappy things about her? That's a helpful thing? I didn't believe her. Melissa, Jamie, and I are good friends now, and we could have been then. But there were too many lies flying around.

In the end, I thought the show was really good. Not because of how I came off; I just thought it was a good show. I got calls from cast members flipping out, but I didn't feel the same way. Without a doubt, I was one of the background characters. I think that's probably a lot easier than being one of the focuses. I got to watch it on television as if I were a regular viewer. A lot of what happened was news to me.

Matt and Julie have really taken advantage of the fame aspect of the show. I won't say that's necessarily a bad thing. Hell, the fame can be fun. The good parts of fame are when you're ready for it— that is, you've taken a shower, aren't hung over, and you're spinning around in circles, not tripping over your feet. The worst is when you're not ready for it and you're in a bad mood.

My family is so cool. They loved *The Real World*. My mom said one day, "How fascinating is your life?" She was like, "Stop being bitter, and think about how great your life is. You're on a television show; you've got the love of your life; you travel places. It's incredible." Nobody in my life was ever pissed off at me or negative. My relationships just went right back to normal. From what I hear from other people on the show, that's a blessing.

As far as my cast is concerned, you know, it's weird. It's like you start on one level and then you start slip-sliding down. You watch the show and see what people say about you, and you promise you're not going to get mad about anything, but it's hard to resist. I was so mad at Jamie at first. I think we're both really stubborn. He and I needed to let our guards down. He's just a really charming cool

I like speaking at the universities. I can't say there's a better feeling than people coming up to me and thanking me for talking about depression or my thoughts on abortion. It's phenomenal to me that people would care what I think. It's crazy, but they do.

Do I think I've changed? Yeah, I'm a lot happier now. I relax and try to enjoy my life. I don't know if that has anything to do with the show; maybe it's just about growing up. A lot has happened to me in the past year. I changed the city I live in. I moved in with a boyfriend. I've learned patience. Living with a guy will teach you that really fast! I think I've probably learned to bite my tongue, too.

Peter is cute about the fame stuff. He gets shy, but you can tell from the glint in his eye that he thinks it's kind of fun.

Want to hear one of my favorite stories? This guy came into the ER. He was out of control, having some kind of a weird psychotic break. He was screaming at everybody, scaring people. Peter came over to try and calm him down. He had this wild look in his eyes, and then all of a sudden, he looks at Peter good and close and goes: "Aren't you that doctor from *The Real World*?" He totally calmed down and started asking a million questions about the cast.

If I wanted to tell readers one thing, it'd be this: allow people on these shows to change and grow. Don't attach too much significance to the episodes you see. Don't hold us accountable for things we said in passing. Let us move on like everybody else. That's it, I guess.

FAVORITE MOMENT
When Peter and I are at the coffee shop and I'm telling him I'm going to stay in New Orleans. They put this really intense song over it. It's perfect, about how the person is my life. If we ever get married, I'll play it at the wedding. I love that.

LEAST FAVORITE MOMENT
Hearing my roommates talk about Peter's ex-girlfriend. She didn't deserve to be dragged in to the show like that.

FUNNIEST MOMENT
I know exactly what it was. The night of Melissa's birthday, when she's in her underwear and she's doing that chicken dance. She looked like she was on a puppet string bouncing down the hallway.

WISH THEY'D SHOWN
Danny and I went to church one day. He had never been to an Episcopal church before. I'd told him it was a really accepting community, but he didn't believe me. During the service, I looked over at him and he was just crying. We talked for three hours after that. It was a total purge conversation for both of us. I think that's when our bond was locked down permanently.

FASHION DISASTER
When Melissa and I are arguing and I'm wearing this T-shirt that says "Betty's Surf Shop." My hair is a mess and the shirt had sweat stains. Melissa, of course, looked amazing.

HOUSE OF SHAME
When I threw my leg over David's shoulder like a stripper. Oh, and when I put a prom dress on and slurred my way through a confessional. Not cute.

How to get on *The Real World*

APPLICATION INSTRUCTIONS

1. Please fill out the enclosed application legibly.

2. Use dark-colored ink.

3. Answer all questions honestly and to the best of your ability.

4. Please write only on the printed side of the paper. Feel free to attach additional sheets as necessary.

5. Attach a page to this packet with a recent photo on it. (Yes, another one, even if you sent one with your original tape.)

6. You must staple a copy of your driver's license to the back of the packet.

7. You should return this application TODAY, as we have a very limited amount of time until production begins. DO NOT e-mail the application back

 FIRST: Please fax a copy to: 818.756.5140 Attn: ROB

 THEN: Mail the original copy to: ROB
 REAL WORLD CASTING DEPT.
 6007 SEPULVEDA BLVD.
 VAN NUYS, CA 91411
 Write "ROB" in big letters on the outside of the package, so we can spot it easily.

8. Please make sure to include enough postage when you return this packet.

THE REAL WORLD and ROAD RULES SEASON 11 APPLICATION FORM

Bunim/Murray Productions, Inc.
6007 Sepulveda Blvd.
Van Nuys, CA 91411
Casting info: http://www.bunim-murray.com

NAME: _____ Date: _____

PRESENT ADDRESS: _____

PHONE: _____ 2nd PHONE: _____ Cell/Pager: _____

E-MAIL: _____ 2nd E-MAIL: _____ I check my e-mail a lot: Y ☐ N ☐

SOCIAL SECURITY NO.: _____ BIRTHDATE: _____ AGE: _____

MOTHER'S NAME, PHONE, and ADDRESS: FATHER'S NAME, PHONE, and ADDRESS (if different)
Check here if this is your permanent address: ☐ Check here if this is your permanent address: ☐

SIBLINGS (NAMES AND AGES): _____

WHAT IS YOUR ETHNIC BACKGROUND? _____

ARE YOU OR HAVE YOU EVER BEEN A MEMBER OF SAG/AFTRA? HAVE YOU EVER ACTED OR PERFORMED OUTSIDE OF SCHOOL?

APPLICATION

EDUCATION:

NAME OF HIGH SCHOOL (AND YEARS COMPLETED): _____

NAME OF COLLEGE (YEARS COMPLETED AND MAJORS): _____

OTHER EDUCATION: _____

WHERE DO YOU WORK? DESCRIBE YOUR JOB HISTORY: _____

WHAT IS YOUR ULTIMATE CAREER GOAL? _____

WHAT KIND OF PRESSURE DO YOU FEEL ABOUT MAKING DECISIONS ABOUT YOUR FUTURE? WHO'S PUTTING THAT PRESSURE ON YOU?

WHAT ARTISTIC TALENTS DO YOU HAVE (MUSIC, ART, DANCE, PERFORMANCE, FILM/VIDEO MAKING, WRITING, ETC.)? HOW SKILLED ARE YOU?

WHAT ABOUT YOU WILL MAKE YOU AN INTERESTING ROOMMATE? _____

IF YOU'RE LIVING WITH A ROOMMATE, HOW DID YOU HOOK UP WITH HIM OR HER? TELL US ABOUT HIM OR HER AS A PERSON. DO YOU GET ALONG? WHAT'S THE BEST PART ABOUT LIVING WITH HIM OR HER? WHAT'S THE HARDEST PART ABOUT IT?

HOW WOULD SOMEONE WHO REALLY KNOWS YOU DESCRIBE YOUR BEST TRAITS? _____

HOW WOULD SOMEONE WHO REALLY KNOWS YOU DESCRIBE YOUR WORST TRAITS? _____

DESCRIBE YOUR MOST EMBARRASSING MOMENT IN LIFE: _____

DO YOU HAVE A BOYFRIEND OR GIRLFRIEND? HOW LONG HAVE YOU TWO BEEN TOGETHER? WHERE DO YOU SEE THE RELATIONSHIP GOING? WHAT DRIVES YOU CRAZY ABOUT THE OTHER PERSON? WHAT'S THE BEST THING ABOUT THE OTHER PERSON?

WHAT QUALITIES DO YOU SEEK IN A MATE? _____

HOW IMPORTANT IS SEX TO YOU? DO YOU HAVE IT ONLY WHEN YOU'RE IN A RELATIONSHIP OR DO YOU SEEK IT OUT AT OTHER TIMES? HOW DID IT COME ABOUT ON THE LAST OCCASION?

DESCRIBE YOUR FANTASY DATE: _____

WHAT DO YOU DO FOR FUN? _____

DO YOU PLAY ANY SPORTS? DESCRIBE YOUR ATHLETIC ABILITY:

WHAT ARE YOUR FAVORITE MUSICAL GROUPS/ARTISTS?

DESCRIBE A TYPICAL FRIDAY OR SATURDAY NIGHT:

WHAT WAS THE LAST UNUSUAL, EXCITING, OR SPONTANEOUS OUTING YOU INSTIGATED FOR YOU AND YOUR FRIENDS?

DO YOU LIKE TRAVELING? DESCRIBE ONE OR TWO OF THE BEST
OR WORST TRIPS YOU HAVE TAKEN. WHERE WOULD YOU MOST LIKE TO TRAVEL?

OTHER THAN A BOYFRIEND OR GIRLFRIEND, WHO IS THE MOST
IMPORTANT PERSON IN YOUR LIFE RIGHT NOW? TELL US ABOUT HIM OR HER:

WHAT ARE SOME WAYS YOU HAVE TREATED SOMEONE WHO HAS BEEN IMPORTANT TO YOU THAT YOU ARE PROUD OF?

WHAT ARE SOME OF THE WAYS YOU HAVE TREATED SOMEONE WHO HAS BEEN
IMPORTANT TO YOU THAT YOU ARE EMBARRASSED BY, OR WISH YOU HADN'T DONE?

IF YOU HAD TO DESCRIBE YOUR MOTHER (OR YOUR STEPMOTHER, IF YOU LIVED WITH HER MOST OF YOUR
LIFE AS A CHILD) BY DIVIDING HER PERSONALITY INTO TWO PARTS, HOW WOULD YOU DESCRIBE EACH PART?

IF YOU HAD TO DESCRIBE YOUR FATHER (OR YOUR STEPFATHER) BY DIVIDING
HIS PERSONALITY INTO TWO PARTS, HOW WOULD YOU DESCRIBE EACH PART?

HOW DID YOUR PARENTS TREAT EACH OTHER? (DID YOUR PARENTS HAVE A GOOD MARRIAGE? WHAT WAS IT LIKE?)

DESCRIBE HOW CONFLICTS WERE HANDLED AT HOME AS YOU WERE GROWING UP
(WHO WOULD WIN AND WHO WOULD LOSE, WHETHER THERE WAS YELLING OR HITTING, ETC.)?

IF YOU HAVE ANY BROTHERS OR SISTERS, ARE YOU CLOSE? HOW WOULD YOU DESCRIBE YOUR RELATIONSHIP WITH THEM?

DESCRIBE A MAJOR EVENT OR ISSUE THAT HAS AFFECTED YOUR FAMILY:

DESCRIBE A QUALITY/TRAIT THAT RUNS IN YOUR FAMILY:

WHAT IS THE MOST IMPORTANT ISSUE OR PROBLEM FACING YOU TODAY?

IS THERE ANY ISSUE, POLITICAL OR SOCIAL, THAT YOU'RE PASSIONATE ABOUT? HAVE YOU DONE ANYTHING ABOUT IT?

WHO ARE YOUR HEROES AND WHY?

DO YOU BELIEVE IN GOD? ARE YOU RELIGIOUS OR SPIRITUAL? DO YOU ATTEND ANY FORMAL RELIGIOUS SERVICES?

WHAT ARE YOUR THOUGHTS ON: ABORTION?

PEOPLE WHO HAVE A SEXUAL ORIENTATION DIFFERENT FROM YOURS?

GUN CONTROL?

AFFIRMATIVE ACTION?

DO YOU HAVE ANY HABITS WE SHOULD KNOW ABOUT?

DO YOU: SMOKE CIGARETTES? CIRCLE (YES/NO) DRINK ALCOHOL? (YES/NO) IF YES, WHAT IS YOUR FAVORITE ALCOHOLIC BEVERAGE?

DO YOU SMOKE MARIJUANA OR USE HARD DRUGS? HAVE YOU EVER? PLEASE EXPLAIN:

THE REAL WORLD AND *ROAD RULES* HAVE A ZERO TOLERANCE DRUG POLICY.
IF YOU USE DRUGS, CAN YOU GO WITHOUT FOR SEVERAL MONTHS? _____

ARE YOU ON ANY PRESCRIPTION MEDICATION? IF SO, WHAT, AND FOR HOW LONG HAVE YOU BEEN TAKING IT? ____

ARE YOU NOW SEEING, OR HAVE YOU EVER SEEN, A THERAPIST OR PSYCHOLOGIST? IF SO, EXPLAIN. _____

HAVE YOU EVER BEEN ARRESTED? (IF SO, WHAT WAS THE CHARGE AND WERE YOU CONVICTED?) _____

WHAT BOTHERS YOU MOST ABOUT OTHER PEOPLE? _____

DESCRIBE A RECENT MAJOR ARGUMENT YOU HAD WITH SOMEONE. WHO USUALLY WINS ARGUMENTS WITH YOU? WHY? __

HAVE YOU EVER HIT ANYONE IN ANGER OR SELF-DEFENSE? IF SO, TELL US ABOUT IT (HOW OLD WERE YOU, WHAT HAPPENED, ETC.):

HOW DO YOU HANDLE CONFLICTS? DO YOU FEEL THAT THIS APPROACH IS EFFECTIVE? _____

DO YOU EVER FEEL INTIMIDATED BY OTHER PEOPLE? WHY? HOW DO YOU REACT IN THESE MOMENTS? _____

HAVE YOU EVER INTERVENED TO STOP AN ARGUMENT OR FIGHT? IN YOUR OPINION,
WHEN DOES AN ARGUMENT ESCALATE TO THE POINT WHERE IT SHOULD BE STOPPED? _____

IF YOU COULD CHANGE ANY ONE THING ABOUT THE WAY YOU LOOK, WHAT WOULD THAT BE? _____

IF YOU COULD CHANGE ANY ONE THING ABOUT YOUR PERSONALITY, WHAT WOULD THAT BE? _____

IF SELECTED, IS THERE ANY PERSON OR PART OF YOUR LIFE YOU WOULD PREFER NOT TO SHARE?
IF SO, DESCRIBE (I.E., FAMILY, FRIENDS, BUSINESS ASSOCIATES, SOCIAL ORGANIZATIONS, OR ACTIVITIES): _____

IS THERE ANYONE AMONG YOUR FAMILY OR CLOSE FRIENDS WHO WOULD OBJECT TO APPEARING ON CAMERA? IF SO, WHY?

WHAT IS YOUR GREATEST FEAR (AND WHY)?

IF YOU HAD ALADDIN'S LAMP AND THREE WISHES, WHAT WOULD THEY BE?

PLEASE COMMENT ON YOUR PREFERENCES
FOR THE FOLLOWING ACTIVITIES:

PLEASE DRAW A SELF-PORTRAIT IN THE SPACE BELOW:

ACTIVITY: **COMMENT:**

READ BOOKS

SLEEP 8 HOURS

WATCH TELEVISION DAILY, WHICH SHOWS?

SHOP

GO OUT/PARTY

SPEND TIME WITH FRIENDS

SPEND TIME ALONE

BALANCE WORK/STUDY

TALK ON THE PHONE

COOK

CLEAN

WRITE/E-MAIL

READ NEWSPAPERS (WHICH SECTIONS?)

PLAY WITH ANIMALS

STATE OPINIONS

ASK OPINIONS

CONFIDE IN YOUR PARENTS

VOLUNTEER

PROCRASTINATE

EAT

GET DRUNK

DIET

VOTE

CRY

LAUGH

INSTIGATE

CINEMA

THEATRE

CONCERTS

CLUBS

PARTIES

SURF THE WEB

MY FAVORITE WEB SITES ARE:

LIST 4 PEOPLE WHO HAVE KNOWN YOU FOR A LONG TIME AND WILL TELL US WHAT A GREAT PERSON YOU ARE (EXCLUDING RELATIVES). PLEASE INCLUDE TWO ADULTS AND TWO OF YOUR FRIENDS.

NAME, ADDRESS, PHONE, HOW DO THEY KNOW YOU?

1. _____

2. _____

3. _____

4. _____

PLEASE HELP US GET IN TOUCH WITH YOU. IF YOU HAVE OTHER PEOPLE (ROOMMATES, BOYFRIEND/GIRLFRIEND, BOSS, RELATIVES, ETC.) WHO FREQUENTLY KNOW WHERE YOU ARE AND HOW TO GET IN TOUCH WITH YOU, PLEASE LIST THEM BELOW. AS WE CAST ON A SHORT SCHEDULE, GETTING IN TOUCH WITH YOU QUICKLY HELPS EVERYONE.

NAME: RELATION: PHONE:

HOW FAMILIAR ARE YOU WITH THE *REAL WORLD* AND *ROAD RULES* TELEVISION SHOWS?

HOW DID YOU HEAR ABOUT OUR CASTING SEARCH?

I acknowledge that everything stated in this application is true. I understand that any falsely submitted answers can and will be grounds for removal from the application process and from my subsequent participation in the final series. I further acknowledge and accept that this application form and the videotape I previously submitted to MTV will become property of MTV and will not be returned. By signing below, I grant rights for MTVN/Bunim-Murray Productions (BMP) to use any biographical information contained in this application, my home video or taped interview, and to record, use, and publicize my home videotape or taped interview, voice, actions, likeness, and appearance in any manner in connection with THE REAL WORLD and/or ROAD RULES.

SIGNATURE DATE

Please remember to staple a photocopy of your driver's license or passport to this packet. When faxing, do not include the photocopy. Thank you for your time and effort in completing this form.